Think Art

Theory and Practice in the Art of Today

Think Art

Theory and Practice in the Art of Today

Symposium under the direction of
Jean-Marie Schaeffer

Witte de With, center for contemporary art, Rotterdam

Contents

Bartomeu Marí

Preface

In counterpoint to the presentation of contemporary art, Witte de With, cen-
ter for contemporary art in Rotterdam, has organized conferences and
debates since its creation in 1990. Exhibitions constitute the most impor-
tant element of Witte de With's activity, which is motivated by the belief
that art should occupy an essential position within the public domain. The
wide variety of exhibitions, the artists' intentions and the contents of the
works are continually explored in lectures and panels. Making art accessi-
ble to the eyes and to the mind are two aspects of a single activity, since the
pleasure and emotion experienced in the reception of art are themselves
part of an indivisible whole, where subjective phenomena need to be shared
if they are to be transformed into common values, into realities with cul-
tural relevance. Artists of different generations and professionals in the
fields of art history and criticism have consistently been invited to partici-
pate as integral factors of the center's program. Thus we understand art as
an act of dialogue between active and conscious subjects.

Think Art sums up the proceedings of the seminar organized by Witte de With
under the direction of philosopher Jean-Marie Schaeffer. At its basis is the
desire for a systematic methodological approach to the distance that sepa-
rates contemporary art practice from the intellectual instruments that we
have for 'thinking art.' I conciously say 'thinking,' not 'understanding' or
'explaining.' The status of artworks as means for relating to reality, as tools
for obtaining pleasure and knowledge, may situate them in a universe
where the specific characteristics of the aesthetic method need to be rede-
fined outside the transcendental models inherited from the seventeenth
and eighteenth centuries, which still function as theoretical frameworks for
evaluation.

To approach this relation between art and individuals, we felt it necessary to
recognize the obsolescence of the critical language in which artistic prac-
tice is discussed today. Artistic practices at the close of the twentieth centu-
ry have undergone no profound revolution inside the sphere of the avant-
garde; but outside, the social fabric, the technical field and the matrix of
cultural values in which art functions have indeed gone through such deep
changes.

The relation between artistic objects and the public in the last fifteen years has been marked by moments of relative estrangement in Europe and in the United States. This estrangement has been expressed with different *vocabularies* in the different countries: cases of public censorship of works or exhibitions, bitter debates over the public financing of artistic creations, cases of vandalism against artworks, social rejections of forms, materials, or contents… France has without a doubt seen the most virulent manifestation of this *Crise de l'art contemporain* (to quote the title of philosopher Yves Michaud's most recent book), which has run parallel to other clearly defined political, economic, and social problems. Although it is not my intention to extrapolate from this crisis situation to the whole of Western society, *Think Art* does use this context as the significant background for the study of the ways the contents of today's art come to form part of culture as an enlarged social manifestation.

Paradoxically, contemporary art has never received such governmental and media attention as in this century's final decades. Is this the result of a pendulum swing of acceptance and rejection, or the sign of society's loss of confidence in the usefulness of its beliefs? As professionals dedicated to the presentation and communication of art, we cannot ignore that a continuing and serious debate over our practice is one of the most fruitful tools for ensuring the quality and incidence of art.

We began with the assumption that the questions we were interested in asking are not sufficiently well formulated in traditional academic circles, or that these reflections are too isolated from public opinion. Although individuals belonging to the academic community have devoted their attention to contemporary artistic practices, the fluidity that permits genuine debate has not yet emerged. To think contemporary art means to enter deeply into a paradox, which arises from the lack of the critical distance needed to shape opinions on the objects and on their surrounding contexts. And yet art must be part of the facts of our time. If we compare the relations between theory and practice in the spheres of science, economics, or politics, we may begin to glimpse many of their specific features and their resemblances and differences to the systems of action and belief that we wish to approach.

At Witte de With we have an everyday familiarity with presenting art to the public: through the organization of exhibitions we are in very direct contact with artists, artworks, and the public. Thus our working dynamics and our identity confront us with the facts of the creation and reception of art,

in a systolic-diastolic movement from the local to the international panorama. How this pulse of meaning is elaborated, maintained, and developed is the result of processes which is hard to measure or control, but which is no less real – and no less worthy of a dialogical reflection that seeks to grasp them in objective terms.

The reading of Jean-Marie Schaeffer's work, *Les célibataires de l'art: Pour une esthétique sans mythes*, offered an example of a precise methodological attempt to redefine the object and the method of aesthetic thinking in light of the most recent artistic developments. In this book, Schaeffer introduces the idea that 'aesthetic nature is not a property of the works of art, but a dimension of our behavior in relation both to artworks and to events or objects without specific qualities.' More than theories, Schaeffer says, the object of aesthetics 'should be the behaviors, the relations that link us to the world of the works and to the world in general – behaviors whereby ordinary knowledge is converted into a source of pleasure, involving subjectivity, acquired dispositions, memory, sensations.'

The seminar began with a comparison and contrast between the methodology of the philosopher engaged in aesthetic investigation and the methodologies of the historian, the sociologist and the artist. Three sessions, each including two lectures, were offered as public presentations, followed by a closed-door seminar where some fifteen persons were able to discuss and elaborate on the themes introduced in the lectures, as well as others that came up in the course of the discussions. In the first of the sessions, Catherine Ingraham contributed new considerations developed from a critical and historiographical viewpoint for application to architecture. Thus the thinking and making of art were contrasted with architecture, where the relations between conception and realization involve quite different levels of complexity. Nathalie Heinich presented her positions from the perspective of a sociology applied to the reception of contemporary art. Finally, Johan Grimonprez spoke of the motivations, choices, and techniques used in his own work. Reactions to the lectures by Andreas Broeckman, Felix Janssens & Ben Laloua, Herma Klijnstra, Henk Oosterling, and Renee Turner initiated a genuinely interesting and original debate, from various professional and intellectual perspectives. Johan Grimonprez contributed with a special project emanating from his ongoing media works.

I would like to extend our very special thanks to Anke Bangma for her excellent direction of the seminar, her intense dedication at all times, and the high

quality of her input. And to Jean-Marie Schaeffer, Catherine Ingraham, Nathalie Heinich, and Johan Grimonprez for their generosity and their contributions to the debates.

Acknowledgment should be given to the Dutch Ministry of Foreign Affairs, the Ministery of Education, Culture and Science, the financial support of which allowed us to execute this initiative. Our thanks also goes to The Netherlands Architecture Institute and the Willem de Kooning Academy for hosting the discussions.

Finally, it is our desire to have contributed, with this seminar and publication, to the broadening and reactivation of the debate on contemporary culture. We hope to have defined and actualized the possibilities and limits of a number of relevant methodological questions. To this end, the present publication itself can serve as a stimulus and as a critical framework for a continuing reflection and dialogue in art and about art, which we intend to pursue in the daily activity of this institution.

Jean-Marie Schaeffer

What Theory? What Art?
Some Preliminary Reflections

I would like to unravel some of the questions that, in my view at least, are relevant to this seminar. In choosing my questions I'll take the title of the seminar as a guideline: 'Seminar on the relationship between art and art theory.'

Let's start with the first word: 'seminar.' I suppose that we all agree that this word implies that the aim of our encounters is to give us access to a better understanding of a supposedly pending problem, that of the relationship between art and art theory. So the first question, which is in fact a preliminary one, could be formulated as follows: 'What difficulties are intrinsically linked with an enterprise like this one and what are some of the pitfalls to be avoided?' Or, more briefly: 'What method?'

The second group of questions is linked to the term: 'art theory.' 'Theory' seems at first sight to be a precise concept, but its generality is such that it recovers very different phenomena. So the question would be: 'What art theory?'

The third ensemble of problems is linked to the expression 'art.' This expression gives rise to so many questions that our entire seminar would be insufficient to simply enumerate them. I shall thus limit my discussion to those problems which are specifically linked to the issue of the relationship between art and art theory. This set of problems could be summarized by the following question: 'Why is it that the problem of the relationship between art and theory is *de facto* a problem concerning the relationship of *visual* arts and theory?' Or, more briefly: 'What art?'

I hasten to add that my goal in posing these questions is very modest. In fact, my only aim is to convince you that they are valid questions and that it would be interesting to include them in our collective pondering.

What method?

In my opening sentence I said that I would like to unravel some of the questions which, in my view at least, lie at the heart of our topic. I want to insist on the restrictive clause 'in my view at least,' as a reminder of the fact that my per-

spective is a specific one. I am looking at the problem through the eyes of a philosopher, and these eyes are not the same as those of the artist, the art historian, or the art critic. But I don't claim to speak for the practice philosophy as a whole: my manner of practicing philosophy is a specific one – more in the spirit of a sort of philosophical anthropology linked to analytical philosophy and philosophy of the mind, than in the spirit of what is sometimes called 'continental philosophy' and which is, broadly speaking, the spirit of hermeneutics. This applies also to the part of my philosophical inquiries that is concerned with aesthetics and art: I am more interested in trying to describe and analyze art-making and art-reception as basic human activities, than to interpret artworks as embodiments of (or as clues to) some underlying reality, be it ontological, social, political, etc.; or to evaluate them according to some artistic ideal. Like everyone, I have my artistic and aesthetic preferences but would like them not to interfere with the analytical task.

What I want to suggest with this personal aside is simply that my manner of questioning the relationship between art and art theory has its inevitable blind spots. There exists no cognitive God's Eye: every knowledge is aspectual, which means that it is partial and relative to some specific cognitive and pragmatic aim. I'll try to treat this problem of the aspectuality of every cognitive activity during my lecture 'System, History, and Hierarchy: the Historicist Paradigm in Art Theory' for the second session, where we shall be talking about methodologies. Now, I only want to point out that this intrinsic aspectuality of knowledge has two consequences for our present inquiry:

I. In the nominal phrase 'art and art theory,' the expression 'art theory' should in fact be replaced by the plural: 'art theories.' There exists no unified domain of 'art theory' which could be opposed as such to art-making; theories about art are multiple, they pursue very different goals, and their relationships with art-making are diverse. But if the theories are multiple, and if this multiplicity is that of aspectuality, then we must also be prepared to admit that the notion of 'art' itself is not that of a pure given – there are no labels attached to reality *before* our labeling activity – but is always a specific cognitive construction. By this I don't want to suggest that theories cannot be compared with one another as to their validity, but that this comparison is always also a disputation about the identity of the object which is addressed by the competing theories. This first consequence of the aspec-

tuality of human knowledge leads directly to our second question: 'What theory?.'

II. But before proceeding to that question, it is important to address the second consequence of the aspectuality of cognition. As aspectuality is a general condition of all knowledge, it also applies to this discussion – that is to the metalevel on which our inquiry takes place. Metatheory is as aspectual as theory. For this reason it is important to devise multiple points of entry into our question, and I am happy that this series of conferences and workshops will welcome interventions from artists, critics, art historians, sociologists, and philosophers. This is a fundamental issue because the blind spots of most metatheories result from our eagerness to insist on the relativity, the contextuality of the discourses which are our object of investigation, and at the same time, our hesitance to accept that our own metadiscourse is governed by the same conditions. This does not imply that there are no distinctive levels of inquiry, or that metatheory collapses with its object, or that any valid knowledge about theories is impossible: the analysis of art theories is not an art theory in itself, but an attempt to understand what art theories are about. My insistence on the aspectuality of knowledge is only a reminder of the fact that the logical distinction between metatheory and theory does not correspond to an epistemological distinction between two different levels of cognitive certainty or validity. In other words: all cognitive discourses, whatever their logical level, are part of an ongoing conversation which also applies to our own inquiry and of course to what I am uttering here at this precise moment.

What theory?

Barnett Newman once said that aesthetics is about as important for artists as ornithology is for birds. Insofar as aesthetics is generally considered to be one variety of what our program designates as 'art theory,' I suppose that wherever dear Barnett is today – be it in heaven or be it in the hell of high modernism – there is no doubt that if by chance he were to see the topic of this session, he would mutter something like: 'Damn ornithology!' In any case, for Newman, comparing the artist to a bird and aesthetics to ornithology was meant to convey the idea that for the artist aesthetics has no importance at all.

But his statement can be read in at least two ways.

On the one hand, it is a statement about the psychology of the artist Newman. Many artists loathe theory, as do many connoisseurs and art-lovers. In fact, I would even go as far as to suggest that almost anyone interested in art has thought more than once – while trying to swallow an especially dull piece of philosophical aesthetics or art-theory, or while chewing on a particularly indigestible exhibition catalog: 'Damn ornithology!'. What this complaint amounts to is, I suppose, the idea that theory appears to be irrelevant for the practicing artist and for the enjoyment of the art-lover: the distance between theory and practice seems to be too great for theory to be of any importance to our concrete relationships with art-making and artworks.

But this presentation of the relationship between art and art theory shows only half of the picture, at least when we focus on the contemporary art world. First, we notice art theory, whatever the precise guise under which it comes, whatever its supposed or real irrelevance for the concrete acts of making and enjoying art, is beyond all doubt a very prominent part of the *social functioning* of visual arts today. Second, not only has theory never been as prominent in art as it is in contemporary art, but more importantly, theory has never been as strongly tied to art-making as it is today. I know of no other period of art where the distance between art-making and art theory has come so close to vanishing. And as contemporary artworks themselves often contain an explicit theoretical aspect, the difference between art and art theory tends to become blurred, so that contemporary art itself is more than once rebuked by the general public as being 'damn ornithology' – something of no interest to the layman, precisely because it appears to be unable to function once cut off from the theory which defines its identity.

So we seem to arrive at two opposed conclusions: too much distance on one side, not enough distance on the other. Fortunately the people who complain about the first are not the same as those who complain about the second. Let me take some examples. When a painter – and I insist on the term 'painter' as distinct from the term 'artist' – protests against art theory, his judgment is very often founded on the idea that painting is foremost an affair of visual expression, material touch, and formal sensitivity. Theory, being a conceptual affair, seems to fall outside of this realm of the sensible; paintings have to be experienced by our senses and emotions and conceptual analysis only perverts perceptual experience and emotional response. A conceptual artist, or an installation artist, would complain about some-

thing quite different: because the starting point of these genres is the idea that the artwork itself is the embodiment of an idea, of a concept, this artist tends to think that the only valid art theory is that of the work itself, with all extrinsic theorizing about art being somewhat parasitic to the theory embodied by the work. Of course this protest is sometimes a sort of self-deception: often conceptual artists write auto-commentaries without which the intelligibility of their plastic works would be jeopardized, but which at the same time are as extrinsic to the exhibition-objects as would be any allographic piece of writing done by a critic or theorist. The complaints of the public would again be different: some people are critical not of art theory as such, but of what they see as a certain esotericism of most current art theory; then there are people who think that the appreciation of a work of art belonging to the realm of the *arts plastiques* should be an exclusively visual affair and that works which cannot be appreciated in this way are of no interest; still others complain that the strong interrelatedness of art and theory leads to a situation where the artist, or the mediator between artist and public, claims to deliver the work *and* its interpretation, leaving no room for the specific activity of reception.

As this series of conferences is organized by an art institution, let us finish with the complaints against art theory which would most likely be put forward by institutional decisionmakers of the art world (museum staff, gallerists, agents). In my experience – when confronted with a malfunctioning relationship between art and public, for example when an exhibition is a flop, or when the sponsors of the institution (be they public or private) are dissatisfied – these decisionmakers are sometimes happy to blame art theory, accusing it of being unable to 'explain' the importance of contemporary art to the public: there would be no problem if only someone could educate the masses. This idea presupposes of course that one who does not appreciate a work of art selected by an art institution surely suffers from a lack of art education: if he had the right theoretical framework at his disposal, he would surely appreciate the work. This is an interesting complaint because it is founded on a short-circuiting of the question of aesthetic experience, not only as far as the public is concerned but also as concerns the institution's own choices. This outlook seems to be the survival of an essentialistic conception of art which conflates the question of the ontology of art works – 'What is art?' or better still, in Nelson Goodman's terms, 'When is there art?' – with the question of value – 'What is good art?'. According to this

essentialistic theory, being an artwork signifies being an intrinsically valuable object: if one fails to appreciate an object which is identified institutionally *as* an artwork, it can only be because he fails to understand it. An outlook based on aesthetic experience implies on the contrary that the question of the value of an artwork is fundamentally a question of *attributing* a value to a work based on one's subjective experience of that work. Aesthetic value is not an object-predicate but a relational one: it expresses the relationship between the identified object-properties of the work and the satisfaction or dissatisfaction that my experience of these object-properties elicits in me. So taking into account aesthetic experience gives rise to a somewhat more relaxed vision of the relationship between art and art theory: whatever their relationship, the vital question for the ongoing life of artistic creation is that of its capacity to elicit satisfactory aesthetic experiences, and this capacity is beyond the control of any theory.

These examples show not only that art theory comes in many forms, but also that it is linked to different aims and attentional horizons. This leads to the idea that the contradictory impression of too great a distance – and sometimes, of too small a distance – results for two reasons:

a) We are generally blind to the fact that the expression 'art theory' refers to very different types of discourses, each of which has its specific 'correct' distance, a distance which depends on its cognitive aim and its pragmatic function;

b) This blindness is not only that of the reader of art theory but also that of the writer, whenever he conflates and compounds several different aims in his writing. To use a French expression: *On ne peut pas avoir à la fois le beurre et l'argent du beurre* (You cannot have at the same time the butter and the money for the butter). Often, when engaging in theory, we want dual benefits: we want fact and ideal, we want distance and engagement, we want knowledge and evaluation, etc. Of course in our lives, at one time or another, to need all of these things, but conflating them is the worst way of trying to get them. What I want to suggest is that if every relationship with art is aspectual (or *perspektivisch*, in the sense of Nietzsche, which applies to cognition as well as to axiology), there is no single 'correct distance' but instead different correct distances according to the cognitive aim and pragmatic function of the relationship we are engaged in. Accordingly, every type of discourse has to establish its own correct distance from the practice of art. So, the problem is not one of finding *the* right distance between art and art theory, but to

avoid mixing up the various distances, each of which is appropriate for a particular theoretical discourse.

Let me give one example of what I mean with the expression: 'correct distance.' I mentioned earlier that, in general, philosophical aesthetics is considered to be a variety of art theory. But this identification of aesthetics with art theory is the result of a specific historic evolution of aesthetics, which, in my view at least, has induced what I would like to call a 'category error.' Philosophical aesthetics was born as a theory of the aesthetic attitude – as a theory trying to analyze the specific human attitude of cognitive attention regulated by an intrinsic degree of pleasure or displeasure and not by some extrinsic goal. Philosophical aesthetics, in this sense, is not at all identical to art theory: the latter is the theory of a specific type of human product, whereas the study of aesthetics is the study of a specific human attitude, whatever the object of that attitude, be it an artwork or anything else.

Romanticism abolished this distinction between the question of the aesthetic attitude and the question of art; this is why 'aesthetics,' from that time on, has become interchangeable with 'art theory' to the extent that the artwork is supposed to be *defined* by its aesthetic function (cf: Hegel, whose *Aesthetics* is in fact an art theory). My aim here is not to enter into the problem of the multiple confusions that stem from this identification, but to point out that the confusion of the two problems has made it very difficult, for two centuries, to question the cultural and historical variability of the relationship between the aesthetic and the artistic. (This is one of the points where it seems that Arthur Danto is fundamentally correct: art theory and aesthetics are two different things.) On the other hand, once one recognizes the difference between the two ways of addressing the problem of art, the great distance which separates aesthetic theory from the practice of art is nothing to wonder about. I would even go as far as to suggest that maintaining this distance is very important, because it is precisely this distance which opens the space for a correct approach to the problem of the distance between the creation and the reception of artworks.

So far so good. But all this is a far cry from solving our problem of the relationship between art and art theory. To show this, I'll return one last time to Barnett Newman's statement. Until now I read his statement simply as an expression of a psychological mood, and tried to situate that mood in the larger context of the importance of theory in the contemporary social situ-

ation of artistic creation. But I don't think that Newman's statement was simply meant to express a psychological mood – a way of reacting to current art theory. In fact, I believe that for Newman, the idea that aesthetics is of no importance for the artist meant that it is of no importance for the *real life of art* as such, the expression 'real life' referring to some reality of art supposedly more essential than the *social* reality of art, of which art theory is a part: art theory belongs to the extrinsic social conditions of art circulation and not to the 'essence' of art as art.

This transition from the artist to art as such is very interesting, because it is valid only if we identify the perspective of the creating artist with the concept of art. Such an identification certainly held for the high modernism of Newman, and holds more generally for any conception of art which is founded on the paradigm of the artist as an absolute creator – a conception which considers that artworks have their ultimate and sufficient ground in the creative interiority of the artist. This conception implies that by contrast the social structure of art – the fact that art is an interactive phenomenon linking art-making with the reception of art – is only an extrinsic factor which is irrelevant as far as the essence or nature of art is concerned. Now, what interests me here are not the shortcomings of such a definition of art, but the (trivial) fact that once you develop the implicit presuppositions of the idea that aesthetics is about as important for the artists as ornithology is for the birds, you discover that *the idea of the irrelevance of theory for art is itself the expression of a theory of art.* So, when Newman says that theory is of no importance for art, he already implies a theory about art.

This seems to be an important clue for the problems we are trying to tackle. To hold a belief is already to hold a theory in the sense of a linked ensemble of propositions. This is due to the holistic structure of our beliefs. The expression 'holistic structure' refers to the fact that our beliefs are not linked one by one with corresponding facts and values, but apply in a collective way to a whole collection of states of affairs. What we call 'reality' is the result of the indefinite summation of a large number of such modelizations of collections of states of affairs. This applies also to the domain of art. Whatever the relationship we entertain with art and artworks, this relationship is always structured by beliefs, the most prominent of which are those concerning the identity of art as a human practice, the function of artworks, etc. And these beliefs would not be of secondary importance in our relationship with artworks: our way of dealing or not dealing with art depends

directly on these beliefs to the extent that it is structured by them. But this means that beyond the question of the relationship between art and explicitly propounded art theories lurks a much more fundamental question, that of the relationship between art and our beliefs about art. Art as a social reality is indistinctly a way of making, *poièsis*, and a belief-system, a representation *of* art which guides our dealing with the 'poietic' activity. Needless to say this relationship holds for the artist as well as for other participants in the art world; the historical evolution of art as a practice cannot be understood without taking into account the fact that what we call 'art' is structured as a belief-world. Thus, theory – at least theory in this sense – is not only important for art but is a constitutive element of its identity, and this means that finally there is no way of escaping art theory.

Of course theory conceived as a belief-structure works in ways which are not always the same as the manner according to which explicit art theories work. A belief-structure need not be consciously experienced as a whole to be operational. In fact, most of our beliefs about how the world is, are not self-consciously explicit theories but implicit ones. Some are implicit because they structure our way of seeing things on a pre-attentional level: we see things through our beliefs in such a way that the belief itself appears to be an intrinsic property of the thing. Other theories are implicit in the sense that they are implied or presupposed by conceptions we hold self-consciously, but in such a way that our self-consciousness does not reach down to these implied or presupposed views. This way of operating explains why belief-structures are generally conservative: we don't put them into question because very often we don't experience them as theories but as ontological properties of the world.

This may well be the case with Newman's statement. In fact, the figure of the creative artist as an autonomous genius creating his world as an expression of a purely interior necessity – a figure that played a central role in the development of the autonomy of art since the Renaissance and especially since the end of the eighteenth century – appears to be based on a transposition of the theological attributes of God from the religious domain to the artistic one. And this transposition is not that of one specific idea but the holistic transposition of an entire belief-structure. Once we take into account the complex set of ideas linked to this transposition of the theological concept, we come to understand why, for example, since romanticism, the modern artist has generally been seen as the figure of absolute individuali-

ty and opposed to the rest of society composed only of defective individuals; we also come to understand why he was supposed to detain some ultimate truth which is out of reach of the rest of society, or why he is endowed with a prophetic power, and so on. What I want to suggest is that the figure of the modern artist is founded on a theological model but that, with some exceptions, this model is not consciously experienced as such by the people who hold the beliefs which are linked to that figure of the artist. Nevertheless, it *is* this implicit theological structure which holds together the whole system of beliefs in question.

What art?

The third set of questions I distilled from the title of our seminar involved the problems related to the expression 'art.' To comment on these, we need to quit the field of theory-as-belief-system and return again to the more traditional image of theory as an explicitly and publicly stated conceptual discourse. The title of our seminar tells us that the problem we are interested in is that of 'the relationship between art and art theory.' But the current uses of the expression 'art' have some very strange characteristics. For example, in our title, 'art' refers *de facto* to the open generic network of practices that are the contemporary heirs of what was formerly, until the middle of the twentieth century, largely the domain of painting and sculpture. In French this domain is often called *arts plastiques,* other languages refer more easily to the 'visual arts.' What interests me here is not the difficulty of delimiting the specific domain which is supposed to be the contemporary heir of the old domain of painting and sculpture, but the fact that this domain is identified by the generic *term* 'art' and that the practitioners of this domain are called by the generic name 'artist.' This leads to a permanent equivocation between the generic conception of art and the specific field of artistic practices which descend historically from painting and sculpture. Now, of course, the field of socially identified artistic practices which are part of the open class of 'art' is much larger than that of *arts plastiques:* music is an art; architecture is an art; literature is an art; dance is an art; cinema is an art; calligraphy is an art; and so on. And it is clear that the question of the identity of these art-forms cannot be reduced to the question of the identity of art-as-visual-arts. This situation gives rise to an interesting question which

would merit a whole conference: How did this implicit identification of art as such with the domain of visual arts come to be established? My intuition (but it is only an intuition!) is that this metonymic identification is related to what Danto calls the 'philosophical disenfranchisement of art' to the fact that (in the Western tradition) art has always been thought about according to the philosophical dichotomy intellect *versus* sensibility. In my view, this explains why *visual* art is so often thought of as art *par excellence*: since it seems (or, at least, seemed until recently) to be intimately tied to sensibility, and to the extent that art as such is (was) defined as the realm of the sensible, visual art is (was) considered to be the paradigm of art. If this is true, the obsession with the conceptual content of visual art could perhaps be read as some sort of compensation for this feeling of something missing on the level of the 'purely visual' reality of visual art.

But what interests me more directly here is that, once you address the question of art in its generic diversity, you cannot fail to notice that the question of the relationship between art and art theory which seems so important, and is so hotly debated in the domain of *arts plastiques* or 'visual arts,' does not play the same role in other arts. By this I mean, first that the question as such is not a vital question in the other arts, perhaps because in the other arts the relationship between art and theory is generally of the distant kind. Take the case of literature: literary works, even the most advanced ones, come generally without any theoretical framework, which implies that the relationship between literature and literary theory is much less intimate than that between visual arts and 'art' theory. And the same holds for music: the destiny of music is largely independent of musicology, even if musicology is of interest for (some) musicians and (some) music-listeners. Literary theory is, doubtlessly, mostly ornithology for the writer and the reader; the same holds true for musicology as seen from the standpoint of the creative musician or the music-listener (but I suppose that it is sometimes interesting for the performer of music). And as far as I know, literary theorists and musicologists are quite happy with this situation. Their aim is to describe and to understand specific human ways of doing. This is a quite normal situation; it is, after all, the current relationship between any human activity and the cognitive aim of trying to analyze and understand that activity. For instance, we are all speakers of human languages, but for most of us linguistics is ornithology. The linguist never complains about this. So, why should the relationship be different when the object of inquiry is an artistic

one? I insist on this point to draw your attention to the highly specific nature of the situation in the domain of visual arts. This leads to one of the most interesting questions of this seminar: why is it *only* in the domain of visual arts that there exists this peculiar relationship between art and art theory – a relationship where making art and theorizing about art seem to be inseparable, and where the institutional framing of the practicing artist is inescapably linked to a very powerful theoretical framework?

To tell the truth, this is one of the many questions about art to which I have no answer. Nevertheless, I would like to finish my exposé by proposing two possible directions for research:

I. Contemporary art, in the sense of *arts plastiques* or 'visual arts,' seems to suffer from a deficit of social legitimacy quite unknown in other artistic fields. This might help to explain why so many (visual) art theories are in fact discourses of legitimization – why theory seems to be constitutive of the practice it is reflecting on. The question of the reasons for this deficit of social legitimacy is of course a complex one, and I won't talk about it here, even if I think that sooner or later during our seminar we'll have to confront it.

II. As heir to the traditional domain of painting and sculpture, contemporary art inherits the struggle of painting and sculpture with the philosophically grounded distinction between the liberal arts (*theoria*) and the mechanical arts (*praxis*). According to this historical hypothesis, art theory would have somewhat the same strategic function for contemporary art as mathematical perspective had for Renaissance painting. This approach gives credit to the status of the visual arts as liberal arts. The problem is that the philosophical opposition between *praxis* and *theoria* loses much of its plausibility in light of the contemporary insights into the functioning of mental representation and knowledge: *praxis*, whatever its form, is also always an embedded form of *theoria*, and theory-making conceived as a mental activity is also always a specific form of *praxis*. So, I am afraid that, to the degree that the distinction art/theory reproduces the distinction *praxis/theoria*, we'll have to question it anew from the perspective of a much more inclusive conception of knowledge than that embodied by the classical (philosophical) concept of *theoria*. The implications of this are far-reaching and transcend the domain of the problem of art theory. But this fact simply shows that the question of the relationship between art and art theory is not some exotic question but is directly tied to the most fundamental problems concerning the correct understanding of our basic relationships with reality.

Jean-Marie Schaeffer

System, History, and Hierarchy: the Historicist Paradigm in Art Theory

Some preliminary distinctions

Thinking or talking about artworks and art always involves multiple categorizations and classificatory decisions. This is not due to some peculiarity of art, but to a fundamental specificity of our cognitive and linguistic relationship with reality: to think about something means to identify it as being this or that fact, object, situation, and so on; to identify something as being this or that fact, object, and so on means to distinguish it from other things; and to distinguish something from something else means to classify it, that is to posit it in the network of our semantic model of reality. For example, when we think about artworks, we identify them by classifying them into different forms of art based on their semiotic specificity, or into different genres according to thematic and/or formal characteristics, or into different historical periods, or into different stages in the evolution of an artist's career, and so on. The goal of these multiple classificatory activities is the construction of a correct representation of an independent reality – in our case artworks and arts. This use of classifications, which pervades our cognitive relationships with reality, may be called *descriptive classification*.

But artworks are not created primarily to be thought about or to be classified. They are created to be experienced as representations, as symbols, or as forms. And this means that they are experienced as intentional entities occurring in a shared human world. To experience an artwork in this way is not to encounter an indeterminate phenomenon or a collection of sense-data demanding to be identified and classified: experiencing an artwork is not the same as discovering an unknown plant or bacteria. An artwork is generally experienced as being a poem, a movie, a landscape, a nineteenth-century painting, a piece by Bach, and so on. And these classifications – these labels attached to the works – are multileveled: generally, a poem is experienced not simply as a poem, but, for example, as a sonnet; and this sonnet is experienced not simply as a sonnet but, for example, as an Eliza-

bethan sonnet; and this Elizabethan sonnet is experienced not just as an Elizabethan sonnet but as an Elizabethan sonnet written by Shakespeare; and so on. This means that when we encounter an artwork it is already embedded in a network of categorizations and classifications. The network is given with the work, which means that for the person experiencing the work, its classificatory network is in some way constitutive of its identity. Identificatory classification is not the goal of our experience; it guides our understanding of the work. It functions as a collection of implicit decisions which go unquestioned and generally even unnoticed because they guide the experience and make it the experience it is. In other words, the classifications we use generally are not constructed by us in an empirical process of trial and error, but are inherited through what cognitive psychologists call social learning; we acquire them holistically through a process of assimilation whose empirical feedback is quite loose. This holistic acquisition through social learning is especially important in the categorization of cultural objects, like artworks. Cultural entities are intentional objects: their identity depends partly on socially shared conventions. This means that they can never be grasped adequately on a purely perceptual level – the level on which most of our basic individual learning by trial and error takes place. Of course, the nature and the extent of what is being taken for granted by social learning depends on the context: the common experience of artworks takes for granted other classificatory networks than does art history; art history generally takes for granted other classificatory networks than does philosophical art theory, and so on. But whatever the nature and the extent of what is taken for granted, no cultural classification is constructed from the root, that is by starting from what would be a pure phenomenalistic reality. Classifications at any cognitively accessible level are founded on more entrenched classifications, and the most firmly entrenched are out of reach of our conscious reflexive activity because they are constitutive of this activity, or, to use an expression of the American philosopher John Searle, because they belong to the background of our intentional states. And this is true not only of the classifications we use in everyday life, but also of reflexively elaborated classifications. Even philosophical categorizations or classifications are not constructed by a purely inductive or deductive process rooted in a pure phenomenon or in some absolutely founding concept, but grow out of a complex set of implicit presuppositions, and specifically out of the common classifications constitut-

ing the cultural reality of the society into which the classifier has been born and in which he is living. (Of course mathematics begin with axioms, but axioms are posited as primitive assumptions and not as ontologically unquestionable grounds: once the axioms are posited you can deduce the rest of the propositions, but as the history of geometry shows, axioms are relative and not absolute.)

When an artwork is experienced as a representation, as a symbol, as a complex whole, etc., it is not experienced as a neutral object in a purely physical or conceptual space. It is a human commodity, which means that it fulfills a specific function in a psychological, social, and historical space. Now, to experience something in a functionally defined space always involves evaluative processes, because functional experience is always satisfaction-driven and because a function can be realized in a more or less satisfactory way. So, to experience an artwork is to experience an object endowed with a certain degree of merit. The degree of merit depends not only on the inherent properties of the work, but also on the dispositional mental state of the person who experiences this work: the same work is often graded differently by different people. These differences can result from the fact that the work's implied functions vary among viewers: for example, an artwork which is satisfactory as a prop in a ritual or as a symbol of social distinction is not necessarily satisfactory as an object of aesthetic experience.

But even a consensus concerning function leaves room for differences in grading among individuals or groups. This seems evident where aesthetic satisfaction is concerned, but happens in other functional spaces as well: the dissent concerning the art of Caravaggio, for example, was in part a dissent concerning the adequacy of his manner of painting for the devotional function of the commissioned work. But I am not concerned here with the much debated question of the status, the founding, and the process of legitimation of artistic consensus and dissent. I simply want to point out the fact that in the common experience of artworks, their identity *is* that of evaluatively graded objects, which means that their descriptive identification is always localized in a qualitative space of attractions and repulsions.

Now, to grade evaluatively means to compare in a hierarchical way; thus grading is also a classificatory activity. The distinction between high and low art is an example of such an evaluative classification: it expresses our attitude towards the objects we label by the adjectives high and low, but this labeling *is* a classification, a discontinuous structuring of a collection of artistic

activities. A classification which grades the objects according to a hierarchy of desirability can conveniently be called an *evaluative classification*. Of course every evaluative classification implies descriptive classifications because evaluative grading necessitates that the things which are graded be identified as independent realities.

What is the relationship between descriptive and evaluative classifications? First of all, whatever the practical difficulty of separating the descriptive classifications from implicit evaluations, it is important to insist on the fact that a descriptive classification is not the same as an evaluative classification: to classify stars according to their chemical compositions or their evolutionary stages, is not the same as to classify them according to a hierarchy of value as is the case in mythical cosmologies. The same holds true for the domain of cultural realities and art: to distinguish artworks by their generic specificity is not the same as to place them within a hierarchy of high and low art.

On the other hand it is also true that cognitive attention as such is already value-driven: we pay attention only to cognitively enhanced stimuli, and this enhancement is due to the connection of our cognitive categorizations with the value-systems of the pleasure centers of our brains. This means that in a very fundamental way, the very act of paying attention to something or of not paying attention to something is already founded on a value hierarchy. For example, a student of visual arts may focus on painting and neglect photography; this selective attention is value-driven: in the cognitive hierarchy of the student. When it comes to thinking about art, photography is cognitively less enhanced than painting, which means that it is implicitly graded as being less important than painting. So, in order to understand the relationship between classifications and hierarchies we have to take into account not only the distinction between descriptive and evaluative classifications but also what one could call the *hierarchies of attention*.

But I want to insist once again on the fact that even if descriptive classification is value-driven in the sense that it is always relative to hierarchies of attention which decide which facts are taken into account and how they are taken into account, it remains different from evaluative classification. Evaluative classification is a classification of *values*, of *merits*, whereas descriptive evaluation is a classification of *objects* according to their intrinsic properties, even if the choice of the properties we pay attention to is a value-driven

choice. The classification of art into high and low art is an evaluative classification because the notions of high and low are in themselves evaluative categories ('high' means to be positively valued, 'low' means to be negatively valued); the classification of poetic genres according to their formal characteristics is a descriptive classification, because the notion of, for example, a sonnet is not an evaluative category (to say that a poem is a sonnet is not to say anything about the merit of the poem); and this classification remains descriptive even if the hierarchy of attention which is induced by inherited generic classifications excludes some practices from the focus of attention, as was the case with the genres of romance and novel in most seventeenth- and eighteenth-century classifications of literary genres.

These directions, though simplistic and perhaps seemingly irrelevant to the subject announced in my title, are in fact a necessary blueprint for clarifying the confused and confusing question of the status of systematic art theory and historicism as principles of artistic classifications.

System and historicism

Why take the notions of system and historicism to illustrate the problem of the relationship between artistic categorizations and grading hierarchies? My decision was based on two reasons:

I. The ideas of essentialist systematicity and historicist evolution are the two central concepts of a theoretical paradigm which has been one of the dominant modes of thinking about art during the nineteenth and twentieth centuries: the romantic art theory. This paradigm is not limited to the romantic movement as a historical period. The adjective 'romantic' simply points to the fact that its first canonical formulation can be found in the romantic writings, particularly those of the first German romanticism, the group of Jena (Friedrich and August Wilhelm Schleger and Novalis). But its influence on art theory doesn't end with romanticism, nor is it limited to German postromantic philosophy (Ferdinand Solger, Friedrich Schelling, Georg Wilhelm Friedrich Hegel; but also Arthur Schopenhauer, the young Nietzsche, or nearer to us, Martin Heidegger). On the contrary, as has been abundantly shown, some of its central presuppositions have spread through large sectors of western culture and have gained access to the art world of the nineteenth and twentieth centuries. This means that well after

the end of the romantic movement, the romantic art theory has survived as an implicit grounding figure, an unrecognized presupposition of many of the most firmly held beliefs of what art is and what it is for.

II. This means that much of our art-theoretical thinking has been dominated by what appears to be one of the most potent confusions between fact and value ever devised. This may seem paradoxical since the post-Kantian, romantic model of philosophical art theory claimed to be purely objective, *wissenschaftlich* in the lofty sense that this expression had in German romantic writing, for example in Hegel's work. The explicit goal of these writers was to overcome what they thought to be purely subjective art criticism founded on taste and empiricist generic classifications, and to replace it with an objective theory of art, a *Wissenschaft der Kunst*. This *Wissenschaftlichkeit* was supposed to be guaranteed by two epistemological changes:

a) The loosely defined net of the classicist mimetic categorization of art with its permanent oscillation between analytical classifications and grading hierarchies based on taste had to be replaced by a philosophical deduction of art considered as a specific ontological realm occupying a specific place in the hierarchy of a general ontology. Art was to be defined not, as was the case with imitation-theories, by its semiotic relationship with something prior and exterior to it, but as an independent organism determined by its own essence, which in turn was supposed to be a local specification of a general ontology. Of course, many preromantic classifications of art, for example the classification developed in France by Pierre Batteux in his 'Des beaux-arts réduits à un seul principe,' are also called 'systems of art.' But the concept of systematicity introduced by romantic art theory is very different from the simple idea of a coherent classification based on a common set of mimetic, semiotic, stylistic criteria as was the case with preromantic classifications: because the fundamental presupposition of the systematicity of romantic art theory is the belief that art as such forms a self-enclosed ontological domain, the specifically artistic differences that it posits are based on purely interior determinations, which means that the artistic classifications, whatever their level, must be deductive. On the other hand, as the essence of art is the essence of a specific ontological domain, systematic art theory always presupposes a general ontology from which the specific ontological locus and hierarchical place of art

must be derived. Or, in less technical terms: art theory is grounded on and legitimized by a general vision of the world. And this worldview is a hierarchical vision of reality. For example, for Hegel this general vision was reality seen as the realization of the Absolute Spirit; for Schopenhauer it was reality seen as the reign of the will to live; for Nietzsche it was reality as created by the will to power; for Heidegger it was the *Sein* as the hidden ground of all *Seiendes*; for the political utopias of the first half of the twentieth century it was reality as defined by an interior teleological movement leading from alienation and dissociation to authenticity and harmony. It would be easy to show how in all these theories the essentialist definition of art is directly derived from a general ontology which simultaneously defines the essential content of artworks.

b) The second characteristic which was supposed to guarantee the theory's *Wissenschaftlichkeit* was the idea that the temporal sequence of artistic practices was in fact the historical deployment of the inherent essence of art. This implied that the old – and ultimately Aristotelian – idea of art as a collection of anthropological ways of doing, was to be replaced by the idea of an autoteleological structure realizing itself in a temporal sequence. We are often told that the novelty of nineteenth century thought is the fact that it introduces historical thinking. But of course, in preromantic times people writing about art also recognized that artistic practice had a historical dimension. The difference now is that the historical dimension is regarded as the projection in time of the structural systematicity of art as a self-enclosed reality determined by its essence. So, to know the history of art *is* to know the essence of art; but this implies also that the temporal dimension of art is relevant only inasmuch as it conforms to the deployment of the essence of art. This interdependence of historicity and essentialistic categorization has been neatly summarized by Friedrich Schlegel in a famous phrase: 'The theory of art is its history.' Of course this sentence posits a two-way equivalence. Historicism is precisely this two-way equivalence between essentialistic categorization and historical deployment. This also explains why historicism is so often tied to organicist holism: the historical development of art is like the growth of an organism determined by its internal teleological drive.

As I said, this essentialist-historicist theory of art is not specifically romantic or Hegelian. Today Arthur Danto, for example, has defended a similar conception:

> As an essentialist in philosophy, I am committed to the view that art is eternally the same – that there are conditions necessary and sufficient for something to be an artwork, regardless of time and place. I do not see how one can do the philosophy of art – or philosophy *period* – without to this extent being an essentialist. But as a historicist I am also committed to the view that what is a work of art at one time cannot be one at another, and in particular that there is a history, enacted through the history of art, in which the essence of art – the necessary and sufficient conditions – are painfully brought to consciousness.[1]

My leap from Hegel to Danto is intended to suggest neither that romantic art theory functioned as a sort of master-thought determining modern art-thinking, nor that Hegel's or Danto's complex ideas about art can be reduced to this romantic strain. The very idea that a historical period forms a holistic unity structured by some master-thought expressing its essential reality is a thesis put forward by the romantic-Hegelian paradigm in its historicist form. My aim surely is not to make this thesis my own, because I take it to be fundamentally misguided. If my brief introductory presentation of the transmission of cultural categorizations and classifications is not completely wrong, the working of classificatory models is quite different: a model functions historically as a sort of toolbox, from which different authors writing in different contexts take different tools in different combinations, often adapting them to specific uses. Art-theoretical models function more in the manner of mythical *bricolage*, as defined by Claude Lévi-Strauss, than in the manner of scientific paradigms as defined by Thomas Kuhn. I certainly don't want to say that modern art theory as such embodies the romantic paradigm, or that the authors influenced by the model are replaceable instantiations of the same theory. So it is important to qualify somewhat my picture:

> In the first place, it is important to stress that the interrelatedness of systematicity and historicism is limited to the romantic period and to Hegelian philosophy. Thereafter, the two elements become dissociated:

1. Arthur Danto, 'From Aesthetics to Art Criticism,' *After the End of Art* (Princeton NJ: Princeton University Press, 1995), p. 95.

some authors only subscribe to the systematic aspect, others concentrate on historical development. For example Schopenhauer and the young Nietzsche were surely no historicists; they can even be called anti-historicists: Schopenhauer considered history to be an illusion and Nietzsche propounded a purely pragmatic conception of history. But they were both strong proponents of the idea that art is a specific ontological realm, defined by the place it occupies in a general hierarchy of modes of being. The fact that Schopenhauer built a fully developed system of art while Nietzsche based his theory on poetry and music is of no importance: as I said, the important issue in systematic art theory is not the classification as such but the idea that art is a self-enclosed ontological reality whose relationship with other modes of being is a relation not of representation but of ontological hierarchy. Art does not interact with other ontological realities in the way a representation interacts with what it represents, but in the way real reality (*wahre Wirklichkeit*) interacts with illusion (*Schein*), authenticity with inauthenticity, alienation with harmony, class-society with realized communism, and so on.

Furthermore, when observed on a long term basis, it appears that the most far-reaching aspect of the romantic model has been historicism. It has played an important role in literary history during the second half of the nineteenth century as is shown by, among others, Hippolyite Taine and his holistic concept of a national literature or Ferdinand Brunetière and his evolutionist theory of literary genres. Nearer to us, the whole progressive narrative of modern art seen as the laying bare of the ultimate bidimensional essence of painting – an idea which commanded the historical lecture of artistic modernism until very recently, and whose most impressive proponent has been Clement Greenberg – is a historicist vision of art history. The notion of 'contemporary art' is also largely historicist, because for most art critics the expression 'contemporary art' does not mean 'art that is created today' but refers only to that part of current art-making which is supposed to be in tune with a sense of history: so not all art which is presently created is contemporary. The same of course is true of Arthur Danto's thesis of the end of art. But the influence of historicism has not been limited to art theory and art criticism: it has played an important role in the self-understanding of the artistic avant-gardes. For example, the idea endorsed by Wassily Kandinsky that

the replacement of figurative painting by abstract art was a historical necessity, makes sense only in a historicist conception of history. In fact, the idea that one's art had to be in tune with some supposed historical necessity replaced, for many artists of the modernist period, the more traditional idea according to which the greatness of an artist was to be measured in terms of his competition with his ancestors or contemporaries. And in my opinion the present-day distinction between modernism and postmodernism belongs to the same paradigm, at least when seen as a holistic opposition of two discontinuous historical worlds, as is the case, for instance, in Jean-François Lyotard's theory of postmodernism.

The confusion of fact and value

As I have said already, the essentialist and historicist art theory presented itself as *reine Wissenschaft*. In the same way, the artistic movements which identified themselves with this model thought of their art as being the expression of a historic necessity identified with the search for the ultimate essence of art. Evaluation seemed to be irrelevant. And this implied that dissent on aesthetic grounds was also irrelevant – a thesis put forward for example by Kandinsky.

But in fact, the essentialist definition of art is grounded on a series of equivocations between fact and value. To conclude, I would like to point out some of the most far-reaching among them.

I. The systematic and historicist paradigm induces very specific *hierarchies of attention*. For example the strictly philosophical tradition of art theory launched by romanticism and which goes from Schelling, Solger, and Hegel to Heidegger, based its definition of the essence of art on the traditional system of the five canonical arts (architecture, sculpture, painting, music, and literature). To this extent all of these authors illustrate perfectly my statement concerning the importance of social learning in the domain of cultural classifications. Hegel and Heidegger were convinced that their definition of art was purely intrinsic – that is, determined by the essence of art as such. Both were blind to the fact that when they used the expression 'art' they in fact took for granted a specific culturally transmitted classification. And this classification was a classicist one, thus a largely conservative one. When Heidegger thinks about art, for instance, he is not concerned with

photography or cinema; and when he deals with verbal art he is concerned only with tragedy and poetry and never with the novel. He thus takes for granted a classificatory network which has become largely obsolete at the time he is writing: it is ironic that a philosopher who, being a historicist, should be especially attentive to historical evolution, takes for granted a classification devised for an art-world other than the contemporary one. But of course the progressive version of the historicist paradigm is equally selective; as I said, the notion of 'contemporary art' is based on a hierarchy of attention, legitimized by what is believed to be the historic destiny of art: the notion enhances certain stimuli and weakens others.

Now, of course, *every* cognitive attention is based on hierarchies of attention: cognition is aspectual and therefore selective. But in the case of the essentialist and historicist paradigm, these hierarchies not only go unnoticed, but are explicitly misinterpreted because they are projected on artistic reality itself: as the definition is taken to be the definition of the *essence* of art, anything which falls outside the focus of attention automatically falls outside the domain of art. This induces a perfect immunization of art theory: having been devised out of a preconceived classificatory model which it identifies an evaluative choice with art as such, it is immunized against artistic reality because there are no facts outside those determined by the essentialist definition.

II. The essentialist and historicist model is founded on and puts forth *evaluative categorizations*. As the facts are reduced to positively valued facts, and as the essentialist theory is devised to legitimize the valued facts, the essentialist and historicist cognitive model moves in a closed circle. There are two types of implicit hierarchies which appear, to me at least, to be particularly questionable:

a) The model implies a hierarchy between art and the rest of reality. I said that art was considered by the romantic paradigm as forming an ontological realm of its own located at a specific hierarchical level in a corresponding general ontology. The level it occupies is not always the same: the romantics, for example, placed art at the highest level, implying that for them the perfection of reality was aesthetic reality; Hegel was convinced that the highest level was the philosophical form of reality, implying that art was only a sort of prefiguration of the final state of history, which was supposed to be the philosophical transfiguration of reality. But whatever these differences, all the varieties of art theory

inspired by romanticism considered that art belonged to a substantial form of reality as opposed to the realm of empirical existence which was seen as alienated, inauthentic, and 'disenchanted.'

This dichotomy between authenticity and inauthenticity presupposes of course a dualistic ontology: if art is to be an ecstatic activity we shall have to posit two orders of reality – a *phenomenal reality,* which we can grasp with our senses and our discursive intellect, opposed to an *essential reality* which is normally hidden and which we can access only through art. This means that romantic essentialism was founded on an evaluative ontology implying a split between art and everyday reality: this split and the polemical attitude towards the factually existential, social, or political reality it implies, pervade much of the intellectual and artistic world-views during the nineteeth and twentieth centuries. In fact, the theme is so omnipresent that one could almost say that it defines, at least in part, cultural modernity as such. But it *is* a value hierarchy. And of course its reversal by the older Nietzsche, who in his later years came to valorize appearance over essence, fiction over truth, etc., belongs to the same paradigm because it is based on the same coalescence of fact and value.

b) The model implies a hierarchy between different art forms and works of art. This hierarchy possesses at least three aspects.

First it it implies first a specific hierarchy among the elements supposed to define the artistic nature of artworks. This hierarchy often goes unnoticed because it is deeply embedded in our contemporary prereflexive thematization of art. To understand how it developed, we have to remember that the romantic paradigm was first devised for the domain of poetry and that the high status attributed to poetry was based on the idea that it was the medium through which ultimate philosophical and religious truth manifested itself. This means that poetry is essential poetry only insofar as it can be translated into some conceptual truth. So what one could call 'the hermeneutical translatability' became in fact the cornerstone of the essence of poetry. And this idea was very soon generalized to cover all art-forms. Now the very fact of taking hermeneutical translatability to be the cornerstone of the essence of art as such posits an implicit hierarchy among the constitutively artistic elements which are supposed to be artistically relevant. This is illustrated by Heidegger's celebrated 'reading' of a Van Gogh painting: to adapt Van

Gogh's art to his hermeneutical conception of art, Heidegger has to reduce the painting to its statement in terms of his own existentialistic philosophy. The specifically formal elements go unnoticed, as do the elements which could be related to Van Gogh as a person. (This fact has been well analyzed by Meyer Shapiro.)

This obsession with hermeneutical translatability was not limited to the philosophical theories of art. Since the end of the nineteenth century it has also influenced, to various degrees, artistic practice. This may seem paradoxical since modernism is generally considered to be a formalism. But the modernist formalism was very often hermeneutical. The abstractionist revolution is a good case in point: Kandinsky, Malevich, and Mondrian believed that their abstract idiom revealed some ultimate truth about the world – a truth embodied in the symbolic meaning of shapes and colors. The importance of the hermeneutical translatability as a central criterion for identifying 'real' art was even greater with some later artistic movements: conceptual art, influenced by Duchamp and his polemics against 'retinal art,' has tended to reduce the visual aspect of the work to a mere signal meant to trigger a hermeneutical process. Of course, if you accept that the hermeneutical translatability defines the essence of art, any work which is not translatable will be marginalized or excluded from the realm of art. But as the ontology of art is based on a general ontology, art not only must conform to the principle of hermeneutical translatability, but the meaning to which it gives access must be that of the specific hierarchical world-view which happens to be that of the interpreter. As I've said, the vision which underlies the romantic delimitation of artistically relevant hermeneutical content is a polemical vision which posits that the existing reality is bad. I believe that this is the origin of a commonplace which is omnipresent in present-day art-criticism, which assumes art to be in essence a negative force, a subversive practice, a polemical statement, a denunciation of the *doxa*, and so on. This view implies, of course, that any creation which does not manifest such a negative force does not belong to art.

This leads me to the second important aspect of the evaluative hierarchy: From its beginnings until the present, the art-theoretical model has been associated with a dichotomy between true art and false art, between real art and entertainment, between high and low. In some ways these dichotomies reactivate the old distinction between the liber-

al and the mechanical arts. But the meaning of the dichotomy is not the same: what used to be a grading of different human activities is treated now as an *incompatibility* between two modes of being: authenticity versus inauthenticity, truth versus alienation, and so on. This segregationist conception, which opposes the rarity of 'real' art to an assortment of debased activities which superficially resemble it but are ontologically cut off from it, had, and continues to have, important consequences for the understanding of the anthropological reality of art-making: if there is an absolute opposition, an incompatibility between art as defined by the essentialist and historicist paradigm and what it denounces as an intrinsically debased realm of mass-culture, entertainment, and so on, we have to accept a radical discontinuity between two types of creative and aesthetic patterns of behavior. For example, some theoreticians posit a radical discontinuity between Adolphe W. Bougereau and Edouard Manet, between Stephen King and Franz Kafka, between Steven Spielberg and Jean-Luc Godard, between someone listening to rap and someone listening to Bach, between someone enjoying a painting by Bernard Buffet and someone enjoying a painting by Jean Dubuffet, and so on. But such a radical discontinuity seems highly improbable on empirical grounds; I know of no fact taken from psychology, sociology, history, or anthropology, which could legitimize it. So it seems that if we want to understand why mankind creates art and pays attention to it, we have to abandon this polemical view of art and the vision of human reality on which it is founded.

Finally, the essentialist and historicist model implies also an evaluative hierarchization of historical facts, because it entails that the only true historical facts are the facts which manifest the inherent teleology of the essence of art. Hegel, for example, explicitly indicates that he is only interested in historical facts which manifest the essence of art (as defined by his philosophy) and that he will discard the rest of them, because they are artistically irrelevant. This means that the hierarchy of historical attention is projected on the temporal sequence of the real events: it is seen as being identical to the historical evolution of art itself. It is not the specifically oriented attention of the philosopher which privileges certain facts and discards others: it is the essence of art itself which sorts out the relevant facts from the irrelevant ones. This conception of historical narrative as the transparent manifestation of the

essence of history itself has continued to be prominent in twentieth-century art-criticism, even if many of its proponents ignored its romantic origin.

To conclude, let's take once again the example of the expression 'contemporary art.' It shows quite clearly why the historicist equivocation between fact and value so easily goes unnoticed: the expression 'contemporary art' presents itself as a purely descriptive expression, and not as an evaluative expression, like, for example 'good art' or 'bad art'; this is because the adjective 'contemporary,' contrary to the adjectives 'good' or 'bad' normally functions as a descriptive term. But in fact, as it is used in art-criticism, it generally implies a powerful and hidden hierarchy because, as I said already, it does not refer to art that is created today, but only to art that conforms to a specific vision of the world and of the evolution of art which themselves are valued or depreciated by the critic using the expression. This means that the expression 'contemporary art' (taken positively or negatively) expresses a value judgment, but a value judgment which goes unnoticed because the essentialist vision of art presents it in the guise of an ontological discontinuity between art and non-art.

Jean-Marie Schaeffer

Experiencing Artworks

Anke Bangma's statement, written for this closing session, serves as a convenient starting point for my somewhat erratic ponderings of this evening: 'Recent developments in (European) art seem to move further and further away from any form of essentialism and autonomy. Instead of operating from a deliberately distanced position, recent art seems to be aiming to dissolve into visual culture or everyday life. This development may signify a change that runs parallel to the recent restructuring of specialized methodologies into "cultural studies" in the universities.'

I shall skip past the last point, which concerns the cultural studies, because it seems to me to be a rather more technical question which would be more fruitful to discuss in the workshop. As a consequence I shall limit myself here to the question addressed in the other statements, with which most of us, I suppose, agree. Who could deny that contemporary art practices, or at least part of them, are moving away from the agenda of the artistic avant-gardes of the first thirty years of the twentieth century, as well as from that of high modernism which predominated from the forties until the sixties. This transformation has been given many different names, ranging from postmodernism to what Arthur Danto calls, somewhat misleadingly it seems to me, 'post-historical art.' We have some difficulty in analyzing this art properly because we are its contemporaries and because its outcome depends largely on our – the artists, the public, the art institutions, etc. – way of dealing or not dealing with it.

As far as I can judge, if we want to understand present-day art we have to take into account at least three domains: a) the relationship between art and the other human productions in the domain of visual culture and craftsmanship, and so indirectly the generic definition of art itself; b) the relationship between art and everyday human life, and more generally the place of art in society; c) the relationship between the making of artworks and the experiencing of artworks as they are encountered in the public sphere. I shall try to address these three questions in a general, very tentative, and I am afraid, somewhat subjective way.

I. Art as a way of making

Most historians agree that artistic modernism has been dominated by the idea of the autonomy of art and its implications – namely the idea of a progressive and purely interior historical development, and that of a search for the essence of art as defining the ultimate goal of art itself. This view has been defended by, for example, Joseph Kosuth in a 1969 interview for *Arts Magazine*: 'Being an artist now means to question the nature of art… If philosophy (and religion) is finished, it is possible that art's viability may be connected to its ability to exist as a pure self-conscious endeavor. Art may exist in the future as a kind of philosophy by analogy. This can only occur, however, if art remains 'self-conscious' and concerns itself only with art problems.'

This idea of art being concerned only with its own nature is the outcome of a complex story. It was preceded by the idea of painting concerned with its own nature, or sculpture being concerned with its own nature, and Kosuth in his interview insists on the necessity of going beyond the specificity of painting and sculpture and elevating the question to the level of art itself. But high modernism, be it the formalist agenda of Clement Greenberg, for example, or the philosophical agendas of conceptual art and minimalism, was preceded by a period where the avant-gardes had a political teleology. This political agenda, which was very present in the twenties, seems to be incompatible with the idea of autonomy, certainly in the technical sense of the term as it applies to high modernism. But on a broader level, even for the political avant-gardes 'autonomy' was central: the political dimension was not seen as a specific function of art, but as being identical with its nature. This explains why art as such could be considered to be an autonomous level of social and political transformation, doing in its own field what political organizations did in theirs. Political and artistic utopias were one and the same thing. This may explain the sometimes tragic conflicts between the avant-garde artists and the political revolutionaries, in the sense that they wanted to instrumentalize each other. We know the end of the story: the repression of the artistic avant-gardes. In fact it seems that the formalism of high modernism can be seen largely as a strategic retreat once the hopes of political modernism were smashed by reality.

Nevertheless, the expression 'autonomy' is perhaps not the most convenient one for designating the dominating conception of art during modernism;

in fact it may be misleading. 'Artistic autonomy' is generally considered to be the ultimate outcome of the *aesthetic* autonomy of art as it emerged since the Renaissance. But art functioned in an aesthetically autonomous way at other periods and in other places without giving rise to the conception of art as we have known it in the West since the nineteenth century. In imperial Rome, for example, painting but also many genres of sculpture had a purely aesthetic function; the same is true of most genres of painting and drawing in China (at least since the Sung dynasty) and Japan (from the tenth century on). In none of these cases did this aesthetic functionality of art give rise to the ideas which I presented in my lecture during the second session, 'System, History, and Hierarchy: the Historicist Paradigm in Art Theory,' that is the idea of art as a sort of speculative knowledge opposed to common sense and common reality. What was central for modernism was not the thesis of artistic autonomy as a consequence of the aesthetic functionality of certain types of human production, but the idea that art possesses a sort of ontologic insularity, an idea which was intimately linked to the centrality of the figure of the artist. Modernism was art seen from the perspective of the artist, or, as it has been said, modernist art was art for the artists and for audiences willing to adopt the agenda of the artists. So artistic autonomy has to be distinguished from the question of aesthetic autonomy, and in fact, for many modern artists, aesthetic experience had to be cut off from artistic questions. Kosuth, once again, was very explicit about this: in the interview which I quoted he insisted that it was important to remove aesthetic experience from the further development of art, humanity having outgrown the need for art functioning on an aesthetic level.

In any case, 'autonomy' was the theory and this theory was also a program, which means that it had a prescriptive aspect. But 'autonomy' was never the reality: art, like all human activities, has never been autonomous in the sense of developing according to a purely interior necessity. If we want to understand the attractiveness of the paradigm of autonomy we have to take into account many exterior causal factors. I shall limit myself to one of these factors because its presentation will lead me to the transformations which are taking place today.

The development of modernism in all its forms, from its beginnings in the nineteenth century to its end somewhere in the second half of the twentieth century, was in fact related to a deep transformation, or better, to an ongoing evolution, in the domain of visual culture. This evolution began in the

first half of the nineteenth century with the invention of the first modern technology of image-making – photography; it progressed in the twentieth century with the invention and the tremendous development of the moving image – cinema and television; and it continues today with the birth and rapid expansion of electronic images (be they off-line or on-line). Seen from the vantage-point of the traditional visual media – graphic images (painting) and sculpture – this development amounted to the displacement of these traditional media from their central place in visual culture: socially and cognitively speaking, they moved to the margin. It seems that examining this dramatic shift in the social role of traditional visual arts – taken together with the new conceptual paradigm of 'Art with a capital A' launched by the romantic revolution – can help us to understand many aspects of the evolution of art in the nineteenth and, even more so, in the twentieth century.

Art historians sometimes speak of a crisis of visual representation. But in fact there was no crisis of visual representation; on the contrary, there was, and there still is today, a tremendous development of visual representation whose powers have never been as great as in contemporary culture. The crisis was a crisis of art as the central medium of production of visual representation. And the need to find an agenda for art other than the traditional program of figurative representation was the result of that artistic crisis which ultimately grew out of a deep transformation in visual culture. The historical avant-gardes as well as the movements of high modernism can be seen as a permanent search for a new agenda which could replace the mimetic agenda and which would nevertheless maintain the central status of art as opposed to the rest of visual culture. This obsession with difference took several forms. Let me simply enumerate two of them: a) the opposition between art and the non-artistic productions, especially industrial production and technical culture; b) the distinction between art and so-called mass-culture, a distinction read as a dichotomy between authenticity and alienation, or truth and illusion (think of Greenberg's opposition between art and kitsch for example). In both of these cases the underlying idea is that of a difference in nature between art and the rest of practices in the domain of visual culture, an idea which explains why the twentieth century was so obsessed with questions of defining art, and why this definition took mostly a polemic turn (for example in the art-theory of Adorno where art is the heroic resistance opposed to an alienated society).

Of course modernism has never been a monolithic movement, and it is as much the history of the redefinition of the boundary of art as that of their reinforcements. But these displacements were in a certain way only another strategy aiming at circumventing technological visual culture: the will to displace the limits was not a negation of the legitimacy of the limits as such. For example, when photography became accepted as an art at the beginning of the century, this went hand in hand with a displacement of the limit between art and non-art within photography itself, as an opposition, for example, between artistic photography and informational photography. The same could be said about movies and the distinction between cinema as art and cinema as entertainment – a distinction which of course presupposes that art and entertainment are incompatible.

So even if my picture is crudely oversimplified, I believe that it nevertheless catches something of what functioned as an important constellation of motives in the development of art in the second half of the nineteenth century and during the twentieth century. This agenda gave rise to many tremendously rewarding works of art, but nevertheless, seen as an agenda it failed to succeed: whatever its forms, art concerned with art has never been able to recover the centrality in visual culture that painting and sculpture had before the invention of technological images. And in some way the transformations taking place today seem to be related to our gradual understanding that this strategy of segregation and self-imposed radical enclosure of the agenda of art as art, has not only failed to move art back to the center, but has on the contrary taken it further and further away from any common ground which it could share with visual culture as we know it in everyday life.

So we are less obsessed with the limits of art, insofar as the opposition between art conceived as a special essence and the other methods within visual culture ceases to be at the center of artistic motivation. This is because we finally have begun to understand that human activities, whatever they are, have no intrinsic nature, no prescribed destiny, but that they are what we make them and what we make out of them – an idea perhaps ultimately related to the evolution of democratic self-consciousness and the belief that social realities are not natural givens, but human constructions which are amendable and adaptable. But this shift is also a result of the fact that art seems to be finally willing to engage directly with visual culture as a social reality, whereas for a long time it only searched to immunize itself against possible

intrusions into its supposedly pure realm. Ours is an impure art; or better still, ours are impure *arts*, because the idea of art being *one* is itself losing hold. The ongoing history of cinema shows that entertainment and artistic achievement are not incompatible; the recent developments in photography (for example the rediscovery of nineteenth-century photography, but also the problem of anonymous photography, or of the intimate practices of the family portrait) show that the delimitation of an artistic photography as opposed to its everyday uses is intrinsically unstable; the development of electronic media and virtual reality imposes a redefinition of such fundamental concepts as 'image' or 'representation'; it also challenges the traditional notions of the artwork as a closed whole, that of artistic authorship, and even that of the distinction between production and reception, etc. Under the innovative potency of all these developments, the modernist strategies of artistic segregationism cannot but fail. Even the conception which saw in technological visual culture the domain of inauthenticity or illusion and hoped that high art was the last bulwark against technological alienation, increasingly appears to be simply the contemporary formulation of the old Platonist polemic against *mimesis*. The irony of this situation is of course the fact that the danger that modernism denounced in visual mass-culture, or that which the nostalgic heirs of modernism see today in virtual reality and numeric simulation, is exactly the same danger that Plato saw in painting. This should give pause to anyone who loves art.

In any case, the important shift in contemporary art today consists of its moving away from these *topoi* of modernism and its wish to investigate quite new modes of relationships between the doxaistic practices of visual culture and its own creative urge. For example, since pop art the dichotomy between high art and mass culture has been replaced by the idea of a circulation of images in the two directions: pop art appropriated publicity and cartoon, and was in turn reappropriated by these two activities. The multiplication of genres in contemporary art is another interesting sign: it seems to be linked to the fact that artists have become conscious of the diversity of visual culture today which implies that if art wants to be of any relevance it must invest in the whole spectrum of these activities and must be able to circulate among them, to play with their differences and similarities. All this does not imply that we have moved from artistic segregationism to an uncritically positive relationship with contemporary visual culture: many artworks are questioning the reigning modalities of visual culture, but this

is, nevertheless, a form of engagement. The will to reintroduce art into the larger domain of visual culture, and to consider it as a part of that visual culture, does not imply that art must cease to be critical of certain aspects of this culture. Simply, it seems that this critical voice is not speaking from within the larger domain of visual culture, as one voice or one viewpoint among others, and is abandoning the heroic but at the same time largely ineffective posture of a transcendent realm of purity denouncing a debased reality. And this leads me to my second point.

II. Art and common life

In anthropological terms, art is always a part of social life, not something situated outside it. So the idea of opposing art as such to social reality and real life seems at first glance to be very strange. But it becomes less strange if we understand that historically this opposition developed in an effort to save the religious duality between a bad terrestrial reality and the perfect reality of a transcendental realm. As I tried to show in my text 'What Theory? What Art? Some Preliminary Reflections,' art is always also a belief-structure, and this means that the hard fact that art is always a specific social reality is not incompatible with the contrary belief: beliefs are to be defined foremost by their operability and not by their truthfulness or falseness. (In fact, most of the beliefs we hold are false beliefs. But they are causally as effective as our true beliefs, at least as motivations. If, in our will to live and to be happy, we were only driven by true beliefs, our lives would be, I am afraid, very barren.) The ontological and existential dualism between two realms of reality, an authentic one and an illusory one, has since romanticism been linked very strongly to our conceptions of art. It has taken two principal forms:

I. Art defined as an access to truth, opposed to common reality considered to be alienated and inauthentic. In this form, the theory is intimately related with the dichotomy between art and mass-culture.

II. Art defined as an avant-garde, that is as being historically ahead of the rest of society. This advantage was sometimes considered to be social, as was the case with the political avant-gardes, which saw themselves as working inside the socialist or fascist (in the case of futurism) utopia which the rest of society would attain only later. More often, the avant-garde saw itself as

representing some sort of artistic-philosophical advance; this was the case with the formalist paradigm. But as I've already mentioned, I tend to interpret the paradigm of the formalist avant-garde as a strategic retreat which modernism undertook when the paradigm of social advantage was radically disproved by Stalinism and more generally by totalitarianism. It seems to me that the topos of art as being by nature or by essence socially and politically progressive, which is one of the most entrenched *idées reçues* of the twentieth century, is nothing but a more feeble form of this dualistic attitude as concerns reality. Even today, this *idée reçue* survives, as is illustrated by the fact that when present-day art is attacked from an artistically conservative angle, the defenders of modernism, but also of contemporary art, generally translate the formal conflict into a political one: as Yves Michaud has shown in his analysis of the recent debate about contemporary art in France, the critics defending contemporary art tended to equate being formally regressive with being politically conservative.

It seems that this ultimately Manichaeistic idea of social reality begins to lose ground in the domain of art, and that this is an important aspect as concerns the redefinition of the social function of art – a redefinition which is now under way. This evolution, I suppose, has many causes. I shall simply enumerate those, which I consider most important: a) We have come to understand the dark sides of utopias – the fact that more often than not they are expressions of a will to power. We also have come to measure the dangers which are inherent in any ideal of social purity (be it a classless one). b) The collapse of socialist societies and the subsequent discovery of a complete disconnection between a socially advanced propaganda and a generally bleak reality has made us realize that the gap between ideas and their incarnation can easily transform any idea into an ideological tool without any relationship to reality. This has made us more reticent to adhere to sweeping general theories about society or history. c) At the same time, and perhaps as a consequence of the demise of communist utopia and, who knows, of theoretical utopia as such, the picture of the bourgeois-capitalist societies in which we live has changed: the idea of seeing in them the complete realm of alienation has lost much of its convincing force, and the idea of art leading its life outside of this reality has been disproved by the social reality of art itself. This does not imply that everyone today considers capitalism as the best possible world, but at least it appears to be no longer the only candidate for the title of the worst possible one. Because for the

moment there is no convincing contramodel, we all, in one way or another, seem prepared to accept that for now the only realistic line of action is to make the best of it.

All these changes of social atmosphere and political mood suggest a redefinition of the relationship between art and everyday existence, because the idea of a polemic relationship between them presupposes some sort of dualistic social ontology, founded on a dichotomy between illusion and real being, or inauthenticity and authenticity, and so on. As soon as this dichotomy becomes problematic, the artist is no longer some sort of superhero who will liberate the common man from an alienated and unjust world and lead him into the realm of harmony. He is no longer intervening from the outside, from a privileged vantage point, but like all of us he intervenes from the inside, entangled in a reality which appears to be largely opaque – as reality always is – and which we can only master partially. Being an insider, he is one of many and is no longer entitled to any special position. So he has to conceive a whole new relationship with society at large, but also with his audience and with his own motivation for art-making. Whatever his critical attitude towards social reality, his critique is that of an individual voice in the democratic dialogue, however defective that dialogue may be. At the same time, whatever his ideas about capitalism, he has to find his place in a society which is primarily a society of commodities centered around the marketplace. Contemporary art is the scene where these reevaluations are taking place; the importance of the present art-scene seems to be intimately related to the courage with which art faces reality and rediscovers that this reality is not monolithic but multiple, contradictory, and problematic, and that artworks themselves are an intrinsic part of that reality – art too is multiple, contradictory, and problematic.

III. Experiencing art

Once art is resituated in the global social context of a democratic society and is seen as a part of the ongoing construction and transformation of that society, the relationship between art-making and reception can no longer be ignored or considered extrinsic to the core of art as art. For as long as art was supposed to be only about art, the question of the experience of art was somewhat irrelevant, which explains, for example, why Joseph Kosuth

could say, in the same interview from which I quoted earlier: 'I wanted to remove the experience from the work of art.' Of course, this is a possible way for an art-world to exist, but it is a way which is centered entirely around the artist and *his* relationship to art: the audience is concerned only as far as it is willing and able to adopt the artist's stance. Whatever the rewards of such a posture, it is very different from the typical posture of most audiences to most art-forms, whether literature, music, cinema, painting, sculpture, or others. Generally, people are more interested in experiencing artworks than in taking part in art as such. Kosuth says quite correctly: '…the artist has that same obsessed interest in art that the physicist has in physics and the philosopher in philosophy.' There is no doubt that we generally show interest in what we are doing. But what are we doing when we are on the reception side of art? We are looking at the work, we are pondering it, we are reacting to it, etc. This means that we are experiencing the work, and it would be quite natural for us to have interest in this experience. The artist's interest is in the making of art, because he is making artworks or art; the audience's interest is commonly in experiencing artworks because its relationship is one with already created works, which it encounters, as such, in its experience. This means – and it is a trivial truth – that commonly the perspective of the audience is different from that of the artist. This is simply the price we have to pay if we want to have art as a social practice of some consequence.

But what does it mean to experience an artwork?

Of course, like any object, an artwork can be experienced in very different manners: as being instrumental in a ritual (like masks); as an embodiment of some divinity (as in classical Greek religious sculpture); as a sign of social distinction (like the copies of the classical Greek statues in the villas of wealthy Romans); as a clue to some underlying psychological, social, or other reality; as an object of aesthetic appreciation; as an exemplification of technical skill; and so on. But if one looks more closely at these different ways of experiencing artworks, one can distinguish two fundamental modalities:

I. An artwork can be experienced as a sign for something else (as an index of social distinction, as a symptom of an underlying social or psychological causality, as an exemplification of technical skill, etc.).

II. An artwork can be experienced as an operating structure (as a sign-structure, a perceptual structure, an imaginative pattern, and so on). This is the

case of course when an artwork functions aesthetically, but it is also the case – even if the modalities are different – when it is instrumental in a ritual or in a magical act.

It is only when it functions according to the second modality that an artwork functions as an artwork, which means that the experience it elicits is an experience that is induced by its own operating structure. Now, the primary social function of artworks – and the function for which generally they have been designed by the artist – is to operate as causally effective structures on an audience. In other words, artworks are created not to be explained, but to be experienced; they are created not to be interpreted as signs of something else, but to be reactivated as virtual worlds. Of course, they have to be understood because it is only to the extent that they are understood that they are operative. But to understand an artwork is not the same as to interpret it: the interpretation of artworks is the interpretation of what is already understood – of what has already been experienced as an artwork. And a theory which fuels our understanding of an artwork is not the same as a theory which interprets the work for us.

In our present society, artworks have only marginal magical functions or ritualistic roles. Even if some artists, like Joseph Beuys, try to revive the shamanistic status of the artist, theirs is more a fictional modelization of such a situation than a real reenactment of magical art. This is because for artworks to function magically you need a specific social structure, one in which a magical relationship with the world is not only considered legitimate but in which it defines one paradigmatic way of treating reality. These conditions don't exist in contemporary society. By this I do *not* want to imply that our society is more rational than a society founded on a magical relationship with reality. Behaviors building on magical ways of thinking are still with us and will always remain with us: in the form astrology, for instance, but also on the more fundamental level of the superstitious beliefs which play into so much of our everyday behavior. But these magical behaviors are no longer legitimized on the level of what we consider to be the paradigmatic structuring of the relationship between man and reality – they are no longer legitimized as a constitutive part of our worldview.

What I want to suggest is that nowadays experiencing art takes place in a social setting which is quite different from the magical or ritual one. One could even say that generally it takes place at the opposite end of the spectrum of sociability: not in the realm of a community based activity, but on the level

of an individual commodity encountered outside the sphere of active life (professional, religious, political etc.). This is, in my view, an absolutely fundamental point: the paradigmatic place where artworks are encountered today is that of leisure time. Experiencing artworks is one of the possible modalities of organizing one's leisure time. Now, this context is the typical context which prevails when artworks take on an aesthetic function. The relationship of leisure and aesthetic function is in fact almost one of reciprocal implication. When you encounter artworks experienced in the space of leisure time, you can be almost sure that their social function is aesthetic. For example in Greek literature, the functional shift of dramatic poetry from a ritualistic enactment to the dramatic festivals – that is from the religious space to the festive one – marks the passage from a religious function to an aesthetic one. The relationship works also in the reverse: wherever and whenever an artistic activity is identified socially in terms of its aesthetic function, you can be almost certain that it is also related to leisure time.

If this is the case, to understand what experiencing artworks today amounts to, we have to understand what it means to experience an artwork aesthetically.

What we call 'aesthetic experience' is a very common experience, and it can be defined quite straightforwardly: an aesthetic experience is a cognitive experience which is regulated by the intrinsic degree of satisfaction or dissatisfaction it induces. Let me comment briefly on this definition.

I. Aesthetic experience is a cognitive relationship. The term *cognitive* should be understood in the sense of its current meaning in the domain of the philosophy of the mind or in the domain of cognitivism: it can be perceptual, conceptual, or imaginative; and in most cases it results in fact from the collaboration of our senses, of our mental conceptual frameworks, and of multiple imaginative activities induced by the encounter of the perceptual data with our conceptual classifications. This means, in my eyes, that any aesthetic theory founded on the dichotomy *sensible versus intellectual* is of no use for understanding the real working of aesthetic experience. There exists no privileged relationship between aesthetic experience and what traditional epistemologic dualism called 'sensibility': of course, a painting has to be looked at and a piece of music has to be listened to; but looking at something and listening to something are complex cognitive acts in which concepts of, and imaginative supplementations to what is perceived play a role as important as that of 'pure' visual or auditive perception. We also should

never forget that in an artform like literary fiction, the perceptual aspect – that is, the visual experience of the written word – is hardly a part of the aesthetic experience, but only a precondition for that experience: the real act of experiencing literary fiction takes place on a semantic level, which induces imaginings about the facts that the fictional propositions pretend to refer to. This implies also that the existence of conceptual art is not at all incompatible with aesthetic experience as is sometimes said. More generally, the fact that many artworks today have an important public conceptual or theoretical component – the fact that they are statements of one sort or another – poses no problem. Anything that can be an object of any type of cognitive experience can be an object of aesthetic experience. This explains why the world of artistic objects is an open one and cannot be restricted by criteria concerning the 'correct' type of objects or media. Once we understand how aesthetic experience works, the generic openness of contemporary art ceases to be a problem and becomes, on the contrary, a chance for diversification.

II. The specificity of the aesthetic functioning of our cognitive faculties lies in the fact that in this case the cognitive activity – looking at, pondering about, listening to, reading, etc. – is regulated by the intrinsic degree of satisfaction or dissatisfaction it induces. This means simply that what counts when our cognitive powers function aesthetically is the degree to which the operating of these powers elicits satisfaction. It is important to notice that this satisfaction does not manifest itself after the experience but is part of it, and therefore is able to regulate it, which means, among other things, that the degree of satisfaction determines whether the experience will proceed or will be interrupted. The manner according to which this regulation takes place depends on the person (some people accept more readily than others a momentary dissatisfaction induced by a difficult work, because they count on some superior degree of satisfaction induced at a later moment); it depends also on the quality of the moment (when you are tired you react differently than when you are not…). I want to insist here that it is not a question of 'all or nothing,' but a very complicated regulation which shifts continuously. Its causal factors are multiple, which means that the degree of satisfaction cannot be predicted based on a knowledge of the object-properties of the work alone: it depends also on personal dispositional attitudes acquired in multiple ways, including the process of social learning, and some of which are cognitively inaccessible to the person experiencing the

artwork. This is why we can never fully explain why an artwork elicits a positive or negative response. According to this conception of aesthetic experience, the core of the experience is the ongoing cognitive activity regulated by its degree of satisfaction. This means that what is generally called aesthetic judgment – and what I consider to be an objectification of this intrinsic degree of satisfaction or dissatisfaction – is only a consequence of the aesthetic experience and not its intrinsic finality: works of art are created primarily to be experienced, not to be judged.

Of course this analysis of the aesthetic experience raises some problems, one of which is related to some recent developments in the art world. In the domain of the artistic uses of electronic media, artworks often have an important interactive aspect. This means that the audience is not supposed to contemplate the artwork but to interact with it. Can this relationship be described as a cognitive experience? Does it not belong to the realm of practical activity?

The answers depend of course on what we mean by 'interactivity.' In fact, when we talk about interactivity in the field of electronic media we have to distinguish between two situations:

I. The interaction is a programmed interaction. In this case aesthetic experience combines with play, because the interactive relationship with the artwork is limited by the rules of the program designed by the artist (as is the case in any game).

II. The interaction results from the fact that the work is conceived as a work in progress in which the audience itself becomes a co-producer. To the extent that we collaborate in the ongoing realization of the work, we in fact engage in an artistic activity. This is a situation where the posture of audience and artist coincide, only because the audience is defined as an artist.

Clearly these two situations are quite different. But they both give rise to the same question, or more correctly, point to the same fact: if aesthetic experience is the most important way of relating with most artworks, this does not mean that it is exclusive of any other type of relationship.

This leads me to a further point. The fact that aesthetic experience is an autotelic activity – that it is regulated by its own intrinsic degree of satisfaction – does not imply that our interest in undergoing this experience must be limited to that experience. I don't adhere to the Kantian analysis according to which aesthetic experience is disinterested, because we appreciate an artwork in a manner which abstracts from all empirical, individual, inner-

worldly interests. I don't share this conception because I don't think that 'disinterestedness' is a working hypothesis when we are talking about human behavior, whatever the type of behavior. In my view, what attracts us in artworks we experience aesthetically is, on the contrary, the hope that we'll be able to relate them to our lives. And to relate them to our lives means to relate them to very specific interests which depend of course on the person and on the moment. Sometimes we are simply curious; sometimes we are looking for fun, for *divertissement*; sometimes we are in search of consolation; or we want to know things about the world; or we feel an urge to expand our inner lives. At other moments we are looking for artworks that will help us to transform some aspect of our own lives. In all these situations we approach artworks with very specific interests and the aesthetic experience is instrumental to these interests. Of course it can be instrumental only if it is satisfying, but that is another problem.

I emphasize this point to show that although artworks today are mostly approached aesthetically, they are not by definition cut off from real life. On the contrary, the cognitive relationship is one of our basic relationships with reality, one crucial to our survival and one which needs permanent training. Aesthetic experience induces us to indulge in this activity. But by making parenthetical the danger of reality fighting instantly back, and by taking for regulative principle the satisfaction induced by the activity itself, it permits us to expand our ways of relating to reality without having to pay the price of the stress which is the consequence of most direct – that is non-mediated – relationships with reality. Aesthetic experience is thus a very potent cognitive operator; in fact, it would be possible to prove, I believe, that aesthetic experience is an important vehicle of social learning as opposed to direct interaction based on trial and error.

If the ideas which I've tried to express are not entirely wrong, then the fate of art in our current world is directly related to its capacity to induce satisfying aesthetic experiences. In some way this was also the case during the age of modernism, but it was an issue hidden under other discourses of legitimization. The fact that these legitimizations have lost their credibility implies that we have to confront the aesthetic question directly. For art theory this also implies a very profound transformation. I refer here, of course, not to the theoretical aspects embedded in the artworks themselves, but to the mediating theory as it is exemplified by the discourse of art institutions, critics, philosophers, and so on. In this new context, the most important

function of theory may no longer be to legitimize or exalt *art*, but to facilitate the experiencing of *artworks*. Theory, it seems, needs to replace the question of art with a new interest in artworks and their operating modalities. Of course, this is more easily said than done. But tomorrow is another day.

Catherine Ingraham

Architecture and the Scene of Evidence

I have long been interested, along with many others, in how aspects of American legal history and forms of democracy might give us insight into the interrelated functions of architecture, space, and identity. It is no accident that legal history touches on the question of evidence, a theme that I have also been thinking about in connection with architecture for several years.

One of the most powerful forces that architecture exerts on culture is the maintenance of certain proprieties: how space is lived in and named; what type of building is most appropriate to what use; what materials belong to the exterior, what to the interior, and so on.[1] These proprieties and typologies change gradually, and in important ways, over time: what used to be the parlor is now the living room; what used to be wood is now steel. But some typological paradigm is always in force. The familiarity of the terms of discussion, as in, say, the 'master bedroom,' is a familiarity that is not pre-given or natural, but proper to particular moments in architectural history and culture. At the same time, it is precisely the isomorphism of these terms with particular cultural contexts and times that makes them effective and operational.

Another powerful force that architecture exerts on culture – one inextricably connected to propriety – is the maintenance of the categories of property, property ownership, and real estate – categories which carry within themselves the power to simultaneously anchor and transfer culture. Buildings are always owned, even if it is a communal ownership; this implies that they are simultaneously rooted and transferable. Bankers use the term 'equity' to refer to the residual value of mortgaged property that is in the long (30 to 100 a year) process of being transferred to its owner. But equity also means tacit principles of fairness that correct or supplement law. So this idea of the financial transfer of property belongs in part to common law, which, at least theoretically, underlies statutory, or written laws of a legislative body. I would not want to apply some universal principle of architectural ownership/transferability uniformly to all cultures, since the status of property is

1. Catherine Ingraham, *Architecture and the Burdens of Linearity* (New Haven and London: Yale University Press, 1998), pp. 30-31.

a sensitive indicator of cultural difference (one thinks of the temples in Japan that Jacques Derrida mentions: though perpetually rebuilt timber by timber, they remain unchanging in their identities). Yet every culture might be said to have examples of the passage of a building from one set of hands to another, from parents to children, from individual to government, from government to government, from communal to private. Some of these transfers take place as a matter of routine and others are cataclysmic.

I am interested here not simply in the always provocative coexistence of two opposing tendencies of architecture – the tendency to anchor and the tendency to move – but also in how this seeming paradox affects the political life in and of architecture. For example, during much of the history of colonial occupations, the 'role' of architecture (to speak in the most detached and boring way) has been to harden and close in indigenous structures: tents become sheds, shanty towns become brick projects, Quonset huts become large instititional buildings. Hardening is invariably meant to locate, by means of buildings, entities that are temporally precarious, such as colonial government, or people who are spatially difficult to locate, such as the poor or dispossessed, who need to be somehow propertied in order to be located and contained. In these cases, architecture – as a paradox of stasis/motion, as a force or practice that calcifies in order to locate and appropriate culture – acts in the spirit of what the English originally called common law,[2] the tacit law that supplements legal property statues, and which, as we also know, is where some of the definitions of the self and the organization of personal identity are forged. William Blackstone, whose legal commentaries were very influential in the formation of law in the United States, defines *title* as follows: 'Title is the legal ground of possessing that which is our own… It is an ancient maxim of the law, that no title is completely good, unless the right of possession be joined with the right of property; which right is then denominated a double right. When to this double right the actual possession is also united, then, and only then, is the

2. 'As distinguished from the Roman law, the modern civil law, the canon law, and other systems, the common law is that body of law and juristic theory which…has obtained among most of the states and peoples of Anglo-Saxon stock… As distinguished from law created by the enactment of legislatures, the common law comprises the body of those principles and rules of action, related to the government and security of persons and property, which derive their authority from usages and customs of immemorial antiquity, or from the judgments and decrees of the courts recognizing…such usages and customs…it is recognized as an organic part of the jurisprudence of most of the United States.' *Black's Law Dictionary*, Revised Fourth Edition (St. Paul, Minnesota: West Publishing Co., 1968), p. 345.

title completely legal.'[3] The transfer of a piece of property – architecture in the broad sense – is brought about by joining the right of possession to the right of property and this transaction is only made good when the 'actual possession,' which comes from a different place (existential, material) than the law itself, joins the group. In a similar way, the right to self-possession is only made good when the right of possession (legal rights of citizenship) and right of property is joined to the actual body, which also comes from another place (psychological, existential, material). The common law that governs both of these bodies in culture – the 'natural' body and the built body – is what we might call the common law of 'evidence,' a tacit knowledge of that which supports, underwrites, joins to, makes firm, the whole ephemeral realm of property and self-possession, and the various economies associated with this realm.

The definition of a citizen, one of the names of the democratic subject, is connected in most Western cultures[4] with Blackstone's double right of possession/property ownership, plus the 'actual possession,' mentioned above. This double right – plus actual possession – has included in the past, as we know, the right to own other human beings. Paradoxically, in the case of the slave body, the first legal condition surrounding liberation is the removal of the attribute of property from the slave body, so that this now 'property-free' body can regain itself as its own property and be granted the full rights of property ownership, i.e., citizenship. Citizenship is understood to be a prerequisite for membership in a democracy which, among other things, enables one to own property, but citizenship is also understood to be a prerequisite for 'owning oneself.' This strange attribute of property, as it circulates through culture, attaching and detaching itself to and from other rights, also coincides with definitions of the self that in Lacanian psychoanalytic theory are organized according to principles of excess and supplementarity: the self must exceed itself in order to realize itself. This coincidence has important implications for architecture.

3. See Eric Cheyfitz, *The Poetics of Imperialism* (London: Oxford University Press, 1991), p. 47.

4. I am using these very problematic generalities because I want to arrive more quickly at my larger points. My main purpose in this short article is to make the questions of evidence, property ownership, self-possession, rights, and so on, persuasive in architectural terms, ignoring, for the moment, the precise juridical histories of different cultures. At various points I use inadequate phrases such as 'most Western cultures,' 'Western white cultures,' and 'Western capitalist cultures' to summarize a far from homogeneous group of people, democracies, and architectures.

Bodies in space have legal and property rights associated with them that, in America, for example, are written, most pointedly, into the fourth and fifth amendments to the Constitution.[5] These amendments are interesting to look at for their architectural guarantees. Though they are specific to the American legal system, I cite them in full because they begin to show how architecture and property ownership are intertwined with body and self-identity:

> *Article IV*: The right of the people to be secure in their persons, houses, papers, and effects, against unreasonable searches and seizures, shall not be violated, and no warrants shall issue but upon probable cause, supported by oath or affirmation, and particularly describing the place to be searched, and the person or things to be seized.

> *Article V*: No person shall be held to answer for a capital or otherwise infamous crime, unless on a presentment or indictment of a grand jury, except in cases arising in the land or naval forces, or in the militia, when in actual service in time of war or public danger; nor shall any person be subject for the same offence to be twice put in jeopardy or life or limb; nor shall be compelled in any criminal case to be a witness against himself, nor be deprived of life, liberty, or property, without due process of law; nor shall private property be taken for public use without just compensation.[6]

There are other parts of the constitution and its Bill of Rights that refer to the identity and maintenance of identity of the body in space, but these two articles address, in particular, the safety of 'life, limb, and property'; the safeguarding of the interior space, the house, that is both an emblem for and an extension of the body that is under protection. In particular, the phrase 'nor shall be compelled in any criminal case to be a witness against himself' (one of the most loaded phrases in the Bill of Rights[7] is important because it suggests that one's presence, one's identity – one's American identity in this

5. Much of the following section is taken from Ingraham, *Architecture and the Burdens of Linearity*, pp. 33-36. Chapter 2, 'What is Proper to Architecture,' leveraged a new set of discussions surrounding definitions of citizenship and the democratic subject in relation to architecture.

6. Walter F. Berns, ed., *Constitutional Cases in American Government* (New York: Thomas Crowell, 1963), p. 470.

7. The fifth amendment is often called 'the right to silence,' and it counter-balances the first amendment, 'the right to free speech.' The freedom to speak and the freedom to remain silent constitutes an interesting opposition not only in the American legal system but also in what I discuss in another place as the right of the proper name to property (entitlement). For a history of these amendments see O. John Rogge, *The First and the Fifth* (New York: Da Capo Press, 1971).

case – cannot be broken into by being doubled, as when one sees oneself as a victim or a witness to someone else's victimization. Lacanian theory and certain modernist houses might be said to be engaged in active critiques of this amendment. Pierre Koenig's 'Case Study House #21' in Los Angeles, for example, which has an L-shaped plan so that a complete view of the house is revealed only after a delaying terrace-entrance. This house, like many modernist houses, witnesses itself in order to comply with its (complex) claim to transparency.[8]

The body in Western (white) culture has traditionally been seen as a single entity, named by a single name, in order to be protected and properly housed, and in order to hold title to property. This apparent securing of the self and the house is what makes architectural practice, as we know it, possible. Many Western capitalist cultures have guarantees similar to the Bill of Rights that allow physical structures to be built around bodies as individual enclosures, although enclosures, as a particular way of privatizing property, also have a specific political history.[9] Indeed, *all* cultures, even nomadic and communal ones, have laws – even if they remain unwritten – not only of enclosure and protection, but also of the appropriate *style* of that enclosure and protection, if I may use the word *style* to mean the expression of a culture's position on the proper name/body/enclosure cathexis (architectural, legal, and otherwise). The breach of guarantees, wherever they may occur and whatever form they may take, results in the esoteric array of violent practices that come under the heading of war, civil violence, and so forth. The breach of architectural and identity bonds is never easy or casual. I don't believe that there can be any casual violence in culture because even in the case of a single act of violence against one body, the principle of all protected enclosure and interior is exposed and jeopardized. The passage from the internal to the external must be a protected and protracted one.

Henri Lefebvre, speaking of what he calls 'absolute space' (the precursor to what he calls 'abstract space,' which is the historicized space of social labor) says: 'Typically, architecture picked a site in nature and transferred it to the political realm by means of a symbolic mediation… A sanctified inward-

8. This abbreviates a much longer discussion. The relationships between 'witnessing,' the 'gaze,' and the transparency of modernist architecture, have been broadly discussed by many critics and historians.

9. See Cheyfitz, *The Poetics of Imperialism*, pp. 45-46, for a brief history of the 'enclosures movement' in England.

ness set itself up in opposition to the outwardness in nature.'[10] The inward/outward, internal/external symbolic exchange that architecture is part of and, indeed, a generative force for, is not detached from the philosophical and ideological history of its occupant. Architecture, and the laws and guarantees of enclosure that produce a 'political realm,' are inextricably connected with the history of the body as a physical enclosure for self-identity and the body as a political entity. This history is the history of concepts of the self and the relation of the self to the physical world. But as Lefebvre also asks about the body: 'What conception of the body are we to adopt or readopt, discover or rediscover…? Plato's? Aquinas's? The body that sustains the *intellectus* or the body that sustains the *habitus*? The body as glorious or the body as wretched? Descartes's body-as-object, or the body-as-subject of phenomenology and existentialism? A fragmented body, represented by images, by words, and traded retail? Must we start out from a *discourse* on the body?'[11] The question of the body as a common-law enclosure that supplements legal definitions of the self, of architecture as a common-law enclosure that supplements legal definitions of property, and the question of internal environments and external milieu, as well as the way in which the space of architecture and the body thus becomes political – or is always political – are linked, I think, with the issue of evidence.

At a symposium in New York several years ago on 'the Architecture of Display,' the question of display in the projects presented became synonymous, for me, with the question of evidence. Many of the architectural interventions (commissioned by the Architectural League of New York, which also spon-

10. Henri Lefebvre, *The Production of Space* (Oxford: Blackwell Press, 1984), p. 48.

11. Lefebvre, *The Production of Space*, pp. 194-95. Lefebvre's answer to this is that we should start from the 'social' body: 'a body battered and broken by a devastating practice, namely the division of labor, and by the weight of society's demands.' But Lefebvre is also interested, in this section, in asking how we can consider the 'body *in itself*, without ideology.' He has the following remarks to make about this (merely) spatial body. I cite these remarks because it is through the spatiality of the body that the architectural analogy to the body is usually made (i.e., as non-ideological, symmetrical, and so on). Lefebvre writes: 'When the body came up earlier on in our analysis, it did not present itself either as subject or as object in the philosophical sense, nor as an internal milieu standing in opposition to an external one, nor as a neutral space, nor as a mechanism occupying space partially or fragmentarily. Rather, it appeared as a 'spatial body.' A body so conceived, produced and as the production of a space, is immediately subject to the determinants of that space: symmetries, interactions and reciprocal actions, axes and places, centres and peripheries, and concrete (spatio-temporal) oppositions. The materiality of this body is attributable neither to a consolidation of parts of space into an apparatus, nor to a nature unaffected by space which is yet somehow able to distribute itself through space and so occupy it. Rather the spatial body's material character derives from space, from the energy that is deployed and put to use there.'

sored the symposium) tried to link displays – appearance-driven, surface-driven, identities – with more urbanistic, 4-D spheres of experience made possible by objects in space and time. This had the effect of making a small tear in the veil of the commercial use of display; inside that tear was what I have come to call evidence: display that is no longer operating as its own end, but is operating on behalf of something else, usually on behalf of something sinister that has come to light. The examples I used at that symposium were the natural history dioramas at the New York Museum of Natural History, where the display of stuffed animals in vitrines is viewed by the average museum-goer as a display of a natural nature reenacted.[12] While the diorama-as-image of stuffed animals in a vitrine is picturesque, both naturalistic and scenographic (calculated), the diorama-as-evidence is about a murder, that is, the murder of the animal for the purposes of displaying its stuffed body. Once we connect with the scene of evidence, the distance necessary to the spectacle collapses. In some of the interventions, architecture, or proto-architectures, supplied the three dimensions, plus time, that changed the scene of display, so to speak, to a scene of evidence. How long these architectures hold an evidentiary posture, and how effective these postures are in political or critical terms, is another question.

The issue of display and evidence in architecture returned again this year, when I was asked to consider the relation of architecture to the postcolonial debates taking place in India, Asia, Malaysia, and elsewhere – debates that seem to have reached a theoretical impasse; since everything is now postcolonial, the category no longer makes sense. Much of colonial architecture, like Lutyens' Viceroy's Palace in New Delhi, proposes to display a unified cultural identity but, of course, delivers a mixed bag of cultural evidence. This is a particularly difficult example because I can't say in which court of law, so to speak, this evidence is being marshalled forth. Is it English law, Indian law, laws that govern the practice of history, touristic law – or some combination of these – that finds, in the Viceroy's Palace, a delivery of the 'actual possession' that underwrites the double right of possession that Blackstone theorizes. Viceroy's Palace, indeed the entire master plan for New Delhi, was designed by Sir Edwin Lutyens and Sir Herbert Baker as the monumental concretizing of British colonial identity in India. But once

12. See Donna Haraway's seminal discussion of the natural history museum in 'Teddy Bear Patriarchy,' *Primate Visions, Gender, Race and Nature in the World of Modern Science* (New York: Routledge, 1989).

the colonial occupation was over – although we know that it is never over in a clean sense – the building's meaning shifted relatively effortlessly to a monumentalization of India's postcolonial power. The Viceroy Palace, because of its genealogy, has prolonged that colonial occupation, but it also actively attempts to suppress it in the interest of everyday life.

The almost effortless transfer of this gigantic mass of stone, labor, history, symbolic virtuosity, from one culture to another, is possible, I think, because architecture acts quintessentially as evidence. As such, it is subject, like all evidence, to the law of evidence: something is evidence only insofar as it is evidence *for* something. But architecture is not like the stray glove found in a house, that subsequently is put on exhibit in a court of law as a piece of evidence for a murder that took place in the house. The glove is plucked from one function, as glove, and drafted into another function. Buildings, on the other hand, are permanently on display as evidence of or for something – at one moment they are evidence for British hegemony, at another for Indian hegemony, but they have no other function than to act in this evidentiary way. At the same time, evidence that is always evidence lacks the special distinction accorded to the glove, for example. Architecture fades into its scene. Civic buildings lose their isomorphism, and thus their ability to protect identity, during colonial occupations. Colonial architectures often try to repair this civic disjunction for the invaders by building buildings that seem familiar to the occupiers. But when the colonial period is over, both colonial and noncolonial architecture sink back into artifactual culture. And it is both this isomorphism, and the shifting character of the evidence, that make it impossible to evaluate architecture for *itself*, in aesthetic or functional isolation. These properties of fading into the scene, transferability and presentation, also keep architecture latent, as common law, beneath the scene of official or legal culture.

In other words, architecture acts as a common law that supplements statutory law. It supplies the 'actual possession' needed for legal property transactions to take place. Land, objects, and other entities that seem indisputably available, do the same thing, but architecture does it in a larger and more specific way. Further, architecture (the 'house' in the terms of the Constitution) acts as this supplement alongside 'persons, papers, effects, things, life' and – one more word – 'liberty.' Architecture, like the democratic ideal of liberty, is not only a supplement to the law, but an attempt to guarantee liberty. The securing of 'persons' means the securing of self-possession, which

is the definition of personal liberty in democratic society, similarly securing of house and property releases that house and property to our occupation of them. Finally, this question of liberty brings me back to discussions of certain ethical questions that are raised by the Lacanian debates about democracy, although I will offer here only a brief sketch of a potent conjunction of issues.

The Lacanian critic Joan Copjec[13] writes: 'Human freedom makes radical evil [Kant's term] a structural inescapability. But radical evil contributes to the historical phenomenon, modern evil, only on one condition: the elimination of the perspective of the final judgment.' Copjec's discussion concerns the character of this final judgment in Kant and Lacan. It is not a theological final judgment that Copjec wants to emphasize (and which she takes great pains to differentiate from fundamentalist currents in American culture), but a principle of externality that guides reason through its various paths and purposes – an understanding that the 'subject exceeds itself.' 'From the final judge, the subject learns not what it is, but that it is external to itself.' As Copjec asks: 'What is teleological judgment, what makes it possible, if not the fact that the subject exceeds itself?' Architecture, among other things, quite precisely underwrites, and acts as evidence for, the externalization, the excess, of the self over itself. It is not merely an extension of the self – a kind of tool – but the 'second skin,' the 'envelope,' around the self.

The word 'liberty,' juxtaposed to the word 'democracy,' resonates with the history of Western politics and humanism – a history that is being constantly adjudicated by architects. But it is important not to lapse into an account of architecture as a history of beneficent intentions. Ethical architecture is not an undiluted attention to what is perceived as good at some point in time: ecological practices, comfort, functionality. It is living inside architecture – as both practitioner and occupant – such that its evidentiary force is tied to our everyday psychoanalytic, legal, and ethical lives. I do not mean to suggest that architecture plays some grandiose role in our self-perception; only that the relation between the internal and external milieus – self-identity and space, architecturally represented – brings with it a series of ethical projects related to liberty. It makes sense to explore the physical manifestations of architecture – which is, perhaps, what certain kinds of architectural history imagine themselves to be doing when they pay metic-

13. Joan Copjec, ed., *Radical Evil*, S Series (London and New York: Verso Books, 1996), pp. vi-xxvi.

ulous attention to the details of particular buildings in historical case studies – in order to catalog the exact dimensions, styles, and sites-of-collection of the evidence. It also makes sense to search out new architectural styles or technologies in order to finesse, refine, or investigate, or make larger or smaller the relation of space to body, in details or in large scale projects. What is perilous is to reduce architecture to simple acts of accretion – this brick on this brick on this brick – or to reduce architecture to a 'whole.' As evidence of the excess of ourselves over ourselves, architecture is entangled with human limits and delimitation, entangled with the critical and ethical dimensions of human culture – legal, tacit, political, and so on.

Nathalie Heinich

The Sociology of Contemporary Art: Questions of Method

Far from being secondary or merely technical, questions of method are the principal avenue of access to the object, not only in the process of research, but also in the account that is subsequently made of it. A method is not a transparent mediation between the object and the researcher. This is why it may be worthwhile to reconsider it, as I will do here with respect to my own work on contemporary art (see *Le Triple jeu de l'art contemporain* and *L'Art contemporain exposé aux rejets*).

The plurality of approaches

I would like to stress at the outset that I am against any hegemony of sociology, any claim that sociology is the only legitimate approach to art. What I will propose here seems to me to be the best sociological method for application to contemporary art, but that does not mean that the sociological approach alone is relevant: other disciplines – particularly philosophy, art history, art criticism – clearly have their place in the series of discourses on contemporary art. They simply do not produce the same kinds of knowledge.

I would like to make this pluralistic position towards the various disciplinary approaches more precise. Let us consider, for example, the range of possible responses to a classic question which is often asked of sociologists: the question of the actor's freedom when he or she comes under the sway of social determinations. In this case, the problem is that of the freedom of the artist, and more particularly, the freedom of the contemporary artist.

In the second chapter of *Le Triple jeu de l'art contemporain*, where I discuss the different theoretical approaches to the notion of the borders of art, I criticize the philosophical position – which is also, quite often, the common-sense position – that consists in the assertion that the contemporary artist is free because the range of possibilities is infinitely open, given the situation of

anomie that now prevails with respect to aesthetic criteria (what Pierre Bourdieu calls 'the institutionalization of anomie'). I explain that this liberty is only an optical illusion, analogous to that of a spectator watching a game of chess and imagining that the players move their pieces 'freely' over the board, but not knowing the rules or even realizing that the game has rules – whereas in fact the player's apparent freedom is tightly constrained by the rules, which are so obvious to him, so perfectly internalized, that he sometimes is not even aware he is obeying them, blinded as he is by the need to play with these rules 'better' than his adversary, exploiting to his advantage the narrow margin of liberty that they leave him. An artist, today, is no more or less free than a chess player: he is free to do what he wants, of course, but precisely at the risk of losing the game, or being disqualified from it. To the extent that he accepts to play within the rules, and to the extent that he has understood them (which is far from being self-evident), then the question of freedom is no longer pertinent for understanding what goes on, but rather the question of talent, whether this be defined as cleverness, strategy, inspiration, or creativity.

Nonetheless, in the conclusion of my book I stigmatized the 'permissive paradox' that leads institutions to encourage the transgression of the rules or criteria that they themselves are charged with instituting, i.e., with establishing, transmitting, sanctioning, generalizing. What liberty, I asked, remains to the artist who is thus required to take liberties with his liberties? The liberty to disobey the permissive injunction, by obeying the rules? Or the liberty to obey the imperative of transgression?

Faced with this question, on which I chose to close my reflection, one could object that I actually contradict myself, by concluding with the – paradoxical – freedom of the artist, after having denounced the illusion of this same freedom in the work of the commentators. But rather than a contradiction, I think what we have here are two ways of constructing the description, themselves upheld by two different approaches, at once disciplinary and methodological. Indeed, these are but the possible extremes, or poles if you like, in a two-dimensional space, doubly structured by an axis which opposes the individual to the collective and by an axis which opposes performance to competence, act to potential.

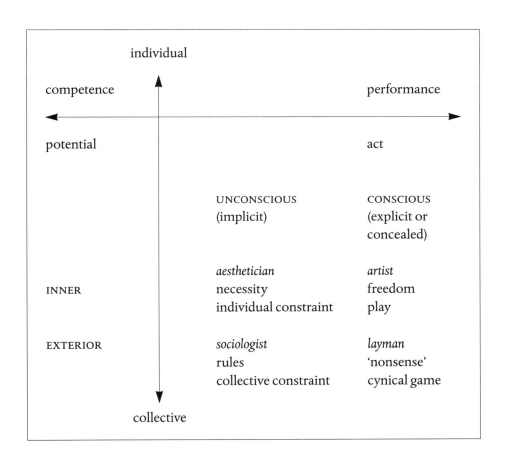

The layman's viewpoint rests on the spontaneous perception of two levels of reality: the exterior level, on the one hand, and on the other, the conscious level (whether explicit or concealed). Thus, seen from the outside and insofar as it is directly perceptible to consciousness, the transgression of aesthetic criteria by contemporary art can appear as 'nonsense,' or as a cynical game with established values: this is the principle of the profound denigrations I studied in the rejections of contemporary art.

At the extreme opposite, the viewpoint of the aesthetician or the specialist in contemporary art rests on an investigation of the two levels of relation to reality, which are, on the one hand, the inner level, and on the other, the unconscious or implicit level. Thus the aesthetician will stress the artist's 'inner necessity.' His submission to a constraint or at least to an individual determinant, which could be on the order of inspiration, of personal history, of a particular talent, etc.

As to the artist's viewpoint, he shares with the aesthetician a sensitivity to inner phenomena (which is hardly surprising, since by definition he is closest to his own experience), while at the same time he shares with the layman a spontaneous perception of the conscious level: after all, neither the artist nor the layman are charged with investigating the depths of the hidden determinants, of history, of unspoken constraints. Thus in the contemporary transgression of the criteria of art, the artist will see above all either an extra margin of freedom offered to him, or a possible game – which he will develop in either a playful or a critical manner.

Finally, the viewpoint of the sociologist, diametrically opposed to that of the artist, rests on the methical exposure of the exterior level (which he shares with the layman) and of the inner level (which he shares with the aesthetician). What the sociologist will therefore expose are the rules, the collective constraints, which are at once exterior to the lived experience of creation (which, precisely, demands the liberties taken with rules, in order to invent) and are largely unconscious, or at least implicit (without which there would be no need for sociologists to explain them).

Thus when I critique the aesthetician's illusory belief in the artist's freedom, I speak as a sociologist, that is, as someone better equipped to understand the collective constraints that underlie a socialized activity. And when, from an opposite perspective, I inquire into the freedom left to artists by the institutions, I place myself at the viewpoint of the artist, who has so perfectly internalized the rules that he can have the feeling of moving in total

freedom – exactly like a chess player who, at each move, is confronted with choices, but who no longer sees that his freedom of choice is only upheld by the extremely constrictive limitation placed on his permissible moves.

Who is right here, and who is wrong? The answer depends on the point of view one privileges. The artist and the aesthetician can reproach the sociologist with only seeing phenomena exterior to the experience of creation, and thereby minimizing the individual freedom, or the individual or properly aesthetic determinants, in favor of the relational and institutional constraints. The layman can reproach the aesthetician and the sociologist with seeking to attenuate the responsibility of the artist by pointing to his unconscious determinants. As to the sociologist, it is hardly surprising that he may find the artist or the layman to be somewhat short-sighted, when they refuse to understand the weight that history and the outer world bring to bear on individual experience, and that he may find the aesthetician equally short-sighted, when the latter reduces the unconscious determinants to the inner phenomena of the artist's individual experience.

Must this multiplicity of possible viewpoints lead one to the conclusion of absolute relativism, rendering these different ways of seeing the world equivalent? I don't think so. Because of course, each way opens up to realities which are a little bit different, each casts a specific kind of light on the material – an observation which discourages any pretension to hegemony, any attempt to impose the exclusive validity of a single viewpoint. But some points of view are more general than others, opening up to realities which cannot be spontaneously perceived: and the scholar's role, with respect to the actor, is precisely to construct tools for investigating that which is not immediately accessible to perception. The scholar can and must take into account the account that is delivered by the actor or the layman, but he is expected to expose phenomena, logical structures, or categories that can account for this account, at a deeper, or, if you will, a more sophisticated level.

As to the matter of knowing which among the various scholarly discourses is the most powerful, again it is a question of choice. If one believes that within unconscious or implicit phenomena the inner level is more rich and interesting than the exterior level, then one will incline toward art criticism. Historians and philosophers will opt for levels of analysis which are oriented more toward collective categories. As to sociologists, they will generalize the problem even further, examining the levels of determination most

exterior to art. Not being a hegemonist, I do not claim to impose the pre-eminence of the sociological approach. I simply practice it, as effectively as possible – as I am now going to explain.

In relation to other disciplines

If one sets aside historiography, which attempts to describe works and to establish the factuality of knowledge about art (attributions, dates, locations, etc.), one can consider, schematically, that the disciplines dealing with art are traditionally divided into two broad types of discourses: evaluative, on the one hand, and hermeneutic or interpretative, on the other. Art criticism is particularly expected to produce an evaluation of the works – with all the associated problems of objective judgment, which we will not discuss here. Aesthetics and the philosophy of art reserve themselves for the interpretation of the artwork's meaning – whatever the 'code,' the domain of reference whereby these interpretations are produced. Art history, for its part, tends to alternate between plastic description and categorization, evaluation and interpretation.

My viewpoint is that sociology should not impinge on the other disciplines, should not seek to do better than they: all that can come of such hegemonic claims are, at best, programmatic declarations, poorly equipped critical evaluations, or interpretations that attempt, with varying degrees of intelligence and skill, to trace generally unconvincing links of cause and effect between an object (the artwork) and a collectivity – family, social class, or the whole of 'society.' It is better to apply the principle of specificity, seeking to do what the other disciplines can not. In this case, I have tried to stick to a pragmatic approach, in the two senses of the term: pragmatic in the epistemological sense, since it is a matter of analyzing artistic phenomena in concrete situations and contexts, and not in an abstract way; and pragmatic in the etymological sense, since it is a matter of analyzing what the works *do,* and not what they stand for, what they signify.

So what do artworks do? First of all, they move people, in both the literal sense (people travel to see them) and in the figurative sense (they raise emotions). They make people act: to frame them, to transport them, to insure them, to restore them, to exhibit them. And then, they make people talk, they make people write about them and discuss them formally – as proved by what we

are doing here. But they also displace those less palpable objects which are mental categories, frameworks of perception, criteria of evaluation: and this in particular is, as I have tried to demonstrate, the essential quality of modern and above all of contemporary art, which ceaselessly displaces the borders between art and non-art, always pushing them further back, continually enlarging the space that is imparted to art.

This opening to the pragmatics of the works implies a reduction of sociology's space of competence. For sociology will then be unable to produce instruments for the evaluation of the works (thus, a work will not necessarily be considered a good work merely because it transgresses the common-sense or scholarly criteria of aesthetics, and nor will the work be considered valuable because it is not transgressive). Even more importantly, sociology will have to renounce any discourse on the artist's intentions: there is no immediate relation between what a creator 'sought to do' or to 'say' and what the work produced does or says to the different categories of spectators or addressees – if only because of the unconscious or non-explicit aspect of the work, which, as we have seen, can be investigated with the specific tools of the scholarly disciplines, aesthetics and sociology. The work is not what can teach us the most about the creator's intentions – rather it is the creator himself, to the extent that he can explain what he is doing. And the transgressive *effect* of the works is not necessarily the product of a transgressive intention (as often postulated by the detractors who accuse artists of seeking provocation rather than authentic expression) – indeed, a transgressive intention can end up transgressing nothing whatsoever, if it fails to achieve the desired effect.

Now, our spontaneous relation to art is largely founded on the desire for psychological explanations (the artist's intentions), on aesthetic evaluations (the quality of the creations), and on hermeneutic significations (the meaning of the works). So it becomes very clear that the sociological approach I have chosen can frustrate those desires and engender misunderstandings, when readers expect from this analysis precisely what it abstains from providing, not because it would be uninteresting, but because other disciplines are better placed to do so. Readers then need simply to change their expectations in order to get something out of these studies, without demanding from them that which, by definition, they are unable to give.

In relation to sociology

The pragmatic approach obliges one to articulate the different dimensions of aesthetic experience: the analysis of the art objects themselves, identifying what it is that produces certain effects (in contemporary art, this entails the description of the different categories of transgressions); the analysis of their reception by the different categories of publics; the analysis of the mediations carried out by the different categories of specialists, from the collectors and dealers to the critics, exhibition organizers, curators, and agents of the state. For an action simultaneously involves an object, an emitter and a receiver, in addition to possible intermediaries and translators, all within a specific context. Each of these elements must be studied in its relation to the others, in its 'interdependency,' to use one of Norbert Elias's key concepts.

This is one of the primary characteristics of the method that I have used, this time in relation to the sociological tradition; I have tried to systematically articulate domains of the sociology of art which are too often isolated by specialization. The sociology of the works, the sociology of reception, the sociology of mediation or of institutions, do not all involve the same scientific operations, but they must be articulated with each other to reconstruct the logic of the movements. Thus the distinction between 'internal' sociology, focusing on the description of the works, and 'external' sociology, focusing on the description of the modes of circulation through the world, loses some of its pertinence here: the sociologist can move along a continuum that stretches from the object produced by the artist to the most general context of reception, examining the articulation between the different moments of an object's career rather than isolating these moments in analyses cut off from each other by the researcher's specialties.

A second characteristic of the sociological method I have used involves the pragmatic position discussed beforehand: when one chooses to study what an artwork does or what it displaces, one has good reason to stress the analysis of phenomena in concrete situations, or in other words – to use a metaphor borrowed from linguistics, and more precisely, from pragmatics – to stress performance rather than competence. That is how I closely examined the phenomena of the rejection of contemporary art – because the negative reactions, bearing witness to a loss of immediate legibility, bring out spontaneous responses or 'explicitations' which form extremely

valuable raw material for the sociologist. As we know, crisis situations are the best vectors for an understanding of normal conditions, through their negative image.

To study these rejections concretely, I avoided two classic resources of the sociological tradition, namely, statistics and interviews. Indeed, as I explained in the chapter devoted to 'indifferences,' the gathering of opinions has a double disadvantage: first, that of flattening out the differences in the intensity of reactions, and thereby prohibiting one from working on the person's degree of involvement or detachment; and second, that of often producing standard statements, pre-formatted by the situation of the interview and by the requirements of courtesy, which lead the person to try to please the interviewer, or by those of self-esteem, which incite people not to lose face by revealing themselves incapable of producing an opinion.

There again, to be sure, one loses information by depriving oneself of statistics, which allow tastes to be related to positions in social space. But quite to the contrary of the methods we are so familiar with from opinion polls, the goal of my inquiry was not to produce an explanation of tastes, but a description of the values that underlie the justification of these tastes (because where opinions on contemporary art are concerned, trying to bring tastes into a direct relation with positions in social space becomes particularly problematic, for reasons which I tried to clarify in a discussion of the 'blurring of sociological categories'). This is why I chose a method closer to ethnographic methodology, which prescribes 'following the actors,' observing and analyzing spontaneous reactions – for example, the inscriptions on exhibition guest books. It was also a matter of moving away from the formulation of opinions to stress the description of lived experiences, through direct observation or accounts rendered by the actors themselves. This allows one not to 'explain' the positions from a perspective of cause-and-effect, but to 'render them explicit' from a descriptive perspective.

Finally, a third characteristic of this sociological method stems from the recognition of the specificity of the instruments available with respect to the objects under study: one cannot study the works in the same way as one studies the gazes that fall upon them, the actions they give rise to, and the objects that underlie them. Moreover, the differences in the availability of the sources or instruments of research are themselves part of the object of the research. Thus, it is not insignificant that the history of institutions and

the economy of market exchanges have been much more thoroughly developed by sociological research than the observation of the emotional states produced by the confrontation with the works, or even than the analysis of the criteria of judgment used by the experts in their decisions when they sit on buying or funding committees. The stance I took here was to use the sources when they existed (which is why almost the entire chapter of 'the means of the mediators' rests on the exploitation of pre-existing data) and to produce them when they did not exist: through the observation of acquisitions committees, the study of rejections, the 'internal' analysis of the works on the basis of their transgressive effects, and even some personal observation of phenomena of conversion or acceptance.

Specificity of the sociological approach

The variety of tools available to the sociologist brings us back to the question of the specificity of the sociological approach: indeed, it is no accident that these tools are far more developed in the areas that traditionally constitute sociology's strong point, if not its *raison d'être*, that is, the demonstration of an object's conditions of circulation, of the contextual effects, mediations, and even the power relations that condition its situation in the world. Thus the market, the institutions, the configuration of the audiences, the professional status of the intermediaries, have all been the object of sophisticated studies.

Yet this focus on everything exterior to the artwork runs counter to the aesthetic values that are spontaneously considered as intrinsic to the object that has been created: what forms the value of a work for an aesthetician are its intrinsic characteristics, whether they be material or spiritual, purely formal or expressive of more general meanings; what forms the value of a work, for a sociologist, is the valorization given to it by the actors, produced by the full set of aesthetic accreditations. It is comprehensible that under these conditions, the sociological project, even when it seeks to be purely descriptive, necessarily produces critical effects: it has every chance of being interpreted as an attack on the authenticity of artistic values – which adds to the misunderstandings that the sociologist's work provokes in the art world.

This is what I tried to develop in the conclusion of my book, by analyzing a little event that occurred at the Musée de Marseille: the exhibition of objects stolen by an artist, and the surprising results of that exhibition in the social life of Marseilles and far beyond, in intellectual circles. The simple narrative of the various moments of this story sufficed to reproducè the effects of denunciation – and particularly, the denunciation of the sociologists who had gone before me. Here one reaches the limits of methodological vigilance: just as artworks circulate in the world and are affected by it, similarly, sociological studies circulate in a world which takes hold of them, interprets them, and uses them – not always in the way the sociologist would have liked, even if he makes every effort to be prudent, to survey his neutrality, to reconsider his tools, to reflect on his method…

I won't go so far as to claim that sociology is a form of art. However, contemporary art may well have affinities with sociology, to the extent that it attempts – like Duchamp in his early experiments with the ready-mades – to introduce into the work something quite different than the object created by the artist, namely, the relations that form around it, the institutions it brings into operation, the narratives it gives rise to, the whole range of ties whereby it exists in the world. The contemporary work of art most often includes far more than the object created by the artist, if only because it plays with the expectations of the audiences – which is not unrelated to the various misunderstandings and disappointments that it too brings about.

This is why contemporary art resembles a sociology in acts, or if you prefer, in works.

Fahrenheit 451 – the temperature at which book paper catches fire, and burns…

'Do you ever read any of the books you burn?'

Montag laughed. 'That's against the law!'

'Oh. Of course.'

'It's fine work. Monday burn Millay, Wednesday Whitman, Friday Faulkner, burn 'em to ashes, then burn the ashes. That's our official slogan.'

They walked still farther and the girl said, 'Is it true that long ago firemen put fires out instead of going to start them?'

'No. Houses have always been fireproof, take my word for it.'

Faber's hands itched on his knees. 'May I?'

'Sorry.' Montag gave him the book.

'It's been a long time.' Faber turned the pages, stopping here and there to read. 'It's as good as I remember.' Faber sniffed the book. 'Do you know that books smell like nutmeg or some spice from a foreign land? I loved to smell them when I was a boy. Lord, there were a lot of lovely books once, before we let them go.'

Beatty leaned forward in the faint mist of smoke from his pipe. 'So! A book is a loaded gun in the house next door. Burn it. Take the shot from the weapon. Breach man's mind. Who knows who might be the target of the well-read man? Me? I won't stomach them for a minute. And so when houses were finally fireproofed completely, all over the world there was no longer need of firemen for the old purposes. They were given the new job, as custodians of our peace of mind, the focus of our understandable and rightful dread of being inferior: official censors, judges, and executors. That's you, Montag, and that's me.'

'Here we go to keep the world happy, Montag!'

Beatty's pink, phosphorescent cheeks glimmered in the high darkness, and he was smiling furiously.

'Good night!' She started up her walk. Then she seemed to remember something and came back to look at him with wonder and curiosity. 'Are you happy?' she said.

'Am I what?' Montag cried.

But she was gone – running in the moonlight.

'One last thing,' said Beatty. 'At least once in his career, every fireman gets an itch. What do the books say, he wonders. Oh, to scratch that itch, eh? Well, Montag, take my word for it. I've had to read a few in my time, to know what I was about, and the books say nothing! All of them running about, putting out the stars and extinguishing the sun. You come always lost.'
'Well, then, what if a fireman accidentally, really not intending anything, takes a book home with him?'

Faber examined Montag's thin, blue-jowled face. 'How did you get shaken up? What knocked the torch out of your hands?'

'I don't know. We have everything we need to be happy, but we aren't happy. Something's missing. I looked around. The only thing I positively knew was gone was the books I'd burned in ten or twelve years. So I thought books might help.'

'You're a hopeless romantic,' said Faber.

'When you're quite finished,' said Beatty behind him, 'you're under arrest. It was pretty silly, quoting poetry around free and easy like that. It was the act of a silly damn snob. Give a man a few lines of verse and he thinks he's the Lord of all Creation. You think you can walk on water with your books. Well, the world can get by just fine without them. Look where they got you, in slime up to your lip. If I stir the slime with my little finger, you'll drown!'

Beatty grinned his most charming grin. 'Well, that's one way to get an audience. Hold a gun on a man and force him to listen to your speech. Speech away. What'll it be this time? Why don't you belch Shakespeare at me, you fumbling snob? 'There is no terror, Cassius, in your threats, for I am arm'd so strong in honesty that they pass me as an idle wind, which I respect not!' How's that? Go ahead now, you second-hand litterateur, pull the trigger.'

'Police Alert. Wanted: Fugitive in the city. Has committed murder and crimes against the State. Name: Guy Montag. Occupation: Fireman. Last seen …'

Excerpts from *Fahrenheit 451*
a novel by Ray Bradbury
Selected by Johan Grimonprez

Henk Oosterling

Intermediality
Art Between Images, Words, and Actions

In 1897, Stéphane Mallarmé commented that poets can learn a great deal from the black-and-white layout and the typography used in newspaper articles. The poet whom Michel Foucault claims, in *The Order of Things*, was the first to broach 'not the meaning of the word, but its enigmatic and precarious being'[1] evidently does not consider it beneath himself to make positive statements about popular media. In the poem 'Un coup de dés jamais n'abolira le hasard' (A throw of the dice will never abolish chance) Mallarmé introduces revolutionary typography.

Throughout the century that follows, many artists will allow this fascination with public media to influence their work. After newspaper text, photographs, film, video, and computer will constitute part of the range of means by which visual artists introduce a tension to a particular medium and thereby intensify the reflective quality and conceptuality of the work. Newspaper fragments in the cubist paintings of Georges Braque and Picasso, word pictures with Max Ernst and René Magritte, the neon texts of Bruce Nauman and word installations of Jenny Holzer – the tension between word and image introduces, by means of a material reflection, a reflectiveness in the work. The autonomous work no longer mirrors reality in a representative sense, but via its own medial reflectiveness. Due to the cross-breeding of artistic and technological media, layers of meaning accumulate, and about a half century later visual art will become food for structuralists and semioticians.

What interests me, as a philosopher, in the relationship between words and images is not the painterly incorporation of an ostensibly foreign medium – language – into visual arts, but the specificity of the reflective tension that this incorporation generates in the viewer/receiver of the work. I call this experiential dimension 'intermedial' and merely raise the question as to whether this intermedial tension could be the basis of our experience of self in postmodern times. Art comes back into the picture and begins to have a

1. Michel Foucault, *The Order of Things* (1966) (London: Routledge, 1994), p. 305.

voice when it appears that this 'condition,' generally experienced as dispersion or interim, must be given shape. It is against this ethico-aesthetic background that I discern a web of interconnections within the fabric of the multimedial and interdisciplinary avant-garde.

I place the painterly word and literary visual experiments in the context of a broad and diverse range of artistic and culturally political activities that begin to unfold at the end of the nineteenth century and continue to have repercussions in present-day art practices. Some multimedia artists aim, with their interdisciplinary and multimedial experiments, to arrive at a new culturally political context, while others give particular emphasis to the effects of an autonomous multimedial sensibility in the existence of the individual. The first group aspires to a communal experience of cultural policy, the second to an individual stylization of their lives. Both experiments are political activities in the broadest sense of the word: there is a systematic and conscious pursuit of medial interaction in public space. This may explain why multimediality is often linked with happenings, performances, and *Aktionen* in which artistic (group) activities deliberately intervene in the socio-political domain.

Multimediality: words and images

Sensitivity to linguistic images and to metaphors determines, to a great extent, the literary qualities of writers. Experiments with word pictures are generally attributed to writers. The cross-breeding of painterly images and words has already taken place before Mallarmé's typographical experiment. In 1883, for instance, the writer Alphonse Allais incorporated into his books monochromes that he made himself. He gives a red monochrome the title 'Tomato harvest by stroke-prone cardinals on the banks of the Red Sea.' Here language is the carrier of a basically meaningless image (so long as we do not give in to the temptation of a retrospective interpretation based on twentieth-century abstraction). The title structures the reader's gaze and generates an image that would otherwise be imperceptible in any manner whatsoever.

The introduction of words in visual art is not an exclusive achievement of the late nineteenth century. Already in fifteenth-century paintings, sacred Latin sentences are put in the mouths of saints. And haven't words accom-

panied images almost invisibly throughout (art) history? Works are, after all, given titles as a matter of course. This relationship between title and image was, of course, largely descriptive in nature: the title mimicked the image in a discursive manner, while the image mimicked an experienced reality in a material way.

At the end of the nineteenth century, a qualitative change appears. In *Invisible Colours. A Visual History of Titles*[2] John Welchman provides an analysis of titles that no longer describe but rather define the figurative image in material terms or in metaphors from another art form or from the perspective of another sense. The nineteenth-century American painter James McNeill Whistler was among the first to establish a connection between title and image that departs from the conventional manner of description. He calls, for instance, a portrait of his aged mother *Composition in Grey and Black* (1871) and used musical terms such as 'Nocturne' for other depictions. This metaphorical shift gives rise to a restructuring of the viewer's gaze: if he wishes to observe the entire work and not just the image, he will need to give consideration to the materiality of the medium or to the matter-of-factness of his metaphorically structured gaze.

In the poster art of Henri de Toulouse-Lautrec – in 1891 he produced the notorious 'Moulin Rouge' poster – the interaction of word and image is used for the purposes of consumerism. Jan Toorop's 'dripping' poster is a characteristically Dutch variation on this. Publicness and publicity are intrinsic to word images. When, in 1911, Braque paints on his canvases words that refer to big-city life and Picasso builds newspaper-clippings into his work, these words from the public domain offer a common ground for images that are becoming decreasingly representative and increasingly idiosyncratic. These early word images create, by way of medial tension, a reflective detachment which at least disrupts the aesthetic contemplation of the image.

Should painters contextualize their images by means of words, the writers knock the words out of their obvious context through typographical imagery and thus evoke a reflective detachment that also has a higher conceptual caliber. Marcel Duchamp bridges these two experiments.

Later generations of artists continue to elaborate on this multimedial experiment. Physical publicity – in the form of a performance – is present in the

2. John Welchman, *Invisible Colours. A Visual History of Titles* (New Haven, Conn: Yale University Press, 1997).

work of futurists, dadaists, surrealists, De Stijl artists, members of Cobra, Fluxus, makers of pop art, body art, and conceptual art. Due to the public nature of words and the physical presentation, their work takes on a political dimension that cannot be reduced to strictly political statements. Nauman, Ruscha, Mol, Finlay, Holzer, Dwyer and Kruger experiment architectonically with these developments in new materials.

Autonomy and medial reflectiveness

Are the words a little story to go with a picture or is there something else going on? As soon as a title is no longer merely descriptive – and thus no longer underscores reality – it evokes a medial reflection. This reflection is doubled as soon as visual artists include words in their images and then furnish these entire word images with titles. The classic example is the widely known painting by Magritte, also discussed by Foucault, in which the image of a pipe is given the caption 'Ceci n'est pas une pipe' (This is not a pipe) and the entire work has the title *La trahison des images* (The treason of images, 1929). What is the effect of the words beneath the work on the combination of words and images that are incorporated in it?

Things become even more complicated in Penck's or Basquiat's images packed with words, where the title makes the entire work topple once again. Where does medial reflection stop? When is it no longer part of the work? In order to limit this reflection, some artists opt – just as with a painting called 'untitled' – to render only the text that can be read in the work. Installation artists such as Holzer and Kruger, who literally envelop the viewer with their verbal spaces, limit themselves to 'Installation View.' Perhaps in doing so they wish to avoid the reflective struggle, through which the viewer could become detached, by way of the title, from the political impact of the work.

The grafting of words and images onto each other gives rise to self-reflective dynamics within the work as soon as the viewer becomes involved in the work. His gaze is held by the tension. He is forced to give consideration to the interrelationship of words and images. This 'intermedial' tension makes the viewer more than a passive observer. Through intermediality he becomes an active participant in the production of the work's meaning. This effect causes the autonomous work to remain communicative. Effective interactivity begins with intermediality.

The mimetic function which the autonomous work can no longer fulfill thereby remains in tact in an indirect manner. The incorporation of words known to the audience – the interplay of associations of meaning and sound – constitutes a twofold tactical move: in a single gesture the eye is directed at the self-reflective autonomy of the work and at the worlds beyond this.

The *Gesamtkunstwerk*: its multimedial and interdisciplinary nature

In retrospect, 1917 was an ominous year. Revolts and revolutions were taking place not only in politics, but in art as well. As a short-lived political and artistic experiment, the Russian Revolution has repercussions throughout Europe. Dada presents itself in Zurich, and in New York Duchamp 'politicizes' the institution of art by making banality and conceptuality fundamental characteristics of the artwork in a unparalleled artistic gesture. From this point onward, nothing is simply beautiful or ugly. Duchamp's sensitivity to every aspect of the word will prove to be crucial to the way in which word and image make (art) history thereafter.

But it is not only visual artists who are toying with words and images at that point. After Mallarmé, the poet Apollinaire takes this union a step further. From the trenches he sends poems in the form of utilitarian objects, natural phenomena and the like. He calls these 'calligrams.' In Paris the composer Erik Satie is experimenting with his sound images and adapts his notation to this. He will compose, among other things, 'a piece in the form of a pear': on the music sheet on which he writes this, the image of a pear is made with musical notes while his instructions take on an impressionistic quality: rather than 'andante' he indicates 'with a relaxed feeling.'

The word/image experiment proves to be part of a much broader cultural experiment when – also in 1917 – Picasso, Apollinaire and Satie put on the multimedial and interdisciplinary spectacle *Parade* together with the choreographer Léonide Massine. In this total theater *avant-la-lettre*, the artistic and cultural/political tone of the new age is set. In this typically French version of the *Gesamtkunstwerk*, Charles Baudelaire's call for modernity above all else is developed in a multimedial and interdisciplinary manner.

To me, multimediality and interdisciplinarity seem to be expressions of an artistic aim to present the critical and reflective powers of art as coherently and poignantly as possible. The Cartesian distinction between body and mind is negated: matter and concept prove to be indivisible, at most distinguishable only in an artificial manner. But not only are senses and the consciousness of the audience harassed integrally in this conceptually embedded, multisensory bombardment, the community-forming function of art, which had to be sacrificed after art became autonomous during the course of the nineteenth century, is also revitalized. Traditional cultural and political goals are dismantled to an increasing degree from the eighteenth century onward. Nietzsche's nihilism thesis casts some light on this in retrospect. During the late nineteenth century art is, for artists, *the* synthesizing force by which public life, subject to increasing rationalization – and thereby to a seemingly rampant fragmentation – regains coherence. They graft art and life onto each other in such a way that individual existence, or even the entire culture, can again be inspired and oriented. The experiment in cultural politics takes shape in Wagner's megalomaniac project of the *Gesamtkunstwerk*, which is given a philosophical basis by the young Nietzsche: he attempts to charge the worn Christian culture with Apollonian/Dionysian élan. A more small-scale experiment is carried out in the dandyism of Charles Baudelaire and Oscar Wilde which is supported by literary activities: they concentrate on an aesthetic refinement of individual performance. I should like to use a term introduced by Foucault for this stylization of life: an *aesthetic of existence*.

Whereas Wagner pursues the inspiration of all socio-political life, Baudelaire focuses solely on that of individual: in his life and work he aspires to an interplay of the senses – a synaesthesia. While the theatrical composer sets his sights on a mythical and heroic past, the dandy poet mainly echoes modern city life with its excessive and dark aspects.

But no matter how great the differences may be, both manage to be inspired by an aesthetic theatricality and by 'publicity.' The *Festspielen* of Bayreuth are, in that sense, the megalomaniac equivalent of sauntering down Parisian boulevards. Although the scale and the tone of the two experiments differ, both endeavor to bring life and art into a reflective relationship. This reflection need not be explicitly critical. On the level of artistic media, reflection is primarily material and physical: images are reflected in words, which then are reflected in actions. Even so, in the multimedial experiments and

interdisciplinary activities of avant-garde artists, the criticism will become increasingly explicit and the work more conceptual. Experiments in visual language and word imagery are accompanied by actual performances. Word-image artists from Schwitters to Beuys were always transposing their words into actions. Between Schwitters's *Merzbau* and the social sculptures of Beuys, there are the exhibition activities and events of the surrealists, the happenings from the fifties and sixties, the Fluxus performances and the body-art performances, and *Aktionen*. Existential input, the component of communal experiences, is needed in order to make an explicit political statement.

Graphic design: publicity and reception

Was the gradual dissolution of the common political base that provided images throughout nineteenth century with coherent, collective meaning – Myth, Emperor, God, King, Merchant, and Nature – partly the reason why elements from another common domain – that of language – were incorporated into visual art? Did the silencing of the previously self-evident discourse, which gave meaning and coherence to painterly and literary images, necessitate explicit statements in the form of word images? Did the visual work – raised to the level of an autonomous reality after having been the individual expression of a self-aware but tormented artist – need to be charged with 'political' meaning, i.e. with a communal reality? Is this why Braque introduces his words? I admit, this may go a bit far, but that the communal and public nature and communicativeness of words strongly influenced the decision to combine these with images does not seem entirely unlikely to me.

That graphic design – advertising following in its footsteps – emerges during the same time could offer some support to this shaky thesis.

It, too, thrives on communicability, a certain public character and reflective interactivity. Aside from dealing with new technologies, multimediality is also one of its traits. Its language of images and forms is moreover supported by well-considered concepts in which specific individual behavior is anticipated. Nor is it entirely coincidental that the genesis of graphic design is closely linked with the ideal of the *Gesamtkunstwerk*. In the Netherlands this ideal is still in its infancy around 1900 and is taking its first timid steps

with visual artists and architects: Jan Toorop and Berlage provide the impulses that will come to fruition – this being through the implementation of new techniques such as the photocollage – with Zwart and Schuitema.

Berlage's notion of *Gemeenschapskunst* (public art) also complies with other developments that began to emerge during the mid-nineteenth century. While the inspirations of the late-nineteenth-century English 'arts & crafts movement' were still focused on the guild system and, in that sense, were conservative, a progressive counterpart to this, the *Wiener Werkstätte*, presents itself around 1900. Several decades later, after the experiments in the wake of the Russian Revolution, Gropius attempts to realize this communal ideal with the Bauhaus. De Stijl artist Van Doesburg, who is experimenting with typographical images in his literary work under the pseudonym I.K. Bonset, is affiliated with the Bauhaus. He works with Kurt Schwitters. Schwitters expands words and images into three dimensions and develops this architectonic structure into an existential practice: hence his *Merzbau*. For him, an aesthetic of existence and the *Gesamtkunstwerk* are practically synonymous. In his experiments the use of mixed disciplines and various media is sustained by a conceptual imagination that wishes to explore and give shape to all areas of existence: from household life to inner thought, from design to Heideggerian *Dasein*.

Intermediality: Internet and digital language

Until recently, small groups of graphic designers have conveyed political convictions for the purpose of changing the world – that is to say individual awareness and collective behavior – while most of them have confined themselves to the aesthetic and functional streamlining of social traffic or finding the most efficient way to introduce and promote commercial products. By now, however, the distinguishing of autonomous designers, functionalists and ad-makers has become highly problematic. Recently the crisis of the 'Great Narratives,' as Jean-François Lyotard labels the legitimizing discourses of Kant, Hegel, and Marx – a crisis inherent in modernity – has itself become hypercritical: the discourses of socialism and liberalism have disintegrated along with the USSR, and new substantial criteria for the legitimization of the political community are hard to find.

This crisis of legitimacy began much earlier in visual art. The faulty attempts to speak nonetheless about the post-, trans-, and neo-avant-garde attest to this. Even so, the dispersion that has been both celebrated and maligned as postmodern pluralism by no means rules out the fact that multimedial work continues to aim at reflective interaction, which can even be explicitly critical with respect to existing social and political constellations.

In our time, the political and critical power of art may lie more than ever in this 'inter' or in-betweenness. If art and life have a suspenseful relationship with each other, if art and politics cannot be reduced to each other, if various media within the work set off a reflective experience that also cannot be reduced to the media used, what, then, is the status of this 'inter'medial dimension?

The term 'intermedial' or 'intermedia' is brought up only occasionally in art but has never been examined systematically. Coleridge used the term at the start of the nineteenth century. After this it was developed by artists who wished to politicize their interdisciplinary and intermedial activities by deconstructing existing institutional contexts and ideas. Via Duchamp and John Cage, the term is passed on to the Fluxus artist Dick Higgings, who uses 'intermedia' in 1965 with artworks that can be situated, in a conceptual sense, between two or more artistic media. Again it remains a suggestion, and the term fails to catch on.

In a recent interview Peter Greenaway speaks about 'intermediality.' Greenaway's work is pre-eminently multimedial and interdisciplinary. At an early point in his career as a visual artist, he begins to write texts. This combination is developed by him in a predominantly theatrical setting and, in collaboration with minimal musicians from the Fluxus movement such as Steve Reich, in films. Greenaway is known for his highly conceptual films, considered reprehensible by 'true' film fans. There is use of the most recent technology, the paintbox in his film *Prospero's Books* from 1991. He works with choreographers and composers, films ballets and has produced the opera *Rosa*. In short, if anyone is conceptual, multimedial, and interdisciplinary in his work, it's Greenaway.

But he, of all people, rejects the term 'intermediality.' To him this term expresses art's propagandistic function, which was also evident during the baroque age: particularly the work of Bernini, who used all sorts of media in order to revive a flagging interest in religion, would have been outstandingly intermedial. Greenaway's critical stance with respect to commercial film

prompts him to see this kind of intermediality as a form of propaganda in which the audience is presented with a capitalistic paradise. Nonetheless, his observation that politics and publicity are the issue and his use of concepts, media, and disciplines offer a pretext for reassessment.

New impulses for the contemplation of the term 'intermediality' come from an unexpected angle. In a contribution to the volume of essays *Mythos Internet* (1997) in which the matter of interaction on the World-Wide Web is brought up, Sybille Krämer launches the term 'intermediality' without any explanation whatsoever. She uses it to characterize the surfer's relationship to what appears on the screen and what can sometimes be heard on his speakers: words, images, sounds. As a learned intellectual she sees the web – following in the footsteps of French thinkers such as Jacques Derrida and Julia Kristeva – as an inter-textual medium in which information can be conveyed at the speed of lightning. This intertextuality, Krämer believes, is changed into an 'intermediality' in the digital network.

The increasing integration of new media into socio-political intercourse and the discussions on the similarity between the human brain – and its self-awareness, some say – and the computer raise, at the least, the question of the status of in-betweenness which is so characteristic of the 'Inter-net.' It looks as though we still fail to conceive of this 'inter' as a self-regulating, autonomous process. The discussion about whether or not there is political meaning in digital art that has been done recently on the World-Wide Web under the name *Eyebeam*, as an extension of the *documenta X* net discussion, continues to be haunted by the idea of a new *Gesamt* already developed by Marshall McLuhan: the Global Village. Even a conceptualization such as 'virtual community' attests to the ineradicable desire to anchor the in-betweenness of intermediality in a new type of *Gesamt*. But is it not this very totalization that intermedial art practices resist? Don't these effects of inter-medial art at least give one the sense that every totalization is by definition *arti-ficial*? Can the multimedial and interdisciplinary experiment that the avant-garde supports be seen as a continual plea for a non-reducible, reflective and critical state of in-betweenness in which human self-awareness unfolds?

Hegel has already demonstrated so poignantly that medial self-reflectivity is the very core of human existence. Hegel's philosophical system may indeed have lost its universal expressiveness – despite Francis Fukuyama's failed attempts to revive it – but the inspiration for his conceptual imagination

has hardly been affected. He has shown, more profoundly than any other philosopher, that human self-experience is merely a vain ideal when taken out of the context of an endless series of cultural/historical mediations. Human existence is medial through and through, this being manifest in its 'essence': self-reflectivity. Perhaps man is actually the medium of all media. Being human is, above all, 'inter-esse': being in-between.

We do, however, still tend to ascribe independent positions to producers and recipients of works, regardless of the medium being used. Self-reflexivity – an exclusive quality of human awareness that is now being attributed to computers – remains rooted in a previously given identity. That this artificial identity could be a function of never-ending self-reflectivity is almost incomprehensible. It would be an interesting experiment in thought to link this Hegelian perception with the Internet in order to gain an understanding of the specific experience that is produced in dealing with the World-Wide Web. Perhaps in retrospect we can acknowledge the word/image experiments of Whistler, Allais, Mallarmé and Braque as expressions of a micropolitical sensibility to in-betweenness, which is manifest as 'inter-est' or involvement in a micropolitical sense.

Inter-esse: In-betweenness as micropolitical sensibility

By now we are well aware that we live in an age of in-betweenness. We are *Zwischenmenschen* ('in-between people'), as Peter Sloterdijk aptly remarked in a recent television interview. Okay. But between what? Between modernity and what will come after it? Between an implausible world and an envisioned paradise? Between art and politics? Between visual art and literature? Between form and content? Between word and image? Between understanding and materiality? Between... Isn't this betweenness simply oppression and distress? Isn't it simply a hopeful tentativeness?

In my opinion this is too linear and rational a view of in-betweenness. In-betweenness as micropolitical sensibility sooner balances between sheer presence and a kind of absence. Perhaps it is most strongly expressed in the momentum of an aesthetic experience, which is senseless and heads nowhere as an unarticulated event. (Or do we, after all, think while we are observing?) In-betweenness is not a conscious, discursive experience, but a twofold, reflective awareness that I prefer to label as 'sensibility': this 'sense'

operates between body (the sensory) and mind (meaning and direction). As such it is a continual movement which inevitably leads to the taking of sensible positions. But this movement cannot be reduced to these positions: it is a flux, we could say, in the words of Deleuze and Guattari. Or, speaking in terms of Derrida, a *différance*: not an action that is initiated by a subject, but 'a medial form' in which the relationship between subject and object, between the viewer and the work, between word and image can actually take shape. A work proves to be, first and foremost, 'a process or an operation': *work in progress* as the fundamentally tentative and provisional.

Its development can, of course, be framed, but the emphasis lies on the process, which always implies but cannot be reduced to the intentions of its producer and the expectations of the recipient. The laboratory and studio functions in the making of contemporary art, the shy attempts to allow museum space and public space to become one, the generally politically motivated tendency to transform emancipative potential into edu-tainment or info-tainment: these phenomena acquire a certain coherence in light of a micropolitical sensibility that would be based on in-betweenness.

Is the present self-experience of individuals – that which previously has been referred to as cogito or subjectivity – pre-eminently reflected in this in-betweenness, in this tentativeness without a definite end point? Do multi-medial and interdisciplinary ways of making art make the viewer more sensitive to this intermedial experience? If this were indeed the case, then one would no longer speak of an emancipative, but rather a sensitizing impact. By now it should be clear that, for an intermedial existence, this sensitization does not require docile, passive comsumption but a high degree of participation: interactivity, self-reflectivity and intermediality are inextricably bound to each other.

All of this may explain, to a great degree, the recent concern in art – and on the 'arti-ficial' fringes of architecture – for the philosophical reflections of Bataille, Adorno, Lyotard, Derrida, Deleuze and Guattari. With this interaction, the *liaison dangereuse* between philosophers and artists, the same holds true: an interesting imagination can be developed only in the realm of the in-between, where both art and philosophy escape a reduction to one another.

Nathalie Heinich

Aesthetics, Symbolics, Sensibility: On Cruelty Considered as One of the Fine Arts

On November 8, 1994, the exhibition *Hors Limites* opened at the Georges Pompidou Center in Paris. One work was missing: that of the Chinese artist Huang Yong Ping, who had planned to install *Le Théâtre du Monde*: a terrarium in the shape of a tortoise, containing snakes, spiders, lizards, scorpions, millipedes, centipedes, cockroaches, all of which were to be given water and allowed to move about freely. The work would have been a follow-up to an earlier installation presenting insects, carried out by the artist in Oxford in 1993 under the title *Yellow Peril*.

The decision not to include the work in the show had been taken the day before the opening, after a swift and intense campaign by animal advocates. Only the glass cage was exhibited, completed by a display with a sampling of the protest letters sent to the Pompidou Center and the official communiqué distributed in response to them.

Both because of its form and its content, this is a doubly original case of the rejection of a contemporary artwork. It appeared in the form of a mobilization swiftly and effectively channeled by various associations, backed up by a legal action, but with hardly any echo in the press, culminating in a victory for the protesters – who were nonetheless present at the doors of the Center on opening day to manifest their indignation. As to the content of the rejection, here it bore on a value which is relatively rare – and for good reason – in matters of contemporary art: the protection of animals.

A successful mobilization

The affair had begun on September 27, 1994, less than six weeks before the projected date of opening, with a petition launched by Beaubourg's guards, who stated their 'very firm' opposition to 'a project like those which, in times fortunately gone by, would at best have resembled a colonial exhibi-

tion or other such spectacles much appreciated by science (and held under the cover of pedagogy), or at worst, a Roman circus.' They asked if 'the credibility of the Pompidou Center would be reinforced by a spectacle which we judge unworthy of the intellectual level that all its collaborators have always attempted to maintain…[1]

On October 11, at the request of the administration, the exhibition curator had drafted a note explaining the project: 'The object of the work by Huang Yong Ping entitled *Le Théâtre du Monde* is to symbolize in a philosophical way the necessity of harmony between races, cultures, and religions, in spite of the violence, character differences, and cruelty inherent in earthly natures. The insects presented in the terrarium organized by the Chinese artist Huang Yong Ping learn over the duration of the exhibition to tolerate each other and to organize a social life despite their contradictory natures: scorpions, millipedes, and centipedes learn to accept each other. They are fed with other insects, which are cockroaches and beetles. The whole is arranged on a table in the form of a tortoise. The tortoise is the Chinese symbol of peace. So this is a work that militates in favor of harmony between the races and cultures.'

Alerted by the petition, several animal protection organizations mobilized: the National Society for the Defense of Animals, the Brigitte Bardot Foundation, the Animal Protection Society, the Bourdon Association. From October 12 to the day before the opening, all possible resources would be employed to bring pressure on the president of the Pompidou Center and force him to give up the project: telephone calls, telexes, letters (not only to the presidency of Beaubourg but also to Mrs. Claude Pompidou and to the minister of culture, Jacques Toubon), threats of legal action, summons, and finally, an urgent procedure on the day before the inauguration, demanding that the Court of First Instance prohibit the disputed presentation on the assertion that it would fall beneath the French legislation relative to cruelty

1. It was not the first time the guards had manifested their disagreement with the choices made by the Center: the Bernard Bazile exhibition in 1993 had already aroused reserves, indeed rejections, by certain men and women, and a petition had been addressed a few months later to the administration of the museum (cf. Nathalie Heinich, 'Bordel à Beaubourg, *Omnibus* 10, October 1994). Let us also quote this inscription from the exhibition guest book: 'Reception personnel since the days of the MNAM Palais de Tokyo, we are from the 1st team to arrive at Beaubourg, full of hope and illusions. But *what a disappointment!* afterwards, to come to such a regression. We believed! we had faith in 'Beaubourg' – they've assassinated it.' Here one sees the effect of the gap between the professionals of contemporary art and simple employees, for the most part very invested in culture but with expectations nearer to a large portion of the public – particularly the teaching public – than to their administration.

to animals (article 511 of the penal code), voluntary harm to the life of an animal (article 653 of the penal code), and games and attractions susceptible of leading to the mistreatment of animals (March 26, 1987).

These associations in turn mobilized their adherents, who began to manifest their indignation by means of letters from October 20 onward, through part of the month of November: around thirty were sent from Paris and its suburbs, but also from the provinces – Perpignan, Besançon, Nancy, Saint-Nazaire, Tulle, Vezelay, etc. – displaying a capacity for immediate mobilization across the national territory as soon as the protection of animals becomes an issue. A petition even arrived from Viry-Châtillon, dated October 20, two days after a stormy meeting organized inside the Center between the administration and the personnel, and the day after the appearance of a news brief in *Le Monde* noting that the personnel was in disagreement with the project of an 'artistic composition,' and that 'a petition has been launched so that this spectacle, which cannot help but encourage the baser instincts, be refused. The personnel requests that you swiftly express your disapproval by letter to Mr. François Barré…' Yet the affair was hardly to appear in the press, with the exception of a news brief in *Libération* and a short article in *Le Figaro* the day after the opening: the threats of 'mediatization' leveled by one of the associations had no need to be brought to fruition, as they were advantageously replaced by recourse to effective juridical resources.

Indeed, the Center would very rapidly receive – on October 20 – a summons to respond, served by a court bailiff at the demand of an association. Alerted of the affair, the Center's lawyer stressed in her October 24 consultation that the artistic character of the work gave way before the accusation of mistreatment of animals; that in the eyes of the law, the work could be qualified as an act of cruelty, and that it would be useless to counter this qualification with a juridically groundless distinction between animal species (allowing one to exclude insects, for example); and that in addition, the framing of the operation, at once artificial and calling for contemplation, aggravated rather than restricted the case; that the risk of legal action was therefore great, and a penal action could even be envisioned with all its consequences, notably the 'personal appearance of the President before the penal jurisdiction'; and finally, that it would be preferable to avoid the risk by adopting an intermediate solution between the abandonment and continuation of the project, namely, by exhibiting only the concept.

The Center's administration then envisaged showing the piece only on open-
ing day, and replacing it thereafter with photos. But for that the authoriza-
tion of the prefecture would be necessary (which no one seems to have
thought of earlier). It was requested on October 28. On November 7, the day
before the opening, the authorization was refused by the prefecture, 'in
conformity with the regulations pertaining to the presentation of animals
in an establishment open to the public'; particular emphasis was laid on the
'unsuitability of the specific environment to the species presented in such a
limited space, each of the species being given no assurance of having its
own territory,' and also on 'the obligation to separate the species in the con-
text of this exhibition organized in open compartments.'

This administrative decision brought an end to a conflict which the interven-
tion of the Court of First Instance of Paris had been unable to resolve. The
court had been convoked in urgent procedure on the same day, at the
request of the National Society for the Defense of Animals, which demand-
ed that it prohibit the Georges Pompidou Center 'from proceeding with the
disputed presentation, under penalty of a fine of 100,000 francs per day of
delay…' The court declared itself unqualified in the matter, leaving the
NSDA to pay the attendant costs. This decision matched the conclusions of
the Pompidou Center's lawyer, filed on October 31, insisting on the lack of
jurisdiction of the Court of First Instance in favor of the Administrative
Court, and pleading furthermore that 'in the absence of any proof fur-
nished by the NSDA of the natural antagonism of the species to be brought
together, the NSDA cannot legitimately obtain in urgent procedure a mea-
sure as serious as prohibiting the exhibition of the work,' that 'furthermore
it has not been established that the regulations defined by the Rural Code
are applicable to the Center,' and finally that 'the work by Huang Yong Ping
takes its place in a Western tradition of art in the course of which animals
are presented.'

The exhibition therefore opened on November 8 without the installation,
which was reduced to the cage and to a display containing letters of protest
as well as the Pompidou Center's response, in the form of a communiqué by
François Barré (president of the Center), Germain Viatte (director of the
museum), and Jean de Loisy (curator of the exhibition). Here it is specified
in particular that '… The Georges Pompidou Center, taking account of the
legal situation, notes the contradictions existing between legitimate com-
pliance with the law and its mission of testifying to artistic creation. It

regrets that in the debate which has arisen, passion has run higher for the defense of certain animal species than for the freedom of creation. Art is not an affair of tender sentiments. The work has therefore been withdrawn from the exhibition, which retains its structure. Given the questions it poses as to the nature of the work of art, the freedom of the artist, and the role of the museum, it appeared necessary to present the public with documents relating to its contents and to the debates to which it has given rise.'

The disputed work was also to be the object of various opinions expressed in the visitor's book: protests recapitulating the arguments of the animal defenders, or protests against the protests, either in the name of reality (would one also have to 'prohibit the natural history museum, surgical operations, films where animals die?'), or in the name of the refusal of censorship ('After Taslima Nareen, we've had enough!'), or again in the name of respect for human beings, which should come before respect for animals. But these opinions are systematically contradicted by angry refutations. For instance, one female visitor wrote: 'The expression "freedom of expression" is pretty shopworn now… so let's say freedom to show, to shout, to dramatize what one feels – even if a couple of insects and other arachnids lose a few wings, they are just inferior beings, quite low on the scale of animals, etc… In short, a petition against the right-thinking, hygienic totalitarianism of the SPA and other animal friends.' But someone answered back by adding, after 'inferior beings,' 'inferior your mother, oh… fat whore!' Finally, the argument used by a defender of the prohibited work reveals a misreading that makes his protest against the protesters into an extra argument in their favor: 'So Bardot is interested in art?! So showing living insects is prohibited by the museum regulations… but dead insects? Why attack Ping?' To which another visitor hurried to respond: 'They aren't dead insects!'

The artist's silence

It is noteworthy that at no moment did the artist intervene publicly: of the interactional triangle that determines the existence of contemporary art – between the artists' propositions, the public's reactions to them, and their accreditation by the institutions[2] – only the second two instances appear in this polemic. This is a recurrent phenomenon in the rejection of contem-

porary art: the problems of acceptability seem to reside less in the works themselves than in the support given them by the artistic authorities, such that the artists are rarely taken to task (and are sometimes explicitly exonerated of any blame), whereas the institutions are the target of the major protests.

The artist himself seems not have deemed it judicious to intervene, as he explained in an interview after the affair: 'As to a possible reaction in the face of the prohibition against the presentation of the work in its totality, Ping esteems that he does not have to protest in order to deal with the affair, declaring that 'a non-reaction is a reaction,' the journalist explains.[3] 'And it is not up to the artist to think for the public. The institutions are what link the artist to the public, but one can never predict what will happen afterwards,' he stresses.

Indeed, Ping does not seem to have been surprised by what happened: 'The reaction was predictable. First of all, I was conscious of the food chain in my choice of animals.' Yet the way he comments on the affair suggests that he was far from knowingly playing with the reactions, and he does not admit they correspond to real problems. Thus he immediately eliminates the question of sensibility to suffering by denying that it has any pertinence to animals: 'These principles of protection are human principles and have no meaning beyond human beings themselves.' Once accepted that the arguments invoked by the work's opponents are meaningless, he has only to suppose hidden concerns, either political – 'Here people have invoked reasons of hygiene or animal protection, but in the end, in a more or less hidden way, these reasons must be linked to political problems, a politics of power abuse' – or cultural – 'And anyway, I think the real problem is elsewhere, it has to do with artistic creation itself.'

Although this installation quite precisely stages the insurmountable contradiction that haunts the ecological sensibility, between the respect for species and the respect for ecosystems,[4] it does not appear that the artist knowingly or consciously sought such a result. In any case, he takes advantage of the

2. This ternary functioning has been demonstrated in Nathalie Heinich, 'La partie de main-chaude de l'art contemporain,' *Art et contemporanéité* (Brussels: La Lettre volée, 1992) and fully developed in *Le Triple jeu de l'art contemporain. Sociology des arts plastiques* (Paris: Minuit, 1998).

3. Juliette Boussand, encounter with Huang Yong Ping, *Art Présence*, no. 3, 1995.

4. This reflection is inspired by the work of the research group on ecology led by Laurent Thévenot of the Groupe de sociologie politique et morale (École des hautes études en sciences sociales).

affair to which it gave rise by insisting, in the characteristic way, on the critical virtues of contemporary art, so as to turn the conflict into a positive experience: 'This work can be preventative; it's like an anti-viral injection, for example, done to reinforce the nervous system, in that sense it seems positive to me!' And further on: 'Art must disturb if possible, knowing that in any case, everything leaves its mark, with more or less powerful effects.'

Hypotheses

Thus the battle unfolded over less than six weeks, and ended with the victory of the work's opponents: a victory obtained not by the persuasion of the adverse party, despite the numerous letters in protest; nor by the pressure of a broader public opinion, which was hardly solicited because the affair practically did not cross the threshold of the media; nor by juridical channels, since the urgent proceedings resulted in a referral to another court; but by the administrative channels of prefectoral regulations, which stopped the extension of the affair on the levels of both the judiciary and the media.

What would have happened if the prefecture had granted the requested authorization? The administration of the Center would probably have adopted a compromise solution, consisting in the presentation of the work only on the day of the opening, or a merely 'symbolic' presentation by means of texts and photographs, as in the solution proposed by the lawyer: thus the legal risks would have been considerably diminished or even eliminated, yet without totally annulling the artist's proposal. The full maintenance of this proposal would, on the other hand, have been quite unlikely, once it had been established that the Pompidou Center was placing itself in direct infraction of the law. Another possibility would have been to give in completely to the demands of the adversaries by erasing every trace of the project from the exhibition, that is, by withdrawing the cage and not exhibiting the exchange of letters. The chosen solution represented a compromise, a way of demonstrating that although the museum officials had to yield before the regulations and legislation, they were nonetheless opposed to this prohibition, convinced as they were of the illegitimacy of recourse to the law.

It is manifest in any case that neither of the parties succeeded in convincing the other: only a regulatory body was able to halt the dispute, which could eas-

ily spring up again at the next occasion. To understand this irreducible opposition, we must now look no longer at the form but at the contents of the mobilization, examining the arguments of the work's opponents and those of its defenders, as well as the position of the law.

This analysis of a dispute over values nonetheless runs up against an objective limit, which stems from the very method of the investigation.[5] Given the persuasive – much more than expressive – frame of enunciation, the comments produced do not necessarily express the sentiments actually felt by the individuals (the disgust of the opponents or the irony of the defenders), but instead constitute a retranslation judged acceptable for the construction of an argumentation at a high level of generality, susceptible of convincing people not already won over to the cause of animals, or inversely, to the freedom of artistic expression. The analysis of the arguments must therefore be envisaged within these limits, as partaking more of a strategy of interaction than of a need to express emotions.

Opposition to the work and defense of sensibility

The work of persuasion by the adverse party can only take essentially rhetorical paths, as in the – obviously insincere – hypothesis that the project in question is not serious, that it is on the order of a hoax: 'We hope this information is only a hoax and we would be thankful for your confirmation of that,' wrote the representative of an animal protection association to the president of the Center, thus manifesting that the project is so unacceptable that the only way to account for it is the hypothesis of a joke, or, in Erving Goffman's terms, of a transformation of the frame by 'fabrication,' as in all set-ups involving a dupe.[6]

Of an equally rhetorical order is the insistence on the number ('several hundred') and the use of quotation marks for 'work,' as well as the use of the

5. The corpus of our investigation is constituted solely of spontaneous reactions expressed by non-specialists in the face of works of contemporary art: thus it excludes interviews, which have the disadvantage of solliciting opinions outside the context, with no way of measuring the degree of implication and concern. Despite these precautions, the comments or gestures studied do not constitute a direct expression of what is felt by the individuals (this would have to be investigated by other methods, allowing for the measurement of emotions), but only the expression of what they judge pertinent to do or say in a situation of interaction. In other words, the discourses in question are situated at the pole of persuasion rather than that of expression.

6. Cf. Erving Goffman, *Frame Analysis: An Essay on the Organization of Experience* (New York: Harper & Row, 1974).

generic term 'animal' – rather than 'insect' – and the phrase 'devour each other,' explicitly evoking cruelty: thus in a letter to the Center's personnel, another association evokes 'the "work" of the Chinese artist who plans to lock up in a glass cage several hundred living animals destined to devour each other.' Less rhetorical, but of great generality, is the argument appealing to authority, either by reference to great men ('Mr. Pompidou would not agree,' wrote a private citizen), or by reference to the law: 'The indignation and disappointment of the defenders of animals and of nature would manifest itself daily if the law of July 10, 1976, on the protection of nature were to be flouted' (letter from an association to the Center's personnel).

More specific is the 'absolutist' argument: i.e. the refusal, in the name of the absolute character of the unacceptability of suffering, to relativize the values being upheld (in this case the defense of sensitive people). To oppose any attenuation of the case by relativization, consisting for example in the idea that 'they are only insects,' it suffices to shift the threshold of sensibility by referring the plight of animals back to a human situation, as in the ironic suggestion of the petition by the Beaubourg personnel on September 27: 'One could present, under the same conditions, a choice among representatives of the human groups (yellows, blacks, whites, and mixed bloods), an installation which would bring the experience to a much more naked truth.' By calling on people to put themselves in the place of animals, the displacement toward humanity allows the accent to be laid on the cruel dimension of what, initially, might appear as no more than an edifying spectacle. Such an absolutization of the moral value of the refusal to inflict suffering on a living being is in fact in accord with the law, as the Beaubourg lawyer makes explicit in her October 24 consultation when she underlines the impossibility of establishing a hierarchy within the animal world: 'It must be noted that the law makes no distinction, no classification among animals. We do not see by virtue of what principle of selection or classification insects could be excluded from the category of animals, particularly given that bees (domestic insects) and even their swarms are protected in the matter of theft of bees.' Thus it suffices to imagine a displacement of the case toward more familiar animals in order to measure the risk taken with respect to an accusation of cruelty: 'Indeed, if one imagined the same project with other, more familiar animals such as dogs, cats, and others, the question would arise with even more acuity, but would the principles at stake not be the same?'

This displacement of the argument toward species nearer to man, indeed towards man himself, opens the way to a humanization of the case, or more precisely, reveals that its stakes are at least as much human as animal, as much in the minds of the opponents as in those of the defenders of the work, who stress its benefits for humanity. All of that can only manifest itself in an essentially rhetorical form, as when the head of an association write to Mrs. Claude Pompidou that she is 'sensitive to your commitment against human distress.' But more profoundly, the development of certain arguments shows that the very notion of humanity is brought into question here by the opponents of the work. On the one hand, they insist on its barbarity, on the regression of civilization it represents: 'This barbarous and retrograde spectacle' (letter from an association to the personnel of Beaubourg); 'The bloody spectacle of animals ripping each other to pieces, Chinese-style' (letter from a private citizen); 'Let's leave this kind of event to the barbarian countries that organize cock, dog, and bull fights' (idem). Or they highlight everything in the work that could partake of a human regression to animal instincts, such that it is less the quality of the civilization that is at stake than the very definition of the limits of humanity, and the preservation of the latter at its highest level: this work would thus do nothing more than 'flatter the vile instincts and base sentiments which exist in a latent state in certain persons' (letter from a private citizen), 'excite the worst gregarious instincts of a crowd' (idem), express 'vulgarity' (idem), like all 'those spectacles [which] excite the lower strata of the human psyche, by addressing themselves to our reptile brain.'

When they do not take up the juridical register of reference to the law, these different arguments thus partake essentially of the ethical register, defending values of good against evil (when the accent is placed on morals), or of just versus unjust (when the accent is placed on justice). But for this register to appear pertinent, the precondition is that the individuals touched by the work in question should be suffering individuals, for whom moral values, the notions of evil and injustice, have a meaning. In other words, it is only a question of 'sensibility' that can draw the line between the two camps: the sensibility of the just to the wounded sensibility of others, their capacity for empathy or compassion towards suffering beings – something which, for the partisans of the work, has every chance of being disqualified as 'over-sensibility.'

Let us remark that the dividing line defined by the threshold of sensibility does not pass between the partisans of 'good' or of 'morals' on one side, and the partisans of 'evil' or of 'immorality' on the other. It passes, among partisans of good, between two definitions of the latter: those who extend this moral law beyond the boundaries of the human, and those who do not – the first having their hearts set on convincing the others. On the other hand, a dialogue seems unimaginable between those partisans of good who are opposed to the work and the supposed partisan of evil who is its author. That is why it is never the artist himself, the one responsible for this 'act of cruelty,' who is directly interpellated by the animal protectionists, but only the directors of the Center, whose participation in this act can be assumed not to stem from the cruelty that makes torturers into the adepts of evil, but rather from a lack of sensibility which makes them involuntary or passive partners in torture. An administration of the state is *a priori* credited with a mission of general interest, making it a possible interlocutor in a dialogue seeking to establish the boundaries of good and evil. This is not the case of an isolated individual, who is also an artist and therefore eccentric – in addition to being Chinese…

'Trusting in your sensibility': what the opponents seek is this extension of an eminently variable quality, sensibility; they do not accuse the administrators of being absolutely indifferent to moral law, but rather of according it an insufficiently extensive field of pertinence, for lack of compassion for the suffering beings which are the animals. Faced with this ethical demand considered as primordial, all other preoccupations appear secondary, particularly the aesthetic question, which rarely intervenes in the opponents' arguments; only one or two protest in their letters that 'there are so many beautiful things to exhibit – there are enough horrors in the world' – thus betraying a conception which, for the aesthetes most acculturated to contemporary art, appears to share in a sub-aesthetic perception of the artwork which reduces its quality to the beauty of its referent.

An aesthetic opposition

The artistic argument does appear, however, in a letter from a visitor addressed to the administration of the Center; but it is dated November 18 – i.e. after the closure of the affair and the opening of the exhibition – and therefore

reacts not to the artist's project but instead responds to the communiqué of the administration presented in the exhibition. It is worthwhile to examine it in detail, because it shows what a strictly aesthetic – and no longer moral – disagreement with the work in question can be.

Entitled 'Plea for the Lice,' this letter opens with a logical argument aimed at one of the communiqué's phrases: 'Art has nothing to do with tender sentiments.' The author now proposes to apply it not to those values which carry such little weight in the eyes of the organizers and the artists, i.e. the insects, but to those values so highly prized by them, i.e. artworks: 'According to that logic, I, a simple individual independent of any organized movement, propose the following happening: a room, some elephants, and on the ground, works by Picasso, Miró, and others: theme "Nature and Culture." A few battered paintings wouldn't bother you more than a few destroyed insects, since it's in the name of Art. One's "tender feelings" often depend on the value accorded to the object of our attention: life or artifact?'

The author thus carries out the same displacement of the threshold of sensibility as the animal protectionists, but towards artworks and no longer towards human beings,[7] thus highlighting – with arguments more telling for those he is addressing – the relativity of the 'selective choice of what does or does not disturb.' Thus he places the organizers before their responsibility in the establishment of the limits that the artistic institution permits or does not permit artists to cross, making a distinction between the voluntary suffering entailed in body art, and the involuntary suffering of insects transformed into actors despite themselves: '*Hors Limites*: everything is allowed, even threatening one's life. And that of others? Are the only *limits* involved not those traced by the will of the participants and their comprehension of the stakes? Here the lice are not conscious of their role.'

But beyond these questions of logic (the threshold of 'tender feelings') and of professional ethics (the role of the institution in fixing moral boundaries), the author of the letter wonders about the strictly artistic quality of the work proposed: 'A question subsists before this kind of montage: is there really an artistic process, or is it just a pretext for giving free rein to the puerile and altruistic sadism of the author? For these beings are going to

7. Let us note that such an operation is entirely coherent with the nature of artworks, which are normally the objects of a treatment that assimilates them to persons; cf. Nathalie Heinich, 'Les objets-personnes: fétiches, reliques et œuvres d'art,' *Sociologie de l'art*, no. 6, 1993.

interact as they would in nature, but ten times more because of their forced promiscuity: where is the intervention of Art here? Is voyeurism enough to unleash the cultural alibi, to stick the label of 'avant-garde' onto the concentration of lives a little different from our own?'

The artistic value of the work is therefore contested because of the low degree of the artist's intervention, reduced to the concept, as well as the exclusively spectacular (voyeuristic) and transgressive (vanguardist) dimensions of the work. A more positive possibility is then proposed by the letter writer, who would demand a much greater involvement and risk from the author: 'Of course, if Mr. Ping had closed himself up in the cage with several of these beasties, the gesture would have taken on much greater meaning. But only J. Beuys dared that in the face of the coyote, a mythic confrontation between Man and Beast concluding in the truce and even in love between the two strangers. So Mr. Ping should leave the cockroaches in peace, he hasn't risen to the occasion with this trivial take-off on his great predecessor.' Thus it is no longer in the name of tradition that Ping's work is contested, but in the name of the artistic vanguard, incarnated by Beuys – who had just received a major exhibition on the fifth floor of the Pompidou Center.

And the final argument brings together these two heterogeneous values of artistic authenticity and 'equity' with respect to all beings, even the smallest: 'It is courageous and worthy of a great museum to have organized an exhibition on a theme as extreme as that of *Hors Limites*. It would have been even more so if the counterfeits were excluded. I hope that you will accept my argumentation, dictated by a concern for equity towards those on the bottom of the ladder, human or animal, yet nonetheless I don't believe you will approve it.'

Let us now see what the work's defenders use to counter these different accusations, aesthetic and above all ethical.

Defense of the work and displacement
of the threshold of reality

One might expect the partisans of the work to argue in the register which is professionally theirs (that of museum curators) and which is contextually that of the work (an exhibition of contemporary art in a major Paris museum). Yet the arguments of a strictly artistic order are far from the majority –

that is the least one can say – whether in the internal notes of the curator, the administration's communiqués to the public, or the lawyer's conclusion before the tribunal. One finds them under only two forms. The first is the appeal to the freedom of creation and artistic autonomy: 'The Georges Pompidou Center... regrets that in the debate which has arisen, passion has run higher for the defense of certain animal species than for the freedom of creation. Art is not an affair of tender sentiments' (communiqué of November 8). The second argument of an artistic order is the reference to tradition, invoked by the Beaubourg lawyer in her conclusions presented before the Court of Paris on November 7: 'Considering that it is indicated for your information that the work by Huang Yong Ping takes its place in a Western tradition of art in the course of which animals are presented, thus: the artist Richard Serra presented living animals in structures in Milan in 1966, the artist Jannis Kounellis presented horses in an art gallery in Rome, Wolf Vostell presented geese in 1978 in the Musée d'Art Moderne de Paris, Klaus Rinke presented carp in tables transformed into aquariums, Nam June Paik presented fish as part of a video installation.' Yet one may remark that this appeal to a tradition in order to justify a manifestly vanguardist work represents a compromise, tending to reduce its aesthetic value to a value of tradition relatively foreign to contemporary creation; and this compromise is all the more manifest in that the 'tradition' in question comes down to a very small number of proposals – exhibiting animals as works of art – which are decidedly more innovative than traditionalist. Thus the manoeuvering room for an artistic defense of the work in this context appears relatively slim.

One may additionally remark that no defender of the work advances the strictly aesthetic argument which would consist in the affirmation that it is beautiful, or that it constitutes an important moment in the history of contemporary art. The weakness – both quantitative and qualitative – of the arguments belonging to the register of aesthetics confirms a conclusion that I had already drawn from a comparable analysis of the debates surrounding the bullfight:[8] namely, that the aesthetic argument has less force than the ethical argument, since the aficionados, the partisans of the bull-

8. Cf. Nathalie Heinich, 'L'esthétique contre l'éthique, ou l'impossible arbitrage: de la tauromachie considérée comme un combat de registres,' *Espaces et sociétés*, no. 69, 'Esthétique et territoire' (Paris: L'Harmattan, 1992).

fight, tend to answer their adversaries by contesting their ethical arguments rather than by appealing to the beauty of the spectacle. Here too, Ping's defenders hardly risk answering their adversaries with an aesthetic argument which would be dangerously likely to be turned against them, being interpreted as proof of insensibility, inhumanity, or cynicism.

Indeed, the law confirms this difference in the respective force of the two argumentative registers, holding that the artistic character of the work gives way before the accusation of mistreatment of animals. This is underlined by the Beaubourg lawyer in her October 24 consultation: '… although the discussion can have a certain interest, there is no need to inquire into the quality of the original work in Ping's approach, nor into questions of artistic freedom. This problem of intellectual and artistic creation must be put into the background in the face of the principle problem posed by the NSDA: namely is the use, through human intervention, of living insects as envisaged in Ping's project of such a nature as to break the protective dispositions that the legislature has established in favor of animals?'

The work's defenders thus tend to fall back on the register of its opponents, because they cannot allow themselves (except, no doubt, in private) to claim insensibility towards the suffering of cockroaches. The primary argument of an ethical order will then consist in asserting that the work is not cruel, that the animals are treated well and, in particular, are well nourished. But for that they will need to put forth a distinction between two categories of animals, predators and prey, in other words, 'animals' and 'food': 'They are fed with other insects, which are cockroaches and beetles' (note from Jean de Loisy to François Barré, October 11). This argument was to be taken up at great length by the lawyer in her conclusions: 'During the presentation of the work, these animals are nourished with the insects on which they habitually feed, i.e. cockroaches, beetles, crickets, and grasshoppers… As far as the treatment of these animals is concerned, it has been indicated above that they will be regularly given water and that those which habitually eat living insects will, so as not to let them die, be fed normally with their habitual food, consisting of cockroaches, beetles, crickets, and grasshoppers, the latter of which habitually feed on the excrement of the former… If certain animals, i.e. the cockroaches, beetles, crickets, and grasshoppers will effectively die, it is because they constitute the food of the other animals, which naturally cannot be left without food, lest they should die themselves.'

The second argument seeking to demonstrate the morality of the act consists in pleading that 'everybody does the same,' in other words, that the extermination of insects is quite ordinary. Thus the director of the Center, Germain Viatte, offers an ironic comment on the polemic: 'The protesters certainly have bug spray in their kitchen. Soon people in France will no longer be able to put a worm on a hook. It's terrible. The object of the exhibition *Hors Limites* is precisely the transgression of taboos' (*Le Figaro*, November 9). Similarly, the lawyer indicates in her conclusions that 'everyone owning a lizard or a snake buys precisely this kind of insect in the marketplace to feed their favorite animal.'

Yet one must note that the law contradicts this reduction to the ordinary which is apt to trivialize the situation. Because the argument of the bug spray used by everyone to kill cockroaches in their kitchens would probably be countered by jurisprudence with observations on the specific nature of the frame, which is precisely not that of an ordinary situation, a 'primary frame' in Goffman's terminology: we are no longer dealing here with an act of self-defense having a practical end, nor indeed with an act of experimentation having a scientific end, but with an act of provocation and of contemplation of suffering having a playful, aesthetic, or aesthesic end, and thus identifiable with cruelty – cruelty whose gratuitous and public character aggravates the case rather than diminishing it. Indeed, that is exactly what the Beaubourg lawyer underlined in her consultation of October 24: 'If one examines the relative jurisprudence, one finds the following elements: close to barbarity and sadism, the act of cruelty is set apart from simple brutality in that it is inspired by a reflective meanness which betrays the intention to inflict suffering, denoting a perverse will or an instinct of needless perversity... Insofar as Ping's project is concerned, the animals will, it seems, be in the situation of animals in captivity; the fact of staging them in an artificial relation which can provoke combat between them, the provision of other live animals to nourish them, there again in an artificial staging with the aim of arousing the curiosity, interest, delectation, and an intellectual or indeed artistic reaction from the public, seems, I fear, against the law.'

The third argument used to counter the accusation of cruelty no longer belongs to the ethical register, but to the hermeneutic register, insofar as it depends on the highlighting of the work's symbolic character, its hidden meaning. Thus its very nature is displaced: the work is not on the order of the real, but of the symbolic. Before examining this shift to the symbolic, let

us remark the contradictory character of these three successive arguments – perfectly in line with Freud's 'kettle logic' – in their attempt to counter the opponent on his own terrain: first, we are not cruel; second, we are not the only ones who are cruel; third, this cruelty is legitimate because it is a symbol in the service of humanity.

Let us see how this last category of arguments is organized. First of all, the work is presented as a symbol, signifying the exact opposite of what can be seen since the aggressivity of the exhibited animals is charged with illustrating the need for understanding between earthly beings: 'The object of the work by Huang Yong Ping entitled *Le Théâtre du Monde* is to symbolize in a philosophical way the necessity of harmony between races, cultures, and religions, in spite of the violence, character differences, and cruelty inherent in earthly natures' (note from Jean de Loisy to François Barré). This pacifying dimension is also represented by the form of the container, that is, the glass cage in the form of a tortoise: 'Given that the tortoise is the Chinese symbol for peace, and that the artist thus seeks to create a militant work in favor of harmony between the races and the cultures…' (conclusions of the lawyer). Thus the work becomes, paradoxically, an act of pacifist militantism: 'The whole is arranged on a table in the form of a tortoise. The tortoise is the Chinese symbol of peace. So this is a work that militates in favor of harmony between the races and cultures' (note by Jean de Loisy). 'Inside [the tortoise-shaped cage], scorpions, spiders, millipedes, a snake, and a few other animals associated in our prejudices with danger and provoking revulsion, succeed in tolerating each other. Their understanding, sometimes difficult (but real) represents the efforts that societies must make to struggle against racism, intolerance, and exclusion, and shows that whatever our natures, our violence, our diverse cultures, this accord is possible' (communiqué of November 8). One may note in passing that this last assertion, pronounced after six weeks of virulent conflict, constitutes a remarkable denial of the situation…

And if the terrarium is not perceived as a symbol of peace, at least it will represent a real example of social organization, since for the animals it will constitute an *in vivo* learning experience of tolerance and social life: 'The insects presented in the terrarium organized by the Chinese artist Huang Yong Ping learn over the duration of the exhibition to tolerate each other and to organize a social life despite their contradictory natures: scorpions, millipedes, and centipedes learn to accept each other' (note by Jean de Loisy).

'Given that this work includes two snakes, six lizards, six spiders, six scorpions, ten millipedes. Given that these animals, placed in a terrarium, organized by the artist, offer a vision, over the duration of the exhibition, of their tolerance, of the organization of their social life, of their possible antagonism…' (conclusions of the lawyer).

Thus the work's defenders lay the accent on the disproportionate character of the stakes (the life of a few insects that one wouldn't hesitate to squash in the kitchen) in regard to the importance of the symbolic message they convey, which represents – far from any cruelty – a militant act in support of peace.

A symbolic defense

This would also form the basis of the argument used by an academic working on a project at the Pompidou Center, in a letter written to Germain Viatte on October 19 – the day after the internal meeting – to support the defense of the work and to counter its detractors. Spinning out a comparison between the latter and propagandists for the Islamic veil, he parallels 'two fundamentalisms,' one Muslim, the other ecologist, and stigmatizes in both cases 'a tendency to sterilize everything, to make it *politically correct.*' He then insists on the disproportion of the issues at stake, wondering 'what people abroad might think if they knew we were diddling around over 'the protection and the respect of the right to life for thirty cockroaches,' when we may well be on the point of giving into the pressure from the Islamic fundamentalists, with the consequences that could have for thousands of students, artists, and intellectuals in North Africa. They would laugh and think we are awfully lucky to still be able to allow ourselves this kind of coquetry in our sterilized secular bubble, protected from the ills of the rest of the planet.'

Thus the argument is brought to a very high degree of generality – the rise of Islamism, the ills of the planet – so as to discredit the pettiness of the affair in question.[9] The academic sees it as the effect of 'a sort of religion of the living and of nature – a religion in which, obviously, the questions of destiny,

9. On the strategies of the discursive manipulation of magnitudes, cf. Luc Boltanski, 'La Dénonciation,' in *L'Amour et la justice comme compétences* (Paris: Métailié, 1990).

10. This point has been developed in Nathalie Heinich, *The Glory of Van Gogh. An Anthropology of Admiration* (Princeton, NY: Princeton University Press, 1996).

of death, and of the symbolic would have no place, no more, indeed, than the questions of the relation between nature and artifice.' In this topos of the religious we rediscover a procedure of disqualification often used in modern intellectual circles, where the reduction to the religious or the sacred is a fundamental weapon of critique.[10] He closes by expressing his astonishment at a loss of the sense of the symbolic: 'It is stupefying to see in this case how swift these people are to denounce, as soon as it occurs in the symbolic order, that which they can accept so easily in everyday reality.'

What we see occurring here, in a quite remarkable way, is an operation analogous to the extension of the threshold of sensibility called for by the work's opponents: namely, an extension of the threshold of the symbolic. In effect, what is denounced by the opponents as real violence is justified by the defenders as a symbolic violence which can be reversed to become a symbol of peace; and the denunciation of the work is itself denounced by the defenders, who see it as the denouncers' incapacity to enlarge the field of the symbolic, exactly as this denunciation, in the eyes of the detractors, denounced the incapacity of the admirers to enlarge the field of sensibility.

We have then, on both sides of the work, two clashing principles of valorization: an ethical principle of sensibility to others' suffering, allowing one to denounce the evil and injustice done to living beings; and a hermeneutic principle of the symbolization of experience, allowing one to justify certain actions in the name of their meaning. But it is remarkable that the aesthetic register – to which an artwork should belong – has such little presence in both argumentations: as though, in the face of ethics and hermeneutics, in the face of respect for others and in the face of the intelligence of the messages concerned, the question of the aesthetic quality or artistic nature of the work became secondary.

This axiological duplication between aesthetics and hermeneutics is in fact an essential element in contemporary art, which works less on beauty than on the deconstruction of values, especially and above all aesthetic values. But this slippage of artistic value into the hermeneutic register, without which one can hardly understand the stakes of contemporary art, varies according to the nature of the referent invoked: it can either be the history of art, in which case we are dealing with the autonomous dimension of symbolization, proper to its domain of expression; or – as here – it can be the lived world, in which case we are dealing with its heteronymous dimension, exterior to art strictly speaking.

Aesthetics, symbolics, and sensibility

This affair illustrates remarkably well a certain number of principles inherent in the construction of a consensus on values. First of all, one observes the mobilizing force of ethical values when they are drawn from well-established causes with previously constituted jurisdiction and already founded associations, as in the case of the protection of animals. In the face of such causes, it is almost impossible to translate aesthetic values onto the symbolic plane: just as in the case of the bullfight, where the admiration of the spectacle's beauty gives way, when the aficionados are confronted with their detractors, to an insistence on the symbolic value in terms of civilization and humanity. Once posed, the question of the artistic or aesthetic character of the work could have been developed by the opponents as well as the defenders. But it is as though this question lost all pertinence – for the latter as well – before the accusation of inhumanity.

Thus one confirms that although the opponents and defenders clash over the qualification of the acts and the registers of values which they deem pertinent to the discussion – ethical or hermeneutic, sensibility or symbolics – they all refer to the same good, which can be summed up as civilization, humanity, or, in the terms of Luc Boltanski and Laurent Thévenot, 'common humanity.'[11] Despite the heterogeneity of the values invoked, this is what allows for the very possibility of discussion, even if there is very little chance of reaching agreement.

One equally confirms the variability of expectations in artistic matters. For the people least acculturated to contemporary art and least receptive to a strictly aesthetic perception (i.e. a perception centered on the formal qualities of the work rather than on the value of the referent), these expectations are limited to a talented formal expression of a beautiful referent, whereas among the initiated they may include forms which totally escape the habitual frames of artistic expression: for example, a terrarium, inscribed in a frame (the museum) which constructs its artistic nature, and outfitted with a title and a discursive complement which attest to its symbolic intention.

Just as variable as the threshold of artistic acceptability is the 'threshold of repugnance,' in the notion developed by Norbert Elias,[12] which in certain eyes renders the spectacle of the death of insects quite anodyne and the fact

11. Cf. Luc Boltanski, Laurent Thévenot, *De la justification: Les économies de la grandeur* (Paris: Gallimard, 1991).

of deploring it ridiculous, while for others it is unbearable and its organization and representation are revolting. The latter, moved either by empathy with the suffering being, or – as more likely here, given the great ontological distance between an insect and a human – by indignation with regard to their torturers, will spontaneously occupy the ethical register in their perception and their judgment.

Equally variable is the threshold of perception between the real and the symbolic, between action and signification: what is real for some people (the suffering of animals) is symbolic for others, who deplore 'the loss of the sense of the symbolic.' The threshold of perception therefore touches the nature of the beings in question as well: if, for the opponents, the terrarium is filled with animals of different species, for the defenders it is filled with animals, on one hand (the snakes, scorpions, etc.), and food for these animals, on the other (the cockroaches), in other words, with living beings and with things – things living for the needs of the cause, but destined to die. This variability in the definition of the experience, between reality and symbol, is revealed with particular clarity in the comment of the museum director as reported by *Le Figaro* (November 9): 'The object of the exhibition *Hors Limites* is precisely the transgression of taboos.' Whether authentic or invented by the journalist,[13] such a proposition plays on the ambiguity between active or effective transgression and representational or symbolic transgression (an ambiguity which one could indeed suggest is precisely the aim of the exhibition); such that the opponents of the work react to what they perceive as the effective transgression of a taboo – i.e. the organization for entertainment purposes of a mortal risk to living beings – whereas the defenders see it at one remove, as something staged, a discourse on the notion of transgression.

Beyond a disagreement over values, what we have is a situation of total incomprehension between the detractors and the defenders, because not the same reality is seen, and not the same values are solicited. Between aesthetics, symbolics, and sensibility, what we see is less a conflict of values (in which case one would fight to know if the work is moral or immoral, beautiful or ugly, significant or insignificant) than a conflict of registers of value, which

12. Cf. Norbert Elias, *La Civilisation des mœurs* (1969) (Paris: Calmann-Lévy, 1973).

13. Germain Viatte, the director the MNAM [National Museum of Modern Art, Pompidou Center] asserts that he simply said the artists did not fear the transgression of taboos – the journalist having written 'what he desired to hear.'

shifts the disagreement to a prior level, to the question of knowing whether the disputed object has to do with morals, art, or the symbolic.

Finally, it is the heterogeneity of these value-universes that bursts into view in this affair. Thus, just as the opponents were prepared to see the project as a hoax, similarly, the organizers at Beaubourg had not even envisaged the juridical risks and the administrative constraints they might run into. And if the defenders had not even imagined that they could be in the wrong with respect to the law, the opponents cannot even conceive that this might be an artwork: it is 'a terrarium in a documentary exhibition on the animal food chain' responded, hesitantly, a protester questioned at the door of the Center on opening day.

One can understand, then, that the arguments of the two parties have so little chance of corresponding, and that although the affair could be momentarily closed by the force of the regulations, it is hardly concluded, for lack of any possibility for one camp to persuade the other; for lack, in other words, of an acceptance by one of the two of the possible illegitimacy of its position, and of the possible legitimacy of the adverse position. For the artistic argument excludes any constraint, which would immediately be denounced as censorship; yet it can be combined with the symbolic argument which, like it, allows for a distancing effect, displacing and neutralizing the affective charge contained in the eventuality of suffering and death – which immediately appeal to the argument of sensibility, rendering inadmissible and derisory the two preceding arguments.

A second look at the register of values

This little affair of the *Théâtre du monde* is, from the viewpoint of the debates to which it gave rise, quite analogous to the clashes over the bullfight, since in both cases it is a matter of accepting or rejecting the spectacle of animal suffering. In this artistic transgression of an ethical imperative – only one among many others[14] – we rediscover the same characteristics that have been noted concerning the bullfight: first, the fact that it is specifically a

14. 'If in 1827 Thomas de Quincy was able to offer the ironic title *On Murder Considered as One of the Fine Arts* (exposing, in a negative image, the impossibility of reconciling moral law and aesthetic value), it is on the contrary quite seriously that today's artist multiply the transgressions of an ethical order in their work.' Heinich, 'L'esthétique contre l'éthique, ou l'impossible arbitrage.'

matter of a conflict of registers of value, which, by opposition to the conflicts of taste, are susceptible to degenerate into affairs, rendering any reconciliation impossible; then, the similarity, despite this opposition, of the good which is defended in both cases, i.e. humanity or civilization; and finally, the dissymmetry in the strength of the two registers, to the extent that aesthetic argumentation tends to disappear behind ethical argumentation – making relativization difficult.

What was lacking, however, in my 1989 article on the bullfight was the consideration of a third register, whose importance we have observed in the affair of the *Théâtre du monde*, and which a rereading of the clashes around the bullfight would no doubt reveal in similar proportions: the register which I have termed 'hermeneutic,' because it rests on the imputation of a signification and calls for a process of interpretation permitting access to the supposed meaning of the object in question. It is as though when the suffering of a living being is at stake, the aesthetic register is too weak to bear a reasoned defense of the disputed gesture and so must shift toward the hermeneutic register, such that the value of beauty or of artistic creation tends to give way to a value of signification, of symbolization, of a hidden message or meaning – which can then be opposed, without too much risk of being discredited for cynicism or insensibility, to the ethical accusation resting on the refusal of evil or injustice. Thus the partisans of the bullfight insist on the symbolic value of this clash between man and beast; thus Ping's defenders similarly attempt to highlight the allegorical dimension of the installation, whose symbolic message would radically reverse the literality of the object, the war between animals becoming a figurative representation of peace, and bestial ferocity an appeal to human tolerance.

It thus appears necessary to 'explode,' if one may say, the ensemble we had somewhat rapidly assembled under the term of 'aesthetics,' distinguishing clearly that which pertains to beauty, to art, or to the sublime – all of which signal the recourse to the aesthetic register strictly speaking – and that which pertains to the symbolic, the allegorical, the 'belief' in a 'transcendent' signification attached to the materiality of the object.[15] Aesthetics and symbolics have in common the fact of legitimating a distance with respect

15. 'Belief' and 'transcendence' are employed in their primary sense: the one adopted by Georges Didi-Huberman when he opposes the former to 'tautology' (cf. *Ce que nous voyons, ce qui nous regarde* [Paris: Minuit, 1992]), or by Gérard Genette when he opposes the latter to 'immanence' (cf. *L'œuvre de l'art, 1: Immanence et transcendance* [Paris: Le Seuil, 1994]).

to the affects, allowing one to 'detach oneself' from 'involvement' in the sensibility to suffering, which would immediately call for a condemnation of an ethical order.[16]

The reformulation of the problem also touches on the treatment of the question by Luc Boltanski in his book on the spectacle of suffering. Taking up the hypothesis of an 'aesthetic' posture as I advanced it with respect to the bullfight, he tends to restrict it to the value of the 'sublime,' no doubt for lack of a way to identify any qualification of the suffering of others in terms of 'beauty' which would not immediately be discredited as cynical or perverse.[17] Only the hypothesis of another – hermeneutic – posture which would not be reducible to aesthetics allows for the resolution of the aporia engendered by this restriction, which does not do justice to the experience. With respect to this 'aesthetic topos,' Boltanski distinguishes two other possible 'topoi': denunciation and sentiment; yet they seem to differ only in the direction given to the emotion – the affect being turned in the first case toward the torturer, and in the second, toward the victim as object of compassion. Both have in common the fact of expressing themselves in terms of good and evil, or of just and unjust: which makes them two variable modalities of the same register of values – the register I have proposed to name 'ethical,' since it is expressed in essentially moral terms.

Let us note that these three 'registers'[18] adopted by the actors in order to react to the spectacle of others' suffering – aesthetic, hermeneutic, or ethical, the latter presenting itself as 'denunciation' or 'sentiment' according to the orientation of the affect – only take on meaning through their common neutralization of a fourth register: the aesthesic register, expressed in terms of 'good'/'bad,' or alternatively, 'exciting'/'unexciting.' In the face of others' suffering this register is immediately discreditable as a perverse taking of pleasure; but I believe that it is the one which negatively subtends all the others.

16. 'Detachment' and 'implication' refer to the analysis by Norbert Elias of these two postures, in *Engagement et distanciation: Contributions à la sociologie de la connaissance* (1983) (Paris: Fayard, 1993).

17. The aesthetic attitude 'consists in considering the suffering of the unfortunate neither as *unjust* (with a reaction of indignation) nor as *touching* (with a reaction of tenderness), but as *sublime*.' Luc Boltanski, *La souffrance à distance: Morale humanitaire, médias et politique* (Paris: Métailié, 1993), p. 168.

18. I prefer the term 'register' (or alternately, 'posture') to that of 'topos,' which is too rhetorical, or to that of 'attitude,' which is too strictly behavioral: 'register' has the advantage of being able to qualify modalities of action as well as discourse.

The aesthesic register, calling for consumption or pleasure-taking; the aesthetic register, calling for the passive form of contemplation which is delectation; the hermeneutic register, calling for the active form of contemplation which is interpretation; the ethical register, calling for either indignation or compassion: these are the four registers necessary for the comprehension of that which is at play in the disagreements over the way one should react to a spectacle of animal suffering. Let us stress, however, that these four registers are not the only ones possible: they fit into a more general repertory of registers of values, which cannot be described here.

These different registers, as we have seen, do not have the same force, at least not in a given context: in the face of ethical condemnation, the aesthetic tends to efface itself, shifting toward the hermeneutic. Yet the inequality of the respective forces does not here apply to a simple description of the argumentative strategies of the two camps; no doubt one would have to push the argument further to propose an explanation. In any case, the foregoing confirms the idea of a hierarchy in the degree of generality or universality of these registers, already identified in the case of the bullfight. Thus one must take care to avoid proceeding – under the cover of revealing the existence of a plurality of value-regimes, of 'topoi' or 'worlds' – to a flat-out categorization which would render them all equal, without taking any account of their respective force, or, in other words, of effects of domination. The necessary rupture with the 'sociology of domination' represented by Pierre Bourdieu, which implies a univocal relation to the world, and therefore a unilateral construction of the opposition between dominant and dominated, must not in its turn engender a denial of the differences in the force or legitimacy of value systems.

Neither absolute nor inexistent, the inequality between the registers of values, and therefore the possible domination of some over others, must be considered relative: relative to the nature of the disputed object, to the characteristics of the subjects who judge it, and to the properties of the context of enunciation. Here, where the context is concerned, we must take into account the character of the animal protection cause, already well-equipped through the existence of several associations and a body of legislation; where the subjects are concerned, the low acculturation of the protesters to the problematics of contemporary art, their distance from the world of museums and their strong affective investment in the defense of animals; where the object is concerned, the unusual character of the pro-

jected work, its distance from the formal frames of the traditional artwork, rendering all the more raw and brutal the spectacle of violence between animal species. All this allows one to understand why the ethical arguments of the work's opponents were able to win out over those of its defenders, not only in regard to the outcome of the affair – prohibition – but also in regard to the registers – essentially ethical and hermeneutic – on which the two parties clashed.

On the right use of neutrality

Let us close with a last remark, touching on the attitude of the researcher. In the case of the bullfight as in that of the *Théâtre du monde*, the researcher who immerses himself in his object very rapidly experiences a kind of paralysis of opinion, allowing him to alternate between the viewpoints of both parties: isn't this affair a lot of noise for a few insects, and aren't the animal protectionists as the limit of the ridiculous? But also, doesn't the dramatization proposed by the Chinese artist push the provocation a bit far, by playing on the fascination exerted by the spectacle of violence more than on a genuinely creative invention, and don't the commentators' interpretations slip a little too quickly away from the aesthetic question, to take shelter in a rather elementary symbolism?

But the question is no longer that of knowing which of these positions is the right one, nor whether the practice of sociology tends to transform the researcher into a pusillanimous figure, who by a kind of professional malady has become incapable of telling good from evil. The question is to understand that it is just this incapacity to form an opinion that is the precondition of the researcher's competence, and that far from deploring it one must rejoice in it and proudly claim it as one's own. For it is this mutability of opinion, this impossibility to adhere to one party or this absence of any desire to do so, that allows the researcher to shift from one to the other, to understand the logics of both, and, perhaps, to make them understood to both. And of course this has nothing to do with an arbitration, which would imply taking a position: neutrality is not objectivity, as for the arbiter, but a suspension of judgment – which is exactly the contrary of an arbitration.

In other terms, what is illustrated here is the imperative necessity of 'axiological neutrality,' as defended by Max Weber. Let us then take advantage of the

situation to respond to the arguments developed on this subject in an earlier issue of *Agone*, criticizing the researcher's imperative of neutrality toward values and suspension of judgment.[19] Basing themselves on the arguments of Leo Strauss, Thierry Discepolo and Jacques Vialle reproached the scholar who practices neutrality with 'hiding in the dignity of an exemplary private sphere': a groundless argument, since the researcher who intervenes *as such* clearly does not move in a private sphere (the sphere, precisely, of opinions) but in a professional sphere; such that the researcher is committed to axiological neutrality exclusively as a researcher, not as a person or as a citizen. But to accept this point of view one must admit the plurality of regimes governing the relation to experience, and not only the plurality of registers of value that I have just unfolded. And this is a problematic that would refer one no longer to a sociology of values but to a sociology of identity.

Another argument holds that such a position leads to 'producing knowledge without measuring its possible utilization': a groundless argument, since it is on the contrary neutrality which allows the researcher to produce the maximum of effects on the real, by carrying out the shifts that are prohibited by the ordinary assignation of positions. Neutrality is not a refusal to engage in what moves the actors, but on the contrary, an instrument that can weigh on reality in an infinitely more effective manner than through the expression of an opinion, since it allows one to be heard by everyone else and, correlatively, it allows one to make each party be heard (even if only a little) by the others. Thus it is the only effective weapon in the 'struggle to assert one's knowledge,' which in no way opposes but on the contrary demands the 'befitting maintenance' (and yet not so befitting as all that, if we are to believe the frequency of indignant refusals of this position of neutrality by sociologists as well as actors!) 'of a neutrality that finally counts as weakness.' Indeed, as long as the expression of an opinion is valorized as a virile imperative of self-assertion, the professionally controlled abstention from any value judgment can only appear as a weakness, an inability to make oneself heard. But doesn't the weakness lie in the need for that kind of 'strength,' and doesn't strength lie in a resistance to the imperative, so categorical that it is never questioned, of having an opinion?

19. Thierry Discepolo, Jacques Vialle, 'Le Savant, le politique et la modernité,' *Agone*, no. 11, 1993. [The present article was originally published in *Agone*, no. 13, 1995–Trans.]

Let us pass over the argument which declares the demand for neutrality absurd because of its non-existence: this is to confuse the judgment of reality, which makes neutrality into an effective reality (and thus belongs to a rather naive positivism) and the judgment of value – which is what the demand for neutrality is here, but on the epistemological level of the sociological method, and no longer on the axiological level of values which are current in the real world.[20] The professionally controlled abstention from any value judgment is obviously not a reality in itself, but an objective to be attained. Now, it is not because a value is not immediately and entirely realized that it should be declared obsolete. In other words, it is not a matter of 'believing' in a language of reality, but of constituting it, in a strict a manner as possible.

Another argument criticizes the position of neutrality because, as Leo Strauss declared, in that case it would be necessary 'to accept unhesitating as morality, art, religion, knowledge, or the state… anything that claims to be such.' But this is to confuse two postures: the normative posture of the actor involved in the values, who must pronounce upon their legitimacy; and the descriptive posture of the researcher involved in the explicitation of the value-systems used by the actors, who must not pronounce upon their legitimacy but on the way the latter is constructed. The same argument holds for the qualification, evoked by Leo Strauss, of concentration camps, which, he says, cannot justly be described without using the term 'cruelty.' But the role of the researcher is not to decide if the concentration camps are or are not cruel! The actors are adult enough for that, and what's more, they have excellent jurisdiction on the matter. The researcher's role is to understand the processes which activate certain acts, and the reactions they entail – among them, the imputation of cruelty.

This is why the researcher in the position of neutrality cannot be accused, as one hears too often, of 'relativism,' or, as Discepolo and Vialle put it, of encouraging 'the undiscerning circulation of works in the name of cultural relativism, and the proliferation of interpretations in the name of epistemological relativism' – relativism implying, by definition, a normative position of defense and of refusal of a given value. The researcher who brings to light the relativity of values with respect to their cultural inscription or the plu-

20. On this distinction, cf. the article by Emile Durkheim, 'Jugements de valeur et jugements de réalité,' (1911), *Sociologie et philosophie* (Paris: PUF, 1967).

rality of axiological regimes does nothing but state that which, with the progress of the social sciences, ought to have become a truism; but in no way does he take a stance, nor militate for a dissolution of all axiological choices in the name of relativism – unless one is to confuse, once again, epistemological description with axiological normalization, a confusion which unfortunately is still all too frequent, even among researchers… The sole value that the researcher should defend – and there, without any neutrality at all! – is the epistemological value of the tools, methods, hypotheses, and problematics of research: which is what I am doing here, without of course claiming that the valorization of neutrality should be extended to all levels of existence, and above all not to the civic and moral level of the exercise of citizenship and the defense of values. In other words, the sociologist should not replace the actors; or instead, he should abandon research for activism – where he will certainly be more useful politically!

But to accept this distinction between the position of the actor and that of the researcher, one must carry out a clear differentiation between the discursive postures, which the term 'intellectual' abusively combines: the posture of the thinker – who assumes the indispensable function of giving a rational and arguable foundation to behaviors and values – and that of the researcher – who assumes the equally necessary though radically different function of understanding and explaining (which does not mean justifying) the behaviors and values in use in a given society. And one can only remain a researcher on the condition of not taking sides for the values one is analyzing, so certainly is it true that one cannot be at once inside and outside, partisan and analyst, actor and observer. Now, this indispensable neutrality of the researcher is all the more necessary to the degree that the object is charged with emotions; whereby it has nothing to do with a vain quest for 'purity,' as is also sometimes said, since purity would consist first of all in refusing to get one's hands dirty by rummaging through regions of experience dominated by emotion: for example, by closely studying how people behave when they clash in battles as violent as they are seemingly derisory, like the one that set the defenders of animal rights against the defenders of artists' rights.

More generally, this expectation of an opinion which underlies the refusal of axiological neutrality appears above all as a demand for critique from the part of the researcher, who would only be legitimate to the extent that he had a critical function. This position was perhaps paradoxical, and even

useful, one or two generations ago, when the world was not yet, as now, a world saturated with critique, a world where the actors obviously have no need of sociologists to produce critique, and what's more, of an excellent quality. So what would be the use today of a sociologist whose sole ambition would be to stand in for the actors, trying to outdo their contestation of established values? What, on the contrary, the sociologist can can provide that the actors lack, is a capacity to restore links between opposed parties, to reestablish zones of communication, and to let the reasons of the different groups be heard, beyond their arguments.

Thus it is by learning to let go of opinion that the researcher – at least when he intervenes as such – will have some chance to bring something different to the knowledge of his object than the actors can bring themselves. But isn't that a more gratifying result than the short-sighted pleasure of having, for every occasion, one's opinion on everything?

Yves Michaud

The End of the Utopia of Art [1]

The time has come for diagnosis.

In today's situation of generalized pluralism, what is customarily referred to as the 'general public' occasionally still shows deference for the fine arts – which are actually no longer so 'fine' as all that. Usually though, the public asks for explanations, even justifications, when it doesn't react with outright rejection. Public attitude mostly consists of simply turning elsewhere in search of other activities – in spite of all the efforts of the 'Cultural State.' Moreover, the said Cultural State is careful not to put all its eggs in one basket, implementing opportunistic policies supporting not only the arts and high culture but more popular forms of expression as well: not all electors vote ready-made.

In spite of the confusion, artists for the most part keep on working without really paying much heed to the ruckus. In the same way, aesthetic criteria still exist; only now they are concrete, relative to one form of creation or another. If no one is in agreement – 'universally and concept-free' as it were – as to Daniel Buren's or Claude Viallat's place within contemporary art, it is entirely possible to distinguish between good, less good, and just plain bad pieces within their work as a whole.

There are no lack of metaphorical attempts at reconstructing aesthetic rationality – but their failure is patent. Theories which pluralize and relativize aesthetic conduct, on the other hand, are thriving.

In short, what is at issue is not so much a crisis of art as a crisis of our representation of art. And the crisis is double-barreled: it touches the concept as well as our expectations of art.

I. The crisis of the concept of art

A concept crisis? A crisis, in other words, of what we understand by art.

To gain some purchase on just what is at stake here, one has to go back to the 'modern system of the arts' and what it defined as the major arts: painting,

1. This text was originally published as chapter six of *La crise de l'art contemporain* (Paris: Presses universitaires de France, 1997).

sculpture, architecture, music, and poetry – a list which remained more or less the same, variously ordered depending on who was doing the theorizing, from Kant to Hegel, from Alain to Croce.

Such is the system of the 'fine arts,' though there is nothing immutable or eternal about it: it was constituted in the course of the eighteenth century, a product of the same time-frame as the notion of aesthetics itself.

The constitution of the system supposed, successively, the distinction of art from the applied or technical arts, its separation from science and the birth of a specific interest from the point of view of readers, viewers, and listeners as opposed to – and to the detriment of – the artist's point of view. These different steps were gradually reached sometime between antiquity and the eighteenth century; it was only in the eighteenth century that there arose a line of thought identifying the major arts, and then comparing them, examining their principles and seeking to discover their common focus.[2]

The term aesthetics itself was forged by Baumgarten, who used it to designate a theory of knowledge functioning as a counter-piece to the theory of intellectual knowledge. At the beginning, he was above all concerned with poetics and rhetoric, but in his 1750 work, *Aesthetica*, he defined it as the theory of all the arts. In 1790, it was Kant who, in his *Critique of Judgment*, brought aesthetics into the system of philosophy.

This philosophical recognition was the result of the movement that had been accomplished over the course of the whole eighteenth century in the French-speaking world by authors such as Crousaz, Dubos and Batteux, and in the English-speaking world by Shaftesbury, Hutcheson, Hume, Home, Burke and Gérard. But these intellectual sources themselves have to be situated in their context: the setting up of a public sphere where the visual arts and music came to be subject to critique and discussion among a public of connoisseurs: both fine arts doctrine and aesthetics were inseparable from the primacy that was enjoyed from then on by public reception. This was one of the themes of Jürgen Habermas' book on the public sphere.[3] It was central to Thomas Crow's book on painting and public life in

2. P. O. Kristeller, 'The Modern System of the Arts,' *Renaissance Thought and the Arts* (Princeton: Princeton University Press, 1990), pp. 163-227.

3. J. Habermas, *The Structural Transformation of the Public Sphere*, trans. Thomas Burger and Frederick Lawrence (Cambridge, Mass.: MIT Press, 1989), in particular chapter 2, 'Social Structures of the Public Sphere,' pp. 27-56.

4. T. E. Crow, *Painting and Public Life in Eighteenth-Century Paris* (Yale: Yale University Press, 1985).

5. Kristeller, *Renaissance Thought and the Arts*, pp. 225-226.

eighteenth-century France.[4] *The passage to modernity began when art entered the public sphere.*

Interest from then on focused upon what was common to the experience of looking at paintings and monuments, reading books and listening to music. A slow current of discussions and interactions in refined art-lovers' milieus led to aesthetic codifications.[5] These were subsequently widely distributed and reached a broad public through the institutional organization of art (academies, schools of fine arts, museums). They forged the definition and the representation of art which, generally speaking, remains in effect today, notably our conception of great 'Art,' the preeminence of painting, the at-once lofty and sensitive character of aesthetic feeling. When an adolescent who wants to be an artist never imagines being anything but a painter, he or she is the tributary of this representation. When the 'crisis of contemporary art' is identified, to the surprise of no one at all, with the crisis of painting or, at the limit, with the visual or the plastic arts, it is this same concept which is still at work.

And yet it was not long before this system of the arts began to be shaken and to fray apart. The representation which emanated from it was actually astonishingly resistant, given the extent of the changes.

The system first started coming apart in the second half of the nineteenth century with the rise of the decorative arts, taking their vitality from social demand, commercial expansion, the opening up of international markets and the new capacities of industrial production. It came apart with the introduction of new arts of imitation: photography and subsequently cinema. Aesthetic experience itself underwent transformation with the birth of democratic leisure activity. At the same time, a gap opened up between literature and painting as historical painting came to lose its meaning and the novel began to lean first toward photography and then cinema. As for music, it acquired its expressive autonomy, then contributed to the notion of the total work of art. The details of how the system of the fine arts and the concept of art were thrown into question provides virtually unlimited scope for study.

This evolution was accompanied by the rise of the point of view of the producer, underscoring once again the specificity of each medium in relation to any common principle. From this angle too, the concept of art underwent change and the idea of the artist 'in general' lost its meaning.

In fact, what since Harold Rosenberg has come to be known as the de-definition and de-aestheticization of art is nothing new: it is simply the issue raised by arts which have ceased to be fine or beautiful and which can no longer be thought of as Art with a capital A. Catchwords of that kind express an awareness that a whole representation has come to an end. But the end of a representation is not the end of the represented activity; at the worst, it leads to disorientation. This is patent amongst those who actually consider Duchamp and installation pieces to be worthless junk – and, when you get right down to it, that is really precious little to fuel a drama, let alone spark a crisis.

II. The end of a utopia

Yet drama and crises are blazing – and that is what we shall now have to account for.

For there to be drama, the representation had to have been more than a mere representation, providing a concentration of particularly important expectations: it had to have functioned as a utopia.

If contemporary art has come to be identified exclusively with advanced museum-based art and what remains of the system of the arts, if its alleged crisis has fired such hysteria, it is because, one can only suppose, a certain utopia of art has been thrown into question, and in fact is probably dead.

The democratic and capitalist societies which have developed since the eighteenth century have done so around three utopias: the utopia of democratic citizenship, the utopia of labor and the utopia of art.

The utopia of democratic citizenship

The utopia of citizenship is that of equality and liberty.

This is the founding utopia: from Locke to Rousseau, it nourished all eighteenth-century political thought and shaped the projects of both the American and French Revolutions. The nineteenth century never seriously questioned it, even as it critiqued its pitfalls and excesses.

Why a utopia? Because it posits the liberty and equality of each human being quite independently from the reality of that liberty and equality. The fact that Locke was reproached for his possessive individualism and his silence

with regard to the reality of the discrimination prevailing between the small numbers of the enlightened rich and the masses of the poor excluded from politics – not to mention slaves whose very humanity was negated – only serves to highlight just how utopian equality and liberty initially were. This utopian character lies at the core of French-revolutionary debates on citizenship and universal suffrage. The history of the democracies in the nineteenth and twentieth centuries is the history of the slow, late consummation of the 'sanctity of the citizen,' the passage from postulated political equality to its accomplishment. Processes such as the history of the rise of the state of law (still far from over) and the history of the constitution of the Social State all bear witness simultaneously to the utopianism of the utopia and to the force leading to its progressive accomplishment.

The utopia of labor

The utopia of labor, on the other hand, has to do with social change.

From Karl Marx and socialist thought to Max Weber, from the classical economists to the theoreticians of the welfare-state, from the sociologists of industrial societies to the theoreticians of fascism, it has always been in the realm of labor that the conditions and the hope of social transformation has been sought. Labor has been regarded not only as a source of wealth and a factor of economic growth, but was held to be able to bring about the requisite conditions for the transformation of social relations: whether through labor's potential for emancipation and the realization of a socialist society, through market regulation, company organization, or through Keynesian or welfare-state intervention.

It has been a crucial theme – as much in the thought of socialist thinkers and economists as in that of sociologists – that social and cultural change was, would be, and had to be rooted in the development of production, the rise of bureaucratic rationalization, the advent of mechanical solidarity, the triumph of a society based on exchange – *in short, in the victory of all those forms of organization, social solidarity and interaction connected with labor*. Marxist thought, dreams of utopian socialism in all its forms, sociological conceptions of modernity: there is just no end to the list of the possible versions of these theories which place their hopes in finally emancipated or rationalized labor.

Marx counted on the appropriation of productive forces by individuals for the free 'development of individuals into complete individuals and the casting

off of natural limitations.' 'Only then,' he continued, 'will there be harmony between the transformation of labor into the active affirmation of the self and the transformation of hitherto-fettered social intercourse into the intercourse of individuals as such.'[6] In *The Nights of Labor*,[7] Jacques Rancière has described the constitution and emancipation of working-class thought over the course of the nineteenth century, at the intersection of this utopia between this transformative and liberated labor and the utopia of art, aesthetically prefiguring the equality of the producers. The theoretical developments of the Russian avant-garde movements, the constructivists in particular, show in analogous fashion the confusion made between artist and producer, between revolutionary and worker, between proletarian and constructor: the artist who transforms the world is a worker.

This utopia of labor has not only inspired theories and dreams. It has nourished and guided in the most concrete sense all the political projects since the nineteenth century.

Communism – whether it be Soviet-style, Chinese, Albanian, Cuban, or whatever – was everywhere announced as the triumph of the worker: the man of iron identified with his Stakhanovite productive capacities, subsequently becoming the man of marble. Both the Nazi and the Mussolinian variants of fascism also took labor as a reference, even though Nazism combined it with values of racial purity: all of them were workers' regimes. Liberal capitalism is premised on the idea that whoever works hard is able to get rich. Even the projects of the social or the social-democratic welfare state in Europe constantly considered labor a valuable point of reference which made it possible to remedy the injustices in capitalist distribution of wealth and to bring about a redistribution of the effects of growth.

III. The vitality of citizen-based utopia: radical democracy

A citizen-based utopia has lost none of its force – quite the opposite in fact – even if it has taken on some rather surprising modes of coming about.

6. Karl Marx, *The German Ideology*, ed. C. J. Arthur (London: Lawrence and Wishort, 1970), pp. 92-93.

7. J. Rancière, *The Nights of Labor. The workers' dream in nineteenth century France*, trans. John Drury (Philadelphia: Temple University Press, 1989).

8. J. Habermas, *Between Facts and Norms*, trans. William Rehg (Cambridge, Mass.: MIT Press, 1996), p. 360.

As soon as the principles of equality and liberty have been posited, above all with regard to what we know as the Declarations of Human and Civil Rights, as soon as one resolves not to abandon or to renege on these principles, then sooner or later they have to take on concrete form, including forms which today may surprise those who only saw them as empty words.

There came a time when immigrants stood up against national legislation and demanded their human rights, a time when each and every citizen could effectively presume to express his or her opinion on everything and anything, to have a say and be heeded on par with those deemed competent or possessing expertise on a question. There came a time when everyone presumed to take advantage of his or her social rights. Which leads to that form of democracy which Jürgen Habermas so adeptly refers to as radical democracy: not a democracy of perfect, enlightened, rational, educated citizens, but a veritable and imperfect democracy, harmonious and cacophonic, where every citizen lays claim to full citizenship whatever his or her lapses, shortcomings, imperfections, or faults may be. Locke conceived of his citizens as being pious, educated, and rational. Rousseau wanted them virtuous, voluntary, and disinterested. In neither case did that add up to a great many people. One way or another we have progressively come to allow that citizens have the right to be 'awful, dirty, and nasty' and yet be neither so stupid nor so unworthy as to not take part in political life – of which, when it comes right down to it, they have no intention of depriving themselves.

This radical democracy is that of public opinion, which is forever playing a role in politics and culture.

And so the sphere which is forever being formed and torn asunder is no longer the enlightened and limited public sphere of citizens set out by the thinkers of the enlightenment, but rather a sphere constituted on the basis of the interactions of all the actors: associations, groups, parties, as well as families, friends, and work-mates. According to Habermas, this sphere is best described as a 'network for communicating information and points of view (ie. *opinions* expressing affirmative or negative attitudes); the streams of communication are, in the process, filtered and synthesized in such as way that they coalesce into bundles of totally specified *public* opinions. Like the lifeworld as a whole, so, too, the public sphere is reproduced through communicative action, for which mastery of a natural language suffices; it is tailored to the *general comprehensibility* of everyday communicative practice.'[8]

It is an open sphere, a structure of communication where influence is consti-
tuted, where opinions can be manipulated and manipulate one another but
cannot be bought, and which cannot be created at will. In it, the citizen, as
mainstay of the public political sphere, and the member of society are one
and the same person since each is simultaneously actor and acted upon,
purveyor and consumer, taxpayer and recipient of assistance. Everyone can
give his opinion, whatever his competency may be, and no one really
deprives themselves from doing so, without showing any particular respect
for prestigious opinions.

The civil society which thereby comes into being transforms on its own, but
without coming to constitute a sovereign subject: 'Civil society can directly
transform only itself, and it can have at most an indirect effect on the self-
transformation of the political system; generally, it has an influence only on
the personnel and programming of this system. But in no way does it occu-
py *the position* of a macrosubject supposed to bring society as a whole under
control and simultaneously act for it.'[9]

These are merely some initial approaches which will have to be more substan-
tially developed.[10] They define, in any case, the contours of a situation
specific to information- and communication-based democracies. With all
they have by way of transparency and false transparency, with their absence
of a central subject, with their double aspect of permanent contestation and
political consumerism, their ultra-democracy and their inherent risks of
sliding into populism and demagogy. *What interests me most acutely in this par-
ticular case and constitutes one of the central theses of this book is that art and culture
are henceforth within the sweep of this radical democracy. Deference and reverence for
the tastes of the elite no longer hold.*

IV. The crisis of the utopia of labor

It is no revelation to say the utopia of labor is crisis.

The awareness of this crisis first came to light with the observation that the
socialization of the means of production nowhere culminated in workers'
freedom. The monstrosities of fascism provided some inkling of this but it

9. Ibid., p. 372.

10. I hope to flesh them out in an upcoming book, *Le rat démocrate*, to be published in 1999.

still seemed possible to impute them not to labor itself but to some other aspect of what Adorno and Horkheimer referred to as the dialectic of enlightenment. It was no longer possible to entertain any further illusions in the face of the failure of the socialist regimes. The idea of their failure fueled the ideological clashes of the cold-war period, ushering in the discovery of the failure itself when the Berlin wall toppled in 1989.

The crisis of the utopia of labor is also a byproduct of the crisis of the welfare-state. Jürgen Habermas' diagnosis of this crisis deserves consideration.

On the one hand, the regulation of economic activity and its social spin-offs by political-administrative structures led to the dissociation of projects for changing conditions of life and dignity from the program for the emancipation of alienated labor. The state assumed the administrative burden of the projects for the protection against the fundamental risks of wage labor, providing the advantages to which we have grown accustomed (prevention of accidents and disease, protection against loss of employment, provision for old-age) and, also perhaps, with the gray-zones of social control which are its flip-side. In this perspective, full employment is the norm: 'the citizen is compensated in his role as client of the welfare state bureaucracies of legal claims, and in his power as consumer of mass-produced goods, with buying power. The lever for the pacification of class antagonisms thus continues to be the neutralization of the conflict potential inherent in the status of the wage laborer.'[11]

Those who challenged the political system in the 1970s attacked this gray-zone of the administered life where emancipation becomes nothing more than social security.

The welfare-state's action in this respect raises two problems: that of the effectiveness of intervention, that of its capacity to gather support and to produce motivation within the framework of the society's legal-administrative system.

The questions which crop up from the point of view of efficiency are, alas, only too well known.

On the one hand, the extent of state regulation of economic life and its social consequences weighs heavily on the budget of the welfare-state, while at the same time economic rationalization continues to develop in step with

11. J. Habermas, 'The New Obscurity: The Crisis of the Welfare State and the Exhaustion of Utopian Energies' (1984), *The New Conservatism*, trans. S. Weber Nicholson (Cambridge, Mass.: The MIT Press, 1989), p. 55.

gains in productivity. Public budget crises and employment crises have to be dealt with simultaneously. Work, the very basis of social relations, has become scarce. The majority of European states that have not yet down-scaled the welfare-state are today in the throws of this double-sided crisis with all its attendant social and political consequences: the development of exclusion, the rise of extremism, generalized selfishness amongst the privileged – civil servants and those who still have a job included. To which it must be added that the national states are scarcely able to act upon the world economy, except on the occasion of international agreements. They are therefore subject to the consequences of globalization which they must try to render acceptable to the citizens who end up losing their faith in the state's ongoing claim to sovereignty as well as its ability to protect them.

From the point of view of legal-administrative action, the welfare-state's action has for many years gone hand-in-hand with increasing intrusiveness into citizen's private lives. Claiming to uphold values of economic regulation and social protection, 'an ever denser net of legal norms, of governmental and para-governmental bureaucracies is spread over the daily life of its potential and actual clients.'[12] Life has thus become ever more tightly regimented, dissected, controlled and watched over; it also remains the case that 'generating forms of life exceeds the capacities of the medium of power.'[13]

At the intersection of such problems and grounds for disenchantment, one can observe a loss of belief in utopian forces in general – the political realm included – because citizen-based utopia paradoxically foregrounds the reality of a society without a dominant subject or central reference, a society in constant flux but without any unifying project behind this flux. To borrow Niklas Luhmann's expression, 'everything is possible and nothing is working' – a phrase one could fairly easily transpose into an 'everything is working but nothing is possible,' accurately describing a world flattened into the present, without utopian energy and fearful of the future, without memory and whose scant moments of nostalgia are simulated for lack of any relationship to tradition.

It is here that the utopia of art and its own crisis comes into the picture.

12. Ibid., p. 58.
13. Ibid., p. 59.

V. The utopia of art

The utopia of art came to be formulated at almost the same time as that of citizenship. It was also constituted through the rise of the concept of a public and a public sphere over the course of the eighteenth century. The appearance of the concept of aesthetics was a major component: what remains to be established is how, in the public spheres of exhibition and discussion, common criteria of judgment were able to arise – how, to use the expression coined by David Hume in 1757, 'norms of taste' came to be established.

Thomas Crow has studied in great detail how, from 1737 on, the Paris Salon polarized public attention and contributed to establishing the 'public.'

The public, as he has shown, was henceforth to play a new mediating role in a relationship which had previously enveloped only the artist and the patron who commissioned the work. Through discussions, polemics, and conflicts as to the definition of what the public actually was and would be allowed a voice, a system of values came into place. With the appearance of the public, the gaze shifted toward the reception of works by people who were no longer necessarily those who purchased them, but who exerted pressure on those who did. Thomas Crow has pointed out what was at stake in these changes in terms which, on the face of it, were not only to become central to Kantian aesthetics but also concern the current controversy around contemporary art.

> The history of the public sphere of painting began, strictly speaking, at the point when the dependency of artists with regard to the exigencies of an individual or circumscribed elite came to be contested. There need not be anything leveling or democratic about this challenge; it need not seek to dispossess the traditional commissioner nor contest his appropriating the best artworks. It suffices that a third party get involved in the transaction, some disinterested community holding a degree of stability and lasting power, whose authority can be invoked either by the buyer or by the seller of a pictorial service. […] That means with the arrival of a collectivity possessing at once a legislative and legal function, the ultimate depository of a body of rules governing serious art, decorum and moral value and whose continual vigilance is indispensable to their upkeep.[14]

What Crow has also shown with regard to French artistic life is that, right from

14. Crow, *Painting and Public Life in Eighteenth-Century Paris*, p. 22.

the outset, the public has never in any sense been statically defined: the 'public' is the product of the different discourses in conflict, discourses with which one sector of the public or another identifies. Different social groups thus appropriate for themselves different forms of pictorial representation. And it is precisely along this line that the repeated controversies throughout the eighteenth century about the hierarchy of the pictorial genres overlapped controversies of social hierarchy.

The most important point, at least as far as the present discussion is concerned, is related to the correlation between modernism and art's passage into the realm of public control.

Art gained its autonomy *as art* in the middle of the eighteenth century; it became separate from artisanal crafts and the applied arts, becoming Art with a capital A, not for aesthetic but rather for social reasons: as it became an object to be savored and discussed by a public of art lovers.

The apparent paradox notwithstanding, art for art was first and foremost art for the public. It was not aesthetics – or at least not insofar as it is understood as a field of specifically aesthetic experiences – which determined the autonomization of art: it was art's entry into the public sphere which engendered the aesthetic question. And it was only then that the plurality of the public's judgments of taste and their confrontation in the public sphere raised the question of criteria of taste.

It is not sure that we are very much further ahead in relation to this problematic.

And it is at this juncture that we come across Kant and his *Critique of Judgment*.

As numerous commentators have emphasized,[15] Kant's third critique was planned long before it was actually written and published, and was part and parcel of the architectonic system of his philosophy. One way or the other, the question as to whether or not it was planned from the beginning as an integral part in the structure of his critical philosophy, or as a later effort cobbled together to account for an aspect of human thought outside the scope of both the *Critique of Pure Reason* and the *Critique of Practical Reason*, has no bearing on its central preoccupation: Kant's objective was to provide rational foundation for those types of universal claims arising from aesthetic and teleological judgments.

15. For instance, D. Henrichs, 'Explanation of Aesthetic Judgment,' *Aesthetic Judgment and the Moral Image of the World* (Stanford: Stanford University Press, 1992), pp. 32 sqq.

Here is not the place to go into details of Kant's analyses of aesthetic judgments in general. It should suffice to recall that Kant argues judgments of taste are not epistemological judgments – in which the representation is in relation to the object for the purposes of knowledge – but rather aesthetic judgments which relate the representation to the subject and the sense of pleasure or displeasure he or she experiences. The determinant principle of judgment is thus nothing other than subjective: it designates nothing whatsoever in or about the object itself. And yet, this sort of judgment lays claim to a universality which is neither cognitive nor logical but aesthetic; it claims to be communicable *a priori*.

This of course raises the question as to 'the universal communicability of the mental state, in the given presentation, which underlies the judgment of taste as its subjective condition, and the pleasure in the object must be its consequence.'[16]

However, Kant argues that only cognition – or knowledge – can be communicated universally. Insofar as one sticks to the hypothesis of purely subjective communication, another principle is required. It can be founded only upon the basis 'of the mental state that we find in the relation between the presentational powers insofar as they refer to a given presentation to cognition in general.'[17]

With these words in the first pages of the *Critique of Judgment*, Kant provides a clue to his proposed solution for understanding the existence of a common aesthetic sense, to be found in everyone on the basis of the free play of the cognitive faculties which are brought into operation in the presentation itself: 'Hence the mental state in this presentation must be a feeling, accompanying the given presentation, of a free play of the presentational powers directed to cognition in general.'[18] A little further on, Kant again insists – to the point of becoming tiresome – on the 'subjective universal communicability of this mode of presentation'[19] which occurs in a judgment of taste. What is communicated, in other words, can be nothing but the 'mental state in which we are when imagination and understanding are in free play.'[20] Kant immediately adds that such an agreement is required for all

16. I. Kant, *Critique of Judgment* (1790) § 9, trans. Werner Pluhar (Indianapolis: Hackett, 1987), p. 61.

17. Ibid., pp. 61-62.

18. Ibid., p. 62.

19. Ibid.

20. Ibid.

knowledge in general. Kant's proposed solution therefore relies on the concepts of the transcendental analytic in the *Critique of Pure Reason* – that is, on the doctrine of the faculties set out in the first critique.

Clearly and simply, this means this sort of communication does not concern an affirmation with an objective aim (the fact that such and such an artwork is beautiful), but rather the communicability of a 'subjective relation suitable for cognition in general.'[21]

What, in a certain sense, is actually communicated is the communicability of feeling, the effect the free play of understanding and the imagination have on the mind. Aesthetic communication is the universal communicability of a feeling which is known by everyone through the very nature – and free play – of their faculties.

So, just as in the realm of morality it was the universal form of duty which assured universality – without there being any way to ascribe any content to it – in just the same way, in aesthetics, universality is linked to a feeling which is an effect of the free play of the two faculties – without there being any need to agree upon the slightest content. Aesthetic communication consists, at root, in the communion of aesthetic experiences and even in the communion of aesthetes.

At the same time and in so doing, Kant provides a cognitive basis for aesthetic judgment, a cognitive basis with all the solidity and the universality of the theoretical edifice of the *Critique of Pure Reason*.

Kant makes it clear that this play of the imagination and understanding is a condition of possibility for knowledge itself: this means, when one gets right down to it, that 'we have the right to assume that it is a possible state of every mind whose knowledge is of the same kind as ours.'[22] We may all therefore suppose that all human beings are able to reach an agreement with us. Which accounts for the *a priori sui generis* (formal and 'sentimental') validity of aesthetic judgments.

My point is not to evaluate the theory's validity, either from a point of view internal to Kant's philosophy or in relation to aesthetic judgment in general, but rather to draw out the implications for what I have referred to as the utopia of art.

For the concern of Kantian aesthetics is to found the universality of judgments of taste while respecting the singularity of aesthetic judgment.

21. Ibid.
22. Henrichs, 'Explanation of Aesthetic Judgment,' p. 54.

This foundation is assured thanks to universal communication, in fact universal communicability, which is itself founded upon references to the cognitive universals of the subject.

It is easy to see how the 'aestheticizing' understanding of the Kantian project (Kant wanted to be able to account for art *as well*) comes to join with a 'critical-systematic' or architectonic understanding (Kant wanted to *complete* his critical edifice). Alexis Philonenko is among those commentators of Kant who have best grasped that the object of the *Critique of Judgment* was to address the question of communication and intersubjectivity. 'The *Critique of Judgment*,' he writes, 'is an attempt to resolve the capital problem of modern philosophy: intersubjectivity. In the aesthetic act, the person affirming the universality of his sentiment goes beyond his ego and merges with others.'[23]

The only problem is that Philonenko has given this intersubjectivity-related undertaking an ahistorical character. Kant's scheme was in fact firmly embedded in the perspective of the enlightenment's egalitarian project and bore its full political dimension. Fired by the optimism of the enlightenment, Kant may well have considered his solution to be definitive. We, at any event, must be sensitive to what marks it historically.

This was emphasized by Jacques Rancière who pointed out with great perspicacity in *Le philosophe et ses pauvres*[24] a key phrase in 'On Methodology Concerning Taste' which closes the 'Dialectic of Aesthetic Judgment' and which, regrettably, often goes unnoticed. In it Kant writes:

> There were people during one age whose strong urge to have sociability under laws, through which a people becomes a lasting commonwealth, wrestled with the great problems that surround the difficult task of combining freedom (and hence also equality) with some constraint (a constraint based more on respect and submission from duty than on fear). A people in such an age had to begin by discovering the art of reciprocal communication of ideas between its most educated and its cruder segments, and by discovering how to make the improvement and refinement of the first harmonize with the natural simplicity of and originality of the second, finding in this way that mean between higher culture and an undemanding nature constituting the right standard, unstatable in any universal rules, even for taste, which is the universal human sense.[25]

23. A. Philonenko, 'Introduction à la traduction de la *Critique de la faculté de juger*,' (Paris: Vrin, 1980), p. 10.

24. J. Rancière, *Le Philosophe et ses pauvres* (Paris: Fayard, 1982), p. 283.

There is no getting around the publication date of the *Critique of Judgment*: 1790 was a pretty significant year when one considers just how important the outbreak of the French Revolution was for Kant.

A year after the beginning of the Revolution, Kant raised the aesthetic question in the context of the political problem 'of combining freedom (and hence also equality) with some constraint (a constraint based more on respect and submission from duty than on fear).' That is, he raised it at a moment when the notion of what we have called the citizen-based utopia was coinciding with its actual realization. As Jacques Rancière formulates it, his question was: 'What are the possible channels for an equality of feeling which gives to the proclaimed equality of rights the conditions of its real exercise?'[26] It was indeed the same conservative thinkers (Burke for instance) who argued that freedom was unattainable given the inequality of competencies and the fact that the Beautiful was the affair of refined and cultivated people – and Kant *politically* refused 'the absolutization of the gap between popular "nature" and elite "culture".'[27] In different terms, the formal universality of judgments of taste and the communicational sociability which under-pinned them not only anticipated the coming equality, the real future of cit-izen-based utopia, but actually contributed to its achievement.

The utopia of art is a correlate of citizen-based utopia. This utopia of art is a utopia of pos-sible communication, a utopia of 'cultural communism,' or at any rate of the cultural community. The world is not irremediably split between the most civilized and the most uncultivated precisely because there exists this formal universality of judgments of taste.

From then on, this utopia would take on a variety of faces.

One cannot but recall that 1790 was also the year in which, in Paris, Jacques Louis David wrote a dissertation on the political and social utility of the arts, calling upon the National Assembly to reform the Academy and the Salon – which was done in 1793. Thus began David's official involvement with revolutionary culture as organizer of celebrations and ceremonies – as propaganda master. The first achievement of utopia led brutally, therefore, to propaganda.[28] Aesthetic communication turned into organized revolu-

25. Kant, *Critique of Judgment*, § 60, pp. 231-32.
26. Rancière, *The Nights of Labor. The workers' dream in nineteenth century France*, p. 283.
27. Ibid.

tionary communion. One comes across variants of this whenever art puts itself into the service of power in order to aestheticize it and favor communion around it.

Another version of the utopia of art consists in radicalizing the Kantian affirmation of the communicational resources of the free play of understanding and the imagination in aesthetic experience. This was Schiller's approach in his *Letters on the Aesthetic Education of Man*, written between September 1794 and June 1795, and published that same year.

In them, Schiller diagnosed two extremes of human depravity,[29] the crudeness of instincts amongst the lower classes and lethargy amongst the upper classes: 'Thus do we see the spirit of the age wavering between perversity and brutality, between unnaturalness and mere nature, between superstition and moral unbelief; and it is only through an equilibrium of evils that it is still sometimes kept within bounds.'[30]

If the lower classes were accorded political freedoms, he argues, they would abuse them in anarchistic fashion; but if the upper classes submitted to common legislation, the last remainders of natural spontaneity would be stifled. The solution, therefore, lies in exerting an ennobling influence on human character. Turning toward the artist, Schiller writes:

> In vain will you assail their precepts, in vain condemn their practice; but on their leisure hours you can try your shaping hand. Banish from their pleasures caprice, frivolity, and coarseness, and imperceptibly you will banish these from their actions and eventually, from their inclinations too. Surround them, wherever you meet them, with the great and noble forms of genius, and encompass them about with the symbols of perfection, until Semblance conquer Reality, and Art triumph over Nature.[31]

The point was no longer to carry out propaganda but to favor education and refinement, to create the aesthetic conditions for a culture of the soul and the civilization of humanity.

28. See A. Boime, *A Social History of Modern Art*, I, *Art in an Age of Revolution* (Chicago: University of Chicago Press, 1987), pp. 440-45. See also Ph. Bordes, *David* (Paris: Hazan, 1988), pp. 60 sqq.

29. F. Schiller, 'Fifth Letter,' *On the Aesthetic Education of Man* (1795), trans. E. Wilkinson and L.A. Willoughby (Oxford: The Clarendon Press, 1967), pp. 25-29.

30. Ibid., p. 29.

31. Ibid., 'Ninth Letter,' p. 61.

At the end of his reflections, Schiller argued for outstripping the dynamic State of Rights and the Ethical State of Duties with the Aesthetic State of Beautiful Relations which 'consummates the will of the whole through the nature of the individual.'[32] Taste then brings harmony into society – for harmony is henceforth within individuals themselves: 'only the aesthetic mode of communication unites society, because it relates to that which is common to all.'[33] Despite the utopian character he continues to ascribe to it, Schiller describes in these terms the Aesthetic State, which truly appears to consummate the Kantian program: 'In the Aesthetic State everything – even the tool which serves – is a free citizen, having equal rights with the noblest; and the mind, which would force the patient mass beneath the yoke of its purposes, must here first obtain its assent. Here, therefore, in the realm of the Aesthetic Semblance, we find that ideal of equality fulfilled which the Enthusiast would fain see realized in substance.'[34]

I have devoted the preceding developments to Kant and Schiller because they show that, at its purest conceptual core, the utopia of art turns out to be a utopia of communication and civilization. It is, moreover, inseparable from the concern with the aptitude for freedom and equality postulated by a citizen-based utopia. *Aesthetic experience is, under these conditions, the guarantor of the unity between the human world and sociability, and it shores up and reinforces the equality of citizens which has been set out elsewhere.*

It therefore has nothing whatsoever to do with art prefiguring a transfigured, changed or revolutionized world; nor does it anticipate this transformation: it is rather, within the world itself, what enables the consummation of the promises of citizenship. It is itself transformation inasmuch as it is the principle for the transformation of humanity, the principle of humanization.

It was long after Hegel, in relation notably to the socialist utopias of labor – as well as the mirage of technology and the machine – that the utopia of art would impute to art not only a communicating and civilizing function (of *sociability* Kant would say[35] but a function of anticipating a transfigured world. Even the romantic magi and prophets of the 1830s – with whom the

32. Ibid., 'Twenty-seventh Letter,' p. 215.
33. Ibid.
34. Ibid., p. 219.
35. Kant, *Critique of Judgment*, § 41, p. 163.

notion of the avant-garde first appeared – still announced this aesthetic reconciliation of man with his humanity which was the prelude to a new world – without actually being that new world itself. In fact, the Aesthetic State resembled more Clarens' estate in *The New Héloïse*, or the world of the Hegelian beautiful soul, than the futurist world of the *ProOUne* (Project for the Affirmation-Foundation of the New) laid out by Lissitzky in the 1920s. The dimension of social transformation would come later. From this point of view, moreover, an entire 'holy history' of modernism has to be thrown into question: art for art raises the issue of democratic communication, not that of social transfiguration – which could only be political.

VI. The end of the utopia of art

As I have just said, the utopia of art first promised not the direct transformation of society but rather the establishment of communication between equal citizens, civilized by their experience with art. The early aesthetic thinkers were democrats, not avant-garde modernists preaching the aestheticization of life.

Kant was the first to advance this program. He formulated it in the context of the utopia of citizenship by giving theoretical form to the concept and the reality of a public sphere of communication around artworks.

It is actually of no significance that the arts he was actually able to see were in no way 'avant-garde,' but fitted very conventionally into the system of the fine arts as elaborated by art-loving and critical publics of the eighteenth century. It has often been wondered why it was that Kant, as opposed to Hegel, was not awfully concerned with what works he would choose for his examples. One is better able to understand the reason when one realizes that what counted, for Kant as for Schiller, was the very fact of the establishment of communication in the aesthetic experience – at the limit, it made precious little difference what it was established on. What mattered was that aesthetic experience not be reserved for an elite of refined connoisseurs leaving the common mortals to their crudeness and brutality, excluded at the same time from political freedom and equality. In short, the utopia of art is a communicational, democratic and civilizational utopia: it fits into the program of an education (*Bildung*) of humanity (of human beings) into humanity – a quality which, for Kant, had a very precise mean-

ing. As he wrote in the above-quoted and utterly crucial § 60 of the *Critique of Judgment*, 'it seems that for all fine art, insofar as we aim at its highest degree of perfection, the propaedeutic does not consist in following precepts but in cultivating our mental powers by exposing ourselves beforehand to what we call *humaniora*; they are called that presumably because *humanity* means both the universal *feeling of sympathy*, and the ability to engage universally in very intimate *communication*. When these two qualities are combined, they constitute the sociability that befits our humanity and distinguishes it from the limitation characteristic of animals.'[36] The education of humanity through art is therefore a form of education to sympathy and communication, in other words to sociability.

Except that from the nineteenth century on – long before Duchamp or the latest fad in ready-mades – this utopia of communication showed up for the illusion it was.

The movement of throwing utopia into question took place at the intersection of numerous determinations. Amongst them: the religion of art – of Schillerian and romantic origin – which found its expression in the conception of the artist-prophet or romantic magus announcing to mankind its reconciled future;[37] the effect of social movements and socialist thought leading numerous artists to think of themselves as workers, though different from other workers;[38] relations between art and official commissions (the effect of the institution in its relationship to the functioning of the Salon and to State-commissioned works); not forgetting – meanwhile and forever – the rise of democratic tastes within industrial society making the public sphere into a sphere of tensions and conflicts under the quadruple Baudelairian sign of 'era, fashion, morals and passion.'

In every respect, therefore, it was democracy and its principles of freedom and communication, as well as its byproducts of demagogy, commerce and commingling which threw the utopia of communication – and of the aesthetic civilization which was supposed to support it – into question. The enlightened and public critical sphere of the eighteenth century could not remain sheltered from the effects of capitalist and democratic develop-

36. Ibid., § 60, p. 231.

37. See Bénichou, *Le Sacre de l'écrivain 1750-1830* (Paris: José Corti, 1973); *Le Temps des prophètes. Doctrines de l'âge romantique* (Paris: Gallimard, 1977); *Les Mages romantiques* (Paris: Gallimard, 1988).

38. J. Borrell, *L'artiste-roi. Essai sur les représentations* (Paris: Aubier, 1990), pp. 132-41.

ment, and became the sphere of public opinion as well as of the division between classes and social groups.[39] It would certainly appear that art provided the principle of aesthetic communication. But in reality, nobody actually agrees on anything. Everyone is sure of the universalizable character of his or her experience, but no one ever convinces anyone else when a disagreement arises. The history of the Salon in the nineteenth century is the history of continuous dissension agitating and opposing the various publics until such time as the Salon itself exploded and swarmed out into rival and competing salons. The aesthetic community is in fact skirmish and strife.

VII. Several defensive strategies

With regard to this discovery that the esthetic community is nothing but a myth, several different defensive strategies are conceivable and have been put into practice.

The avant-garde work

The concept of the avant-garde artwork, recognized by a progressive elite of discerning connoisseurs was the first attempt at impeding the death process of the utopia: it skillfully imputes the failure of aesthetic communication to obtuse bourgeois philistinism, exonerating the working-class public of any responsibility, explaining away its silence to an involuntary lack of education, and restores an ideal communicational consensus amongst the elite of advanced and involved viewers. One of the best examples of this is the famous text Mallarmé published in English in 1876, 'The Impressionists and Édouard Manet':

> At a time when the romantic tradition of the first half of the century only lingers among a few surviving masters of that time, the transition from the old imaginative artist and dreamer to the energetic modern worker is found in impressionism.
> The participation of a hitherto ignored people in the political life of France is a social fact that will honor the whole of the close of the nineteenth cen-

39. See Jürgen Habermas' analysis in 'The Social-Structural Transformation of the Public Sphere,' in *The Structural Transformation of the Public Space*, pp. 141-80.

tury. A parallel is found in artistic matters, the way being prepared by an evolution which the public with rare prescience dubbed, from its first appearance, *intransigeant*, which in political language means radical and democratic. [40]

Such would appear to be the matrix of the modernist position defending avant-garde art and its utopian value for the prefiguration of a modern world still in gestation in spite of the reality of the non-communication between individuals. And what we have called late modernism – that 'theory' which is defended so torturously and bureaucratically in the current polemic around contemporary art – merely takes it to caricatural proportions. The opening sentence of Karl Marx's *Eighteenth Brumaire of Louis Bonaparte* is well known: 'Hegel remarks somewhere that all facts and personages of great importance in world history occur, as it were, twice. He forgot to add: the first time as tragedy, the second as farce.'[41] Late modernism is the comic form of modernism.

The holy history

A second strategy, which can be combined with the first, consists of taking recourse in history.

The Hegelian model of an adventure of forms here provides the matrix for a historicization, reconstituting the logic of artistic developments and providing credibility for the idea that there exists both precursor movements and others which are after their time or antiquated – *and consequently, that there exist different publics situated at different aesthetic ages.* The projection of an at once formal and historical interpretative grid onto artworks (the history and the life of forms) makes it not only possible to get rid of the evidence of any absence of aesthetic agreement but to make it intelligible. Be that as it may, this sort of rationalization is vulnerable to any ethnological discovery which varies the scope of the forms to be put in perspective. From this point of view, the slow discovery of the primitive arts and the *other* arts in general between 1870 and 1914 undermined historical construction just at the very moment it was getting underway. On the other hand, the logic of artistic history quickly appears frivolous if it is not shored up by another logic –

40. S. Mallarmé, 'The Impressionists and Édouard Manet,' in *Art Monthly Review* (30 September 1876), pp. 121-22.
41. Karl Marx, *The Eighteenth Brumaire of Louis Bonaparte*, in David McLellan, ed. *Selected Writings* (Oxford: Oxford University Press, 1977), p. 300.

one which projects a structure of historical evolution on the society at large. In short, if the avant-garde is not to play at war in art's demilitarized zone, then its action has to be brought into relation with real struggles. The whole problem is to know how long the suspense is able to last: an absence of durable synergy makes the reality of political involvement rather problematic (as was the case in France in the early 1970s) and a true synergy means a 'full-fledged' jump into history, with all the partisanship which that requires.

One cannot but acknowledge that all these various historical constructions have run their course as much in the realm of art[42] as in the realm of forward-moving historical evolution: pluralist lectures are possible, if only because history is worth telling from the point of view of the dominated or the vanquished, whether it be in art or politics. This doesn't necessarily change the balance of power but it does certainly shake up the complacency of the narrator who is indispensable for the story to be convincing.

The politicization of aesthetics

Third strategy, one which consists in making art into the presentation of the new world. To some extent, this overlaps the modernist position, the only difference being that in this case art turns into propaganda: it aestheticizes the world by providing it with its decor. There is no denying that this is a movement for the aestheticization of politics, but one should not be overly idealist about it: the iron presupposition of this aestheticization is the politicization of aesthetics and the submission of art to the dictates of regime. We caught an insight into this in an earlier chapter where I evaluated the pertinence of historical similarities between the present crisis and such episodes as the Nazi crusade against degenerate art, or the establishment of socialist realism. If the constructivists in the 1920s wanted to provide an insight into the ultramodern world of tomorrow, the militant artists of the 1930s had to produce the art the Party expected them to create. In that case, of course, the communicational utopia was entirely preserved, but was situated in the shadows cast by the watchtowers of the camps.

42. See Hans Belting's classic study on the subject, *Das Ende der Kunstgeschichte*.

The ivory tower

And the final strategy, that of withdrawing into art for art's sake in the midst of a hostile world, can of course be identified with the formalist position developed by Greenberg, but actually goes back as far as the art for art's sake doctrine of the nineteenth century. It actually makes no pretense whatsoever of defending the communicational utopia; it aims only to eke out a creative sphere for artists in a philistine and kitsch world incapable of recognizing them. In this respect, the Schillerian program gains new currency – resized to fit the needs of a reduced and isolated artistic community. In the very last lines of his last letter, Schiller had actually admitted this was how it had to be:

> But does such a State of Aesthetic Semblance really exist? And if so, where is it to be found? As a need, it exists in every finely attuned soul; as a realized fact, we are likely to find it, like the pure Church and the pure Republic, only in some few chosen circles, where conduct is governed, not by some soulless imitation of the manners and morals of others, but by the aesthetic nature we have made our own; where men make their way, with undismayed simplicity and tranquil innocence, through even the most involved and complex situations, free alike of the compulsion to infringe the freedom of others in order to assert their own, as of the necessity to shed their Dignity in order to manifest Grace.[43]

To put it differently, it is not a matter of defending utopia but of falling back on idealism: sociability in the Aesthetic State is reserved to those who feel themselves worthy. Clement Greenberg's position is no different: despite all his platonic protestations in favor of a reconciliation of culture and work which at least help us not to 'have to despair of the ultimate consequences for the culture of industrialism,'[44] for him, the split is clear: the cultivated viewer gets the avant-garde and the masses get the kitsch. And if the avant-garde one day manages to seduce the masses, it will be recycled in the form of commercial advertising kitsch.

43. Schiller, 'Twenty-seventh Letter,' p. 219.
44. Clement Greenberg, 'The Plight of Culture,' *Art and Culture* (Boston: Beacon Press, 1961), p. 33.

VIII. Dead and truly dead

Whatever the attempts to obstruct the reality of this disillusionment, utopia is truly dead.

Its death corresponds to the end of a representation and to the end of a belief in it. And this is nothing new. When one thinks about it a moment, it actually seems strange that old beliefs still continue to exert such influence, that they underpin the doctrine of the Cultural State, that anyone actually believes it possible to produce consensus on the basis of a 'public service of creation,' or that anyone dare pretend that Duchamp's *Fountain* was able to engender spiritual aesthetic accord! Who could even believe that for a second and who do they think they are kidding?

The pathos and its persistence actually have to do with the fact that the question is political rather than aesthetic: it touches on our beliefs in the reasons and bases of living together with one another.

What art (and not only contemporary art) stands for is a motive for believing in sympathy and communication. In other words, in the Kantian sense, in the principles of sociability relying not on religion, nor the nation, language, parentage, interest, dependency on commerce, nor reason itself. Aesthetics would then define, so to speak, a negative politics: that of the dream. And art, in the sense of specifically aesthetic experience, represents a principle of the intermediary stage of sociability between the factuality of sensual and visceral determinations, and the pure logic of reason, between the links of natural society and those of the willfully chosen society, between the given which is merely endured and the principle which is chosen. The dream (for at the present time, it is a dream and not a utopia which is at issue) is seductive – but is it anything but a dream? Can the community really be founded on this imaginary principle?

In any case, this eminently political value is at the very core of the debate and the polemic.

Some wish that art were still able to provide a common basis for belief – something it has probably never been anywhere – and, disillusioned, they excoriate the art of their time. Others confine themselves to the simulated conviction that the art of their time provides the common basis for belief. As for the civil servants of the central, cultural and republican State, they evoke pell-mell the avant-garde movements, cultural heritage, the public service, the nation-state, the soul supplement – never forgetting, like Molière's

Sganarelle, their wages. And why not the Great War and the colonial era to boot – given that they too were part and parcel of the Third Republic! Perhaps only Jean Baudrillard, veritable Pyrrhonian that he is, can really make fun of everything because for him there is nothing left to believe in.

All of which leaves one with the feeling of the rehearsal of a strange comedy – the feeling, if not actually of a tragedy, at least of a disabusal: democracy has exhausted utopia and we are left, as Habermas would say, with a legitimation and motivation deficit with regard to the social system. Art continues to be presented as a source of legitimation and motivation able to re-enchant social life – but it is merely a mirage. One can imagine the importance of being attentive to other more modest and less lofty forms of legitimation and motivation. The crisis of art raises the issue of new concepts which have to be formed in order to think through radical democracy.

Renee Turner

A Journey from Démodé to Displacement: Some Reflections on the Relation Between Art and Theory

Before beginning, I would like to acknowledge the very 'interested' as opposed to 'disinterested' position from which I work. Unlike a philosopher or sociologist who observes art from a distance, my view is from within and my vision is tinged with a degree of myopia that comes with association and intimacy. As an artist, teacher, and curator, the speculations and criticisms I make influence the way I operate on a daily level.

My education formed and informed my perspective of what it could mean to combine theoretical inquiry with the practice of art. From the mid-eighties to early nineties, the union of art and theory, though at times an acrimonious alliance, was well on the agenda in American universities and art academies. The climate was such that the canon, meaning the primacy of the masterworks constituting the Western tradition, was severely under criticism. Modernism was pegged as enemy number one and postmodernism – along with its various related 'isms' – was quickly becoming institutionalized. Feminism, psychoanalysis, queer theory, and postcolonial discourse entered into American universities first through the doors of English departments, specifically through literary criticism, and then infiltrated art departments, threatening their status as safe havens for the myth of the individual genius and/or idiot savant. Artists or artist groups such as Mary Kelly, Adrian Piper, Group Material, Trin T. Minh-ha, The Guerrilla Girls, and Allan Sekula were the staple diet of both studio and art history classes. Barnett Newman's classic adage of aesthetics being as useful to artists as ornithology is to birds became an outmoded vision as artists stepped consciously or unconsciously into the roles of theorists, activists, curators, and critics. This shift in artistic practice, along with the changes in art criticism brought about by the likes of Hal Foster, Craig Owens, and Rosalind Krauss, to name just a few, resisted essentialized models of aesthetics, cast doubt on notions of autonomy, and attempted to forge relations with the broader system of social networks constituting culture.

Unfortunately the productive tension coming out of these projects was often lost in the process of distillation as theory was reduced to the perfunctory status of illustration or illumination. 'Theory based' metamorphosed into 'theory paste,' an appliqué to be adhered to any art object. Rather than informing the work, it became a legitimating bolster offered up as the proverbial 'art-excuse.' And the radicality of activism and political engagement which necessitated the assertion of theory in art schools and posed a threat to the status quo, became nothing more than an exercise in illustrating subtle theoretical tropes ad nauseam. Art, subject to a linguistic model, was to be decoded provided we all had the proper code-breaking equipment to do so. What had been introduced as a tool to open up space for new relations and most importantly, new voices, had become exclusive and restrictively literal to the point of asphyxiation.

If the relationship between art and theory calcified within art schools, the trajectory it has taken in the context of cultural institutions, galleries, and museums is perhaps more disturbing. Within these spaces theory has found its 'proper' place as another consumable good. I agree with Hal Foster when he says:

> I supported a postmodernism that contested [...] reactionary cultural politics and advocated artistic practices not only critical of institutional modernism but suggestive of alternative forms – of new ways to practice culture and politics. And we did not lose. In a sense a worse thing happened: treated as a fashion postmodernism became démodé.[1]

Going further, I would suggest that theory, a key feature of the postmodern enterprise, became démodé only after becoming convention – which meant comfort at the expense of confrontation. That inaugural moment when theory first entered the scene, battling for validity, has vanished. Operating only in sanctioned spaces, theoretical discourse has its well-defined perimeters, be it as a preface to a catalog, a symposium next to an exhibition, or a tidied section on the shelves of an art bookstore.

This process of institutionalization has had a profoundly debilitating impact on the efficacy of debate. Actually 'debate' is too flattering a word because it implies a dynamic and responsive relationship which simply doesn't describe the current relation between art and theory. The two have become nothing more than parallel practices where never the twain shall meet.

1. Hal Foster, *The Return of the Real* (Cambridge: MIT Press, 1996), p. 206.

'Issues,' reduced to trends, have become side shows accompanying exhibitions. I have frequently heard colleagues refer to issues surrounding 'the body' or 'identity politics' as 'so eighties' or 'early nineties.' But what are the consequences of statically fixing essential concepts and rendering them unable to be translated, adjusted, or rearticulated beyond fashionable discursive practices? Like commodities, they have a shelf life and are subject to passing their 'sell by' date. On the level of institutional critique, isn't it imperative to reflect on the kind of paradigmatic structure being emulated here? I suspect, to use Hal Foster's words, 'the new ways to practice culture and politics' are now more like the tried and tested of consumer culture.

With theoretical debate tamed to the point of banality and deteriorating rapidly into an exchange of jargon among the enlightened, it is no wonder we're experiencing what could easily be interpreted as a backlash. I would be glossing over the complex mechanisms at work in the art world to reduce the present to a simple case of cause and effect; however, when one sort of discourse disappears or falls by the wayside, another is quick to take its place. Currently, I would suggest that cynicism, myth, and 'madness' have center stage. Think of Bjarne Melgaard's series of drawings, *Young and Depressed in Scandinavia*, where he writes adolescent ravings against minimalism and draws in an almost doodle-like fashion his fantasy of Richard Serra under threat of sexual assault by Mary Kelly; or better yet, when he made the 'radical' gesture of burning all of his books on theory.[2] Or what of the 'young British artists,' sporting the acronym yBa, for whom 'the manufacture and nurturing of myth is more "productive" than the brass tacks of facts, figures, and social relationships.'[3] Or perhaps the most farcical among these examples, the recently self-proclaimed madman and editor of *Flash Art*, Giancarlo Politi, whose overly romantic contextualization of Alexander Brener's vandalism of a Malevich painting in the Stedelijk Museum beckons back to the good old days when a man could be just a poor misunderstood genius. The success of these caricatures, actions, and rantings depends heavily on the circulation of a bankrupt language of the initiates, plus a degree of consensual cynicism, if not utter desperation leading to

2. These drawings have been reproduced in the 1997 *Summer Issue of Zingmagazine: a curatorial crossing* on pages 180-188.

3. Simon Ford, 'The Myth of the Young British Artist,' *Occupational Hazard: Critical Writing on Recent British Art*, ed. Duncan McCorquodale, Naomi Siderfin, and Julian Stallabrass (London: Black Dog Publishing, 1998), p. 134.

nostalgia. Ultimately they represent an impasse that theory and art have reached in terms of dialogue.

Despite this rather bleak perspective, I still believe the relation between art and theory to be both necessary and vital. As Gilles Deleuze aptly points out:

> ...from the moment a theory moves into its proper domain, it begins to encounter obstacles, walls and blockages which require its relay by another type of discourse (it is through this other discourse that it eventually passes to a different domain). Practice is a set of relays from one theoretical point to another, and theory is a relay from one practice to another. No theory can develop without eventually encountering a wall, and practice is necessary for piercing this wall.[4]

The liberative possibilities of such an alliance lie in the potential to pierce through walls thrown up by the process of theorizing and conversely to break down those erected by artistic practice. However a truly open dialogue can only happen when there is a sense of mutual reciprocity or, for that matter, mutual risk; the dilemma is how to attain that state of reciprocity. My at times polemic argumentation and generalizations thus far have been used for the sake of driving home this very question. How can art and theory proceed in order to strike up a conversation on an equal footing so those 'relays' can occur?

Although I have no prescriptive solutions to this question, as a beginning there are some primary elements which can be addressed. A more open dialogue between art and theory can be facilitated by setting aside falsely dichotomous models in search of interactive paradigms acknowledging the fluidity of social change and exchange. As Michel de Certeau writes in *Cultural in the Plural*: 'between a society and its scientific models, between a historical situation and the intellectual tools that belong to it, there exists a relation that constitutes a cultural system.'[5] In order to escape the sequestered isolation

4. Gilles Deleuze in conversation with Michel Foucault, 'Intellectuals and Power,' *Discourses: Conversations in Postmodern Art and Culture*, ed. Russell Ferguson, William Olander, Marcia Tucker, and Karin Fiss (Cambridge: MIT Press, 1992).

5. Michel de Certeau, *Culture in the Plural*, trans. Tom Conley (Mineapolis: University of Minnesota Press, 1997), p. 90.

6. I once attended a symposium on the changing nature of the museum where the panellists, who all happened to be men, sat on a slightly elevated platform at the front of the room. Their configuration erected an impenetrable wall creating a hierarchical if not antagonistic relationship with the audience. Ultimately, the formal arrangement along with the general composition of the panel did little to convince the audience that anything had changed, at least at this specific museum.

of their own specialized tools, artists and theorists must recognize that they are simultaneously products and partial producers of a cultural system. And entrenched in this condition, they share similar concerns and face the same prospects of their work being appropriated or assimilated by larger social and economic forces. Implicated in these networks, cultural production must be continually re-inserted, measured up, and critically evaluated according to a variety of social dynamics.

It is also important to move away from classic constructs of theory versus practice by acknowledging the hybridity of each activity. Theory has its elements of practice, but all too often while critiquing structure, it remains unaware, unaccountable and above reproach in terms of its own manifestations.[6] If theory begins to value its own form, then it is subject to similar representational quandaries and has a great deal to gain from a relation with art.[7] Conversely, there are theoretical capacities in art-making. As the Critical Art Ensemble suggests, art can prepare 'the ground for the introduction of new realities and vision' and 'act as a catalyst for critical and imaginative thought.'[8] By realizing where these mutual territories lie, a relation between art and theory can be created which is based not on a division of labor – the one who does and the one who thinks – but on common issues and interests.

With these few starting points in mind, I am in favor of a relation between art and theory that refrains from the arrogance of expertise, rejects the hermetic tendencies of specialization, and allows the borders of each discipline to be continually redefined when brought into conversation with each other and broader social networks. I welcome an art and theory that shares the potential to critically reflect, speculate, and most importantly transform perception, thought, belief, and practices. Finally, I would hope for an institutional framework that fosters such an exchange, welcoming moments of uncertainty, confusion, crossovers, and perhaps even displacement.

7. Certain theorists have taken to heart this formal challenge, such as Dick Hebdige whose weaving together of proselike writing, circulating media images, and sampling of song lyrics blurs the line between expository writing and fiction. But unfortunately these examples are few and far between.

8. 'Critical Art Ensemble in Conversation with Mark Dery,' *Mute Magazine*, no. 10 (London: Skyscraper Digital Publishing), p. 33.

Herma Klijnstra

Get to work!
The relationship between art and art theory

Herman Melville tells the story of Bartelby. Bartelby is a clerk in an office on Wall Street. Every time his boss asks him to do something, he answers very politely, 'I prefer not to…' It is a beautiful story with a tragic ending. For a number of years, this 'I prefer not to…' was the motto of my artistry. I preferred to regard my thoughts and ideas as impossible objects: like round squares or unicorns. As long as I did not actually produce them, they could not be granted existence in reality and no judgment could be passed on them. I thought of them like I thought of clouds, as *Heimatlose Gegenstände*, as being impossible to categorize or classify. The infinite world of which they were a part fascinated me immensely. I became high from thinking in abstractions of time and place. It was as though I was flying in an endlessly expansive universe.

Naturally, I wondered about my place in it: where in this realm could I be an artist? I discovered that the possibilities within which I was able to produce work did not correspond with what I wanted to show. Philosophy made it possible to discuss my fascination with abstractions and concepts. I could, at any rate, communicate about the ideas to which I could give no shape as an artist. In philosophy I investigate the way in which things exist in the imagination and how that type of existence differs from the existence of things in reality.

About ten years ago there were many symposia about the end of art and the end of philosophy. Now the accent lies more on the relationship between art and art theory. The conditions within which art and art theory take place are being analyzed, and it seems as though a new and fruitful discussion is developing. In his article 'System, History, and Hierarchy: the Historicist Paradigm in Art Theory,' Jean-Marie Schaeffer analyzes the way in which art theory has developed. He describes the effects of the romantic paradigm. By this he is referring to the way in which eighteenth- and nineteenth-century thinkers granted art a place within a larger system. This had always been a constructed system of truths in which art was granted a particular place within a hierarchy. Works of art hereby acquired a constructed

essence, which seemed to represent an absolute truth. This romantic paradigm continues to have its effects. The article by Schaeffer has given me, as an artist, insight on the hesitancy that I feel to continue making work. The conditions within which I must produce my work do not correspond to what I want to show. It is a personal hesitancy which probably stems from my philosophical approach, because generally art is flourishing. There are many artists at work. People are lined up to get into art academies. Evidently it is still quite appealing to be an artist. Artists represent a freedom which is apparently considered very enviable in our Western society. This freedom, an imperative for the artist, is rooted in the romantic paradigm. Can art give up this freedom and become subservient? I wonder about this, because one frequently sees a certain chemistry between museum art and art on the street, between high and low art. The range of art is so vast and varied right now that it is impossible to develop a universal art theory. The philosophical apparatus on which art theory relies is not suited to do justice to the diversity of the art.

Art theory is a field that has arisen from art. Initially, it was mainly artists who developed theories on the basis of their knowledge and experience, in order to be of service to fellow artists and to develop the field further. In these times, when everything needs legitimacy, art theory has grown into a specialism. Philosophers have started to become engrossed in art theory. Aesthetics, traditionally the domain of philosophy, is distinct from art theory. Aesthetics are concerned with the cause and effect of beauty. Art theory establishes rules for what good and bad art is. Aesthetics still refer to the paradigm described by Schaeffer, and that has an influence on art theory.

The presumption that art is undergoing a crisis, as has been proclaimed for the past ten years, is not founded on empirical fact. This presumption is probably related to postmodern philosophy 'that deconstructed the meta-narratives' (Jean-François Lyotard).

Art theory and the philosophy of mind

Art and art theory are inconceivable without a consideration of the way in which human consciousness functions. A large part of art theory is mental activity: the way in which we experience and identify an artwork and make up rules for its classification. The work of art constitutes an empirical fact.

We have language to describe what we experience if we contemplate the artwork. In our assessment we attempt to situate the work within a greater whole. We link the particular with the general.

Consciousness is always directed at something; in other words, it is characterized by intentionality. In order to pass judgment we must first form a mental picture of the object that we intend to judge. Forming a mental picture and judging are two different acts of consciousness. We can speak about the mental picture of an object without having the actual object before our eyes. We often speak about art on the basis of mental pictures or descriptions. There is a considerable difference between an immediate perception of an artwork and speaking or writing about this in its absence. A great deal is written about a limited number of artworks that are not always directly at hand. This yields texts which frequently respond to texts about artworks rather than to the work itself. It is for this reason that I am putting emphasis on intentionality here. Our consciousness is directed at an object, but that object can exist in the consciousness only as a mental picture. That pictured object is distinct from an object which we are able to perceive directly. This can be a reason why there is sometimes a gap between art and art theory. Art theory responds, in many instances, to representations of artworks. Art teaches us about human perception and its potential. In aesthetics, as developed within the systematic thinking of the eighteenth and nineteenth centuries, art was granted a place in an ontological hierarchy, whereby the artwork was required to refer to a truth beyond itself.

We have a special relationship with things that are made; these come into the world new, and we are able to give them a place. We can pass judgment on them. From the perspective of the maker as well as that of the observer, there is a point at which the object exists solely in the consciousness. (This existence of the object in the consciousness is called *Intentional Inexistenz* by Brentano, the founder of phenomenology.) The idea that everything is still possible at the moment of creation is liberating. When one makes something, one experiences the contingency of the conviction or the longing that one expresses. Once a work of art exists in reality as a physical phenomenon, the observer can pass judgment on it. It is possible that this judgment does not lead to classification, because the artwork cannot be situated within the system offered by an art theory. The judgment that we pass is based on certain assumptions contained in an art theory. These assumptions do not refer to an ontological essence but are the premise for a theory.

As in mathematics, one relies on certain axioms, or in the statement 'Zeus is the highest of the Olympic gods' on the assumption of Greek mythology. The assumptions in art theory are in need of further analysis. We should be aware that, in art theory, we are not speaking about essences but about existences.

That which presents itself without necessity is arbitrary. As with the articulation of a sentence or the writing of this text, how it will continue is still contingent at the moment one reads the sentence. One anticipates a certain linearity, a consistent line of reasoning, but every subsequent word is free for me to choose. There is also the possibility that I would use synonyms. Furthermore, the words that I use often have multiple meanings.

The world is not a closed system. The mentioned contingency is present not only in the making of an artwork but also in the forming of a judgment. This judgment must pertain to what becomes manifest, to the phenomenon, not to a possible underlying essence that is situated within a greater ontological hierarchy.

In Western philosophy there are two very distinct tendencies with respect to contingency, and they continue to have influence. In the first view, which was developed in the Monadology of Leibniz, this contingency is fulfilled according to a preestablished plan (*harmony preétablie*). A contrasting view, in which the contingency becomes confirmed as a rule after the fact (a posteriori), can be seen with the philosophy of Kant.

The mechanical reproduction of image and sound has brought us to an age of constant stimulus – stimulus which has put us in a more or less permanent state of shock. We are forced to seclude ourselves, to make our senses less sensitive. This has consequences for the art that is being produced. Some of this work provides refuge for the senses, whereby our sensitivity is increased. This often comes about by bringing up casual and arbitrary matters which lack any explicit message. A great deal of other work literally involves deprivation, as for instance all art that is situated in darkened spaces, where video projections take place. There is also work that makes a direct appeal to our senses, such as an installation by Bruce Nauman at the 1992 *documenta* in which he showed a video with the head of a man shouting 'Help me!' That was bone-chilling.

It seems that one can now speak of a postconceptual moment at which the sensory experience is key. That is why there is a need for a more formalist approach, in which we depart from what is manifest.

The aforementioned is reflected in a revived concern for a more formalist approach: witness the symposium *Come to your senses* organized by the A.S.C.A. and the symposium *The Kantian Turn* organized by the Jan van Eyck Academy, in Maastricht, both in June 1998. I think that this revived concern has to do with a departure from the notion of an essence and an absolute truth which has continued to dominate so persistently in art. As evident from the title, the symposium *Come to your senses* dealt with the sensory experience. This, however, was not expressed through the form in which the symposium was presented: the lectures had an academic character, and the art that was shown served only as illustration for the lectures and as entertainment.

Text as a production factor

Jean-Marie Schaeffer says, in one of his articles in this publication, that theory is for the art of today what perspective was for the art of the Renaissance. Perspective was a strong visual means. Nowadays it is impossible to escape art theory, because we look at art and want to exchange our views on it. We establish rules for what good and bad art is, and as such we construct a theory of art. But here I would like to raise the matter of writing which is a creative product. A new name should be invented for a type of writing that constitutes an artistic product. These texts are not art theory or meta-aesthetics. These texts do not constitute reflection, but these texts make an essential contribution to art which is being made. These texts are not rigid and have nothing to do with structuralism, as was the case in conceptual art. They produce new possibilities, both for the use of text and for visual products. These texts also have a liberating function with respect to traditional aesthetic values and release us from the romantic paradigm. These texts do not deal with essence; they are simply manifest. These texts deal with the coincidental, the contingent, rather than with that which is necessary. The texts themselves become phenomena. These texts are not required to identify or to classify. These texts are a production factor in the imaginative process. By this I am not referring to the myth which is persistently present in Western thinking: the idea of a *creatio ex nihilo*, the illusion of total control. The *homo autotelus*, who generates himself from his own substance. I am referring to something new, something that has yet to be

invented – a use of words and language that can be part of an artistic production. The fact that one is able to imagine something which is not yet there is projected, in fantasy, onto the idea that the world can be created according to a plan. This illusion is not possible in physical life. The analysis of such myths as *creatio ex nihilo* is a task for this type of text. Existing theories will first need to update their theoretical apparatus in order to handle the task of making diversity in visual artwork something worthy of discussion. Moreover, for traditional art theories, a form of *mea culpa* is in order, as they are partly responsible for the stagnation in reflection on the stream of visual art that is being produced. Because these theories have adhered religiously to the autonomous status of art and, in doing so, have kept its platform too small. Current art theories and aesthetics have been occupied too much with the consolidation of a status quo.

Here I should like to emphasize that speaking and writing about the relationship between art and art theory, in general, is pointless. One would need to deal with specific subjects; an investigation into fundamentalism in art and philosophy, for instance, would constitute a good point of departure.

The experience of contingency, that it is neither necessary nor impossible to make or write something, feels like a liberation from excessive expectations, which one must fulfill in the case of an essentialist art theory. What I am writing here cannot be founded on a truth beyond this text. The total lack of necessity is a bitter emancipation. Solace is offered by the fact that what is not necessary is also not impossible. Therefore possibilities for writing and making things do exist. So let's get to work!

Andreas Broeckmann

A Measure of Distance

The following is a loose commentary on Jean-Marie Schaeffer's lecture 'Experiencing Artworks,' in which he discussed the relationship between art and theory. As neither critique nor autonomous essay, I want to elaborate some thoughts which arose while listening to Schaeffer. They deal, in five short sections, with the notions of interdisciplinarity, media theory, history, the experience of art, and the cultural foundations of aesthetics. Some of these ideas were already mentioned during the workshop that followed the lecture; others are added here.

In these notes, I speak from the perspective of a specific experience within the field of contemporary art – that of electronic or media art. A debatable definition of 'media art' is those artistic practices which are centrally concerned with electronic media – video, computer, electronic networks, virtual reality, motion tracking, etc.; practices which use these technologies and at the same time deal with the specific aesthetic effects and experiences they engender. The following notes try to measure both the distance and the potentially fruitful encounter between art that is centrally concerned with electronic media and those 'traditional' art practices which are more or less direct descendants of modern and postmodern art practices. On the one hand, the distinction is hard to draw, and the boundaries have become increasingly blurred. The introduction of media art courses at the academies and the increasing inclusion of media art pieces in 'traditional' art exhibitions herald this process of approximation. On the other hand, the reservations that many art critics and curators still have towards media art means that the presence of art works that rely on and deal with computers is anything but a regular feature of the so-called art world. My own opinion, speaking as an art historian, is that this is a regrettable omission, given the theoretical and aesthetic force that many of these works exert. Unquestionably, differences in quality exist as in any other field of cultural production. The sometimes ferocious criticism against these artworks, however, would be more acceptable if it were based on critically informed opinions rather than, as is most often the case, on ignorance.

I. In media art, interdiscipinarity is not a strategic gesture motivated by a political or aesthetic desire to 'cross over' or to reference 'context,' but a given condition that has to be deliberately ignored in order for it to be absent. Media art uses tools and inhabits a space that is criss-crossed by scientific, technological, and social vectors which, in many cases, make it an imperative for artists to position themselves and their work in relation to these lines of force. The dependencies of the conditions of production and presentation, most notably the reliance on commercial hard- and software, force media artists to act consciously, whether with a critical or an affirmative attitude, rather than being able to choose whether or not to make such conditions a part of their work. The role of media art as a whole is therefore also constantly questioned in relation to other disciplines such as cybernetics, robotics, economics, or military engineering. These interdisciplinary proximities are often precarious, but what is important to point out here is that interdisciplinarity is a matter of necessity rather than of aesthetic choice.

II. Schaeffer usefully describes art theory as a way of dealing with, of approaching, experiencing, and maybe understanding artworks and the modalities under which they operate. In the case of media art, there is a necessity to reflect on the history, the politics, and the economy of the technologies at hand – aspects which are willy-nilly built into many media art projects. Media art theory is therefore, amongst other discourses, closely wedded to media theory and theories of technology. Utopian as well as techno-critical and apocalyptic strands of media theory all feed into the different quarters of debates about media art. In the critically inclined segments of this constituency, there is a noteworthy openness to discussions on 'operating systems' which, in this case however, are not so much an established art system with galleries, critics, collectors, journals, etc., but, for instance, the technical and political OS's of Windows NT, Linux, or UNIX. This as a way to point to the specific politics and economy of media art and its theorization.

III. The history of media art has hardly been written. Efforts are currently made to document and describe its developments in the twentieth and in earlier centuries, creating a proper archaeological field with historians digging in many different directions. Like many other marginalized disciplines, this

historiography is critically aware of the ways in which the developments of technologically informed art practices have been written out of the canonized modernist art tradition. At the same time, only a select number of artists using new media are allowed into the Pantheon of Contemporary Art. Given the more than obvious constructedness of the history of art in the twentieth century, grand statements about the demise or return of the avant-gardes and their utopias appear rather meaningless in the face of a rich proliferation of utopias and multiple avant-gardes as we see them emerging and evolving in the media art field of the last two decades – a history very different from that chronicled in the international art journals and exhibitions of the same period.

IV. In 'traditional' art theory, the division between artist and receiver, and the default description of the receiver as an 'observer,' appear to have remained in place even though the mimetic agenda of classical modernism is supposed to have been replaced by more disparate, multifaceted aesthetic parameters. In contrast, the experience of media art is not so much determined by observing, but by participating. By now, the notion of 'interactivity' seldom elicits more than frowns and yawns, but it has to be affirmed that artworks which rely on an active engagement of the user in order to be realized, mark a paradigmatic shift, if not break, away from an art that is determined by the authorial artist's choices and that remains stable during the reception. As with other observations made here, this characteristic is not unique to media art but has, to greater or lesser degrees, also been part of other artistic projects of this century. Unlike those instances, however, interactivity, a commitment to the art project as a process, the 'coding' of the reception as production, are general conditions of the aesthetic experience in media art.

V. It is, therefore, also problematic to follow the close relation that is still being drawn between art and visual culture, a point which emerges in the debate about whether or not to disclaim art's autonomy and to reinscribe it into visual culture. The continuing prejudice of art theory in favor of the visual runs counter to the multimediatic environments of media art projects which couple and decouple, mix and split auditory, visual, and tactile 'channels.' Even individual artists move freely between these different expressive materials, a fact that can, at times, be challenging for curators who are nor-

mally used to designing exhibitions purely on the basis of a visual and conceptual dramaturgy. More importantly still, the aesthetic paradigms of media art can be seen to move further and further away from notions of representation – something that, in European culture, the visual has proven to be so good at. In its place, connectivity, communication, and collaboration are achieving a paradigmatic status in the conceptualization and evaluation of media art, a fact that makes it difficult for traditionally trained art historians and critics to recognize what might be interesting in visually unexciting art projects. Moreover, some critics are engaged in the formulation of an aesthetics of the machinic which explores the aesthetic potentials of unpredictable and more or less autonomous machinic processes that sideline the intervention of artist or user. Visual culture is quite clearly too limited a framework for assessing these kinds of practices.

Felix Janssens & Ben Laloua

Logistics

reconcile the irreconcilable

FELIX JANSSENS & BEN LALOUA LOGISTICS

reality table 1

reality table 3

eality table 2

Biographies

Andreas Broeckmann

Johan Grimonprez

Nathalie Heinich

Catherine Ingraham

Felix Janssens

Herma Klijnstra

Ben Laloua

is an art historian living in Berlin and Rotterdam. Since 1995 he has been working as a project manager at V2_Organisation, a center for art and media technology, in Rotterdam, where he has co-curated programs for the Dutch Electronic Art Festival and the Next 5 Minutes: Tactical Media conference.

is an artist living and working in Ghent and Berlin. His work has been exhibited widely in Europe and the United States. His video works include *Dial H-I-S-T-O-R-Y* (1997) which was presented at *documenta X* (Kassel, 1997, cat.).

is sociologist at the CNRS in Paris. She published among other titles, *Le triple jeu de l'art contemporain. Sociologue des arts plastiques* (Paris; Minuit, 1998); *L'art contemporain exposé aux rejets* (Nîmes Editions Jacqueline Chambon, 1998); *Etre artiste. Les transformations du statut des peintres et des sculpteurs* (Klincksieck, 1996).

is Associate Professor at the Iowa State University Department of Architecture in Ames. Since 1991 she has been an editor of *Assemblage*, a critical journal of architecture. She published *Architecture and the Burdens of Linearity* (New Haven: Yale University Press, 1998) and *Restructuring Architectural Theory*, ed. with Marco Diani (Evanston: Northwestern University Press, 1989).

is an independent graphic designer living and working in Rotterdam. He is member of the Sober Denken Genootschap, consultant of the Office for Tele(communications), Historicity and Mobility.

is an artist and philosopher living in Rotterdam. Her work has been exhibited in the Dordrechts Museum (Dordrecht, 1996) and the Jan van Eyck Academie (Maastricht, 1998). She teaches at the Jan van Eyck Academie in Maastricht.

is an independent graphic designer living and working in Rotterdam, and is a member of the Sober Denken Genootschap.

Yves Michaud

Henk Oosterling

Jean-Marie Schaeffer

Renee Turner

is professor of philosophy at the University of Paris I Panthéon-Sorbonne and art critic. From 1989 until 1996 he was director of the École nationale supérieure des beaux arts in Paris.

teaches dialectics, aesthetics, and contemporary French philosophy in the Philosophy Department of the Erasmus University in Rotterdam. He is the coordinator of the Center for Philosophy and Art and is heading the project 'Intermediality.' He is the author of *Door schijn bewogen. Naar een hyperkritiek van de xenofobe rede* (1996), a study of the contemporary aestheticization of Western culture.

is researcher at the Centre National de la Recherche Scientifique in Paris. He is the author of, among other titles, *Les Célibataires de l'Art. Pour une esthétique sans mythes* (Paris: Gallimard, 1996); *L'Art de l'Age Moderne* (Paris: Gallimard, 1991); *Qu'est-ce qu'un genre littéraire* (Paris: Seuil, 1995).

is an artist and curator living and working in Amsterdam. Her curatorial projects include, *A Scenic Detour through Commodity Culture* (Maastricht, 1996) and *All is Quiet on the Domestic Front: a look at intimacy and dwelling* (Amsterdam, 1996). She is co-initiator and curator for De Geuzen: a foundation for multi-visual research in Amsterdam.

Editors
Bartomeu Marí
Jean-Marie Schaeffer

Translations
Beth O'Brien (Herma Klijnstra, Henk Oosterling)
Brian Holmes (Bartomeu Marí, Nathalie Heinich)
Stephen Wright (Yves Michaud)

Copy editor
Jennifer Sigler

Coordination and production
Barbera van Kooij

Design
Gracia Lebbink

Typesetting
Holger Schoorl

Printed by
Snoeck-Ducaju & Zoon, Ghent, Belgium

Acknowledgments
'Intermediality'. Art Between Images, Words, and
Actions by Henk Oosterling has been originally
published in Dutch under the title 'Intermedialiteit.
Kunstwerken tussen beelden, woorden en daden,'
in *Delocaties*, no. 4 published by the Centrum
Beeldende Kunst in Rotterdam in 1998, under the
direction of Cornée Jacobs.
'The End of the Utopia of Art' by Yves Michaud has
been originally published in French under the title
'La fin de l'utopie de l'art,' in *La crise de l'Art contemporain*
published by the Presses Universitaires de France,
Paris in 1997.
'Aesthetics, Symbolics, Sensibility: On Cruelty
Considered as One of the Fine Arts' by Nathalie
Heinich has been originally published in French under
the title 'Esthétique, symbolique et sensibilité: De la
cruauté considérée comme un des beaux-arts,' in *L'art
contemporain exposé aux rejets. Études de cas*, published by
Éditions Jacqueline Chambon, Nîmes in 1998.
We would like to express our gratitude to the above
mentioned publishers, for allowing us to use these
essays.

This book was produced and published by Witte de
With, center for contemporary art, Rotterdam and
was made possible through the support of the
Dutch Ministry of Foreign Affairs, the Ministery of
Education, Culture and Science and the Municipality
of Rotterdam.

Witte de With, center for contemporary art
Witte de Withstraat 50
3012 BR Rotterdam
The Netherlands
tel. +31 (0)10 41 10 144
fax.+31 (0)10 41 17 924
e-mail wdw@wxs.nl
site www.wdw.nl

Forthcoming in this series

From/To

Edited by Fareed Armaly and Bartomeu Marí
Essays, media, and lectures from the homonymous exhibition.
(Summer 1999)

Het ogenblik

Edited by Bartomeu Marí and Karel Schampers
Essays around the theme of hallucination and contemporary art
related to the homonymous exhibition.
(December 1999)